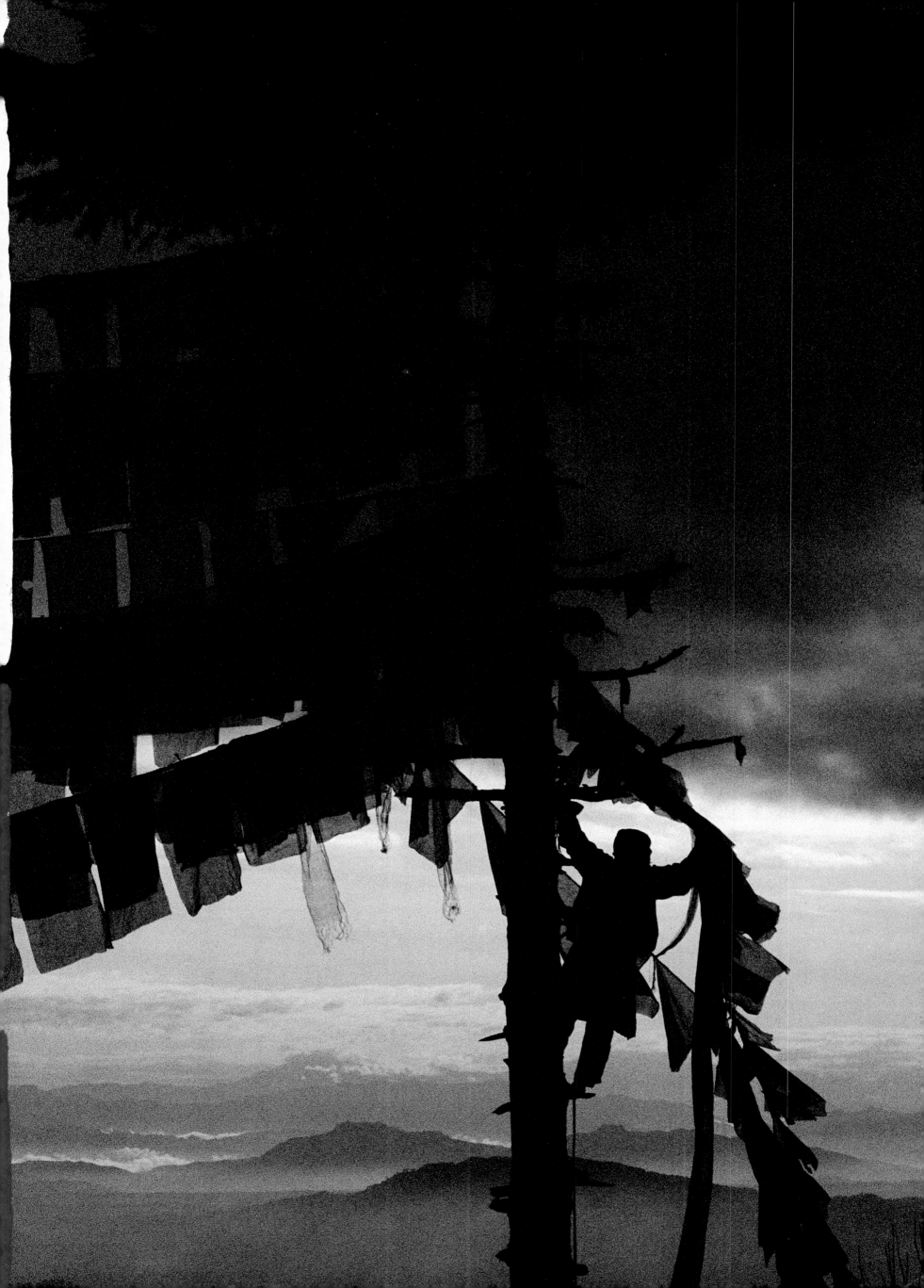

First published in the United States in 1991 by Chronicle Books.

- EDITORS -
PETER SCHOPPERT AND GILLIAN YOUNG

- DESIGN -
PATRICK LEBEDEFF AND MATHIAS DURVIE

- RESEARCH -
JOHN FALCONER AND JANE PERKINS

Printed in Singapore

Library of Congress Cataloging-in-Publication Data
Perkins, Jane.
Tibet in exile / introduction by the Dalai Lama,
photographs by Raghu Rai, text by Jane Perkins.
p. cm.
ISBN: 0-87701-849-9
1. Tibetans -- India. 2. Tibetans -- India -- Pictorial works.
3. Tibet (China) -- Description and travel. 4. Tibet (China) -- Description and travel -- Views.
I. Bstan-'dzin-rgya-mtsho. Dalai Lama XIV. 1935- . II. Rai, Raghu, 1942- .
III. Title. DS432. T5P47 1991
90-2614
CIP

Distributed in Canada by Raincoast Books,
112 East Third Avenue, Vancouver, B. C. V5T 1C8

10 9 8 7 6 5 4 3 2 1

Chronicle Books
275 Fifth Street, San Francisco, California 94103

TIBET IN EXILE

INTRODUCTION BY
THE DALAI LAMA

PHOTOGRAPHS BY
RAGHU RAI

TEXT BY
JANE PERKINS

CHRONICLE BOOKS · SAN FRANCISCO

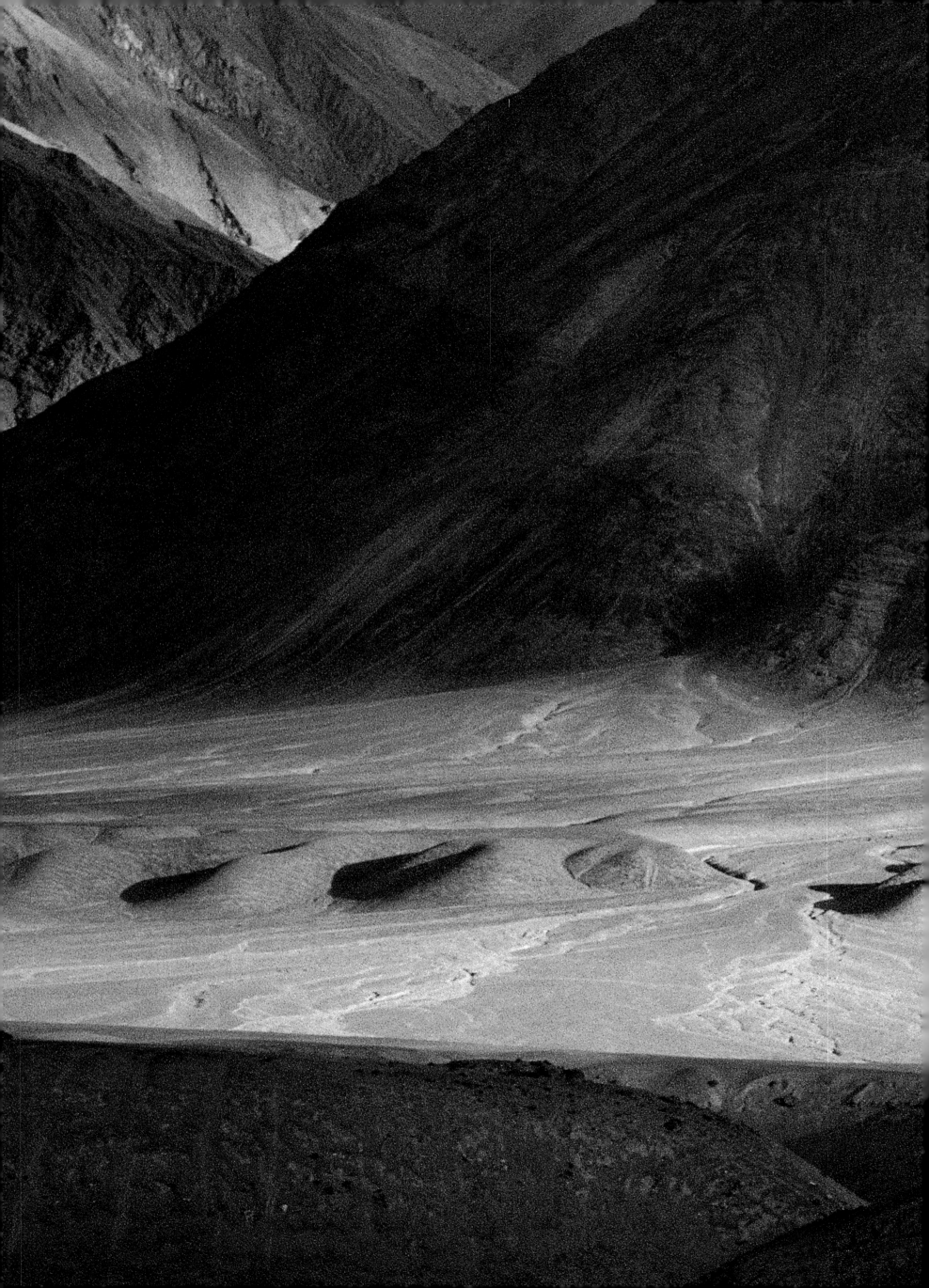

THE DALAI LAMA

The Chinese invasion and subsequent occupation of our country taught us a bitter lesson - to live in contented, peace-loving isolation is not possible in this modern-day world. In hindsight our isolationist policy resulted in the outside world not knowing the true situation of Tibet. Therefore, quite a few people believed the continued Chinese propoganda about Tibet being part of China.

Although materially undeveloped, Tibet was rich in terms of spiritual development. By protecting ourselves from what we saw as harmful outside influences we failed to understand the reality of modern-day politics. It is not enough to be independent: the world also needs to be made aware of it.

Realising the need to communicate and interact with the outside world, we have been trying to use the opportunity available to us in exile to inform the international community about Tibet. In this we have been assisted by a number of individuals and organisations throughout the world.

I believe it is in the interest of the world community to see that Tibet remains alive. Tibetan culture and traditions can contribute much to the development of the world civilization. Although I have always believed that individuals have different mental dispositions and so there should be different religions to cater to these needs, Tibetan Buddhism does have special techniques for developing love, compassion, peace and happiness. It is this Buddhist philosophy which has sustained us through the hard years in exile and has kept the spirit of hope and determination alive among our people.

The Buddhist karmic theory of cause and effect which says we are the makers of our own destiny has the seed of a philosophy which can see misfortunes as blessings in disguise: as an opportunity to learn patience and develop strength through inner peace.

Today a new international trend is emerging. Through popular movements many oppressed nations are breathing the fresh air of democracy. We have seen that the people of China also desire freedom and democracy although their efforts have been ruthlessly suppressed.

The moral force of Mahatma Gandhi is gaining more followers. There was a time when many of our friends and supporters honestly believed ours was a lost cause as we upheld non-violence in a world where physical might seemed to have the upper hand. However, history has now proved that we were following the right path.

I have a dream that Tibet will one day be transformed into a peace sanctuary, a Zone of Ahimsa - a place where people bogged down with the tensions and pressures of modern life can come to seek the true meaning of peace within themselves. My desire is that Tibet should be a place where man and nature live in harmony.

We have learned much in our diasporic life. We have learned to face the modern-day world and to take from it valuable tools that educate and advance mankind. We have learned to test the truth of the Buddha's teachings on suffering and to apply the antidotes. We have also learned that too much material success without a counterbalance of mental development leads to craving, dissatisfaction and unhappiness.

I am happy to have chosen India as our second home. Here, in the Land of the Buddha, we have had the time, security and mental peace to preserve the essentials of our culture and religion, and to educate new generations of Tibetans to face the complex challenges of tomorrow. India's generosity to us in the face of her own poverty has been a great lesson in loving kindness. In ancient times it was India which gave us spiritual guidance in the form of the teachings of the Buddha. Today, it is again India which has come to our assistance through material aid.

I am therefore particularly happy that this photographic record of our life in exile is the work of an Indian - and a friend. I am confident that the book will enable many of its readers to understand the Tibetan nation and its people better.

The Fourteenth Dalai Lama
May 18, 1990

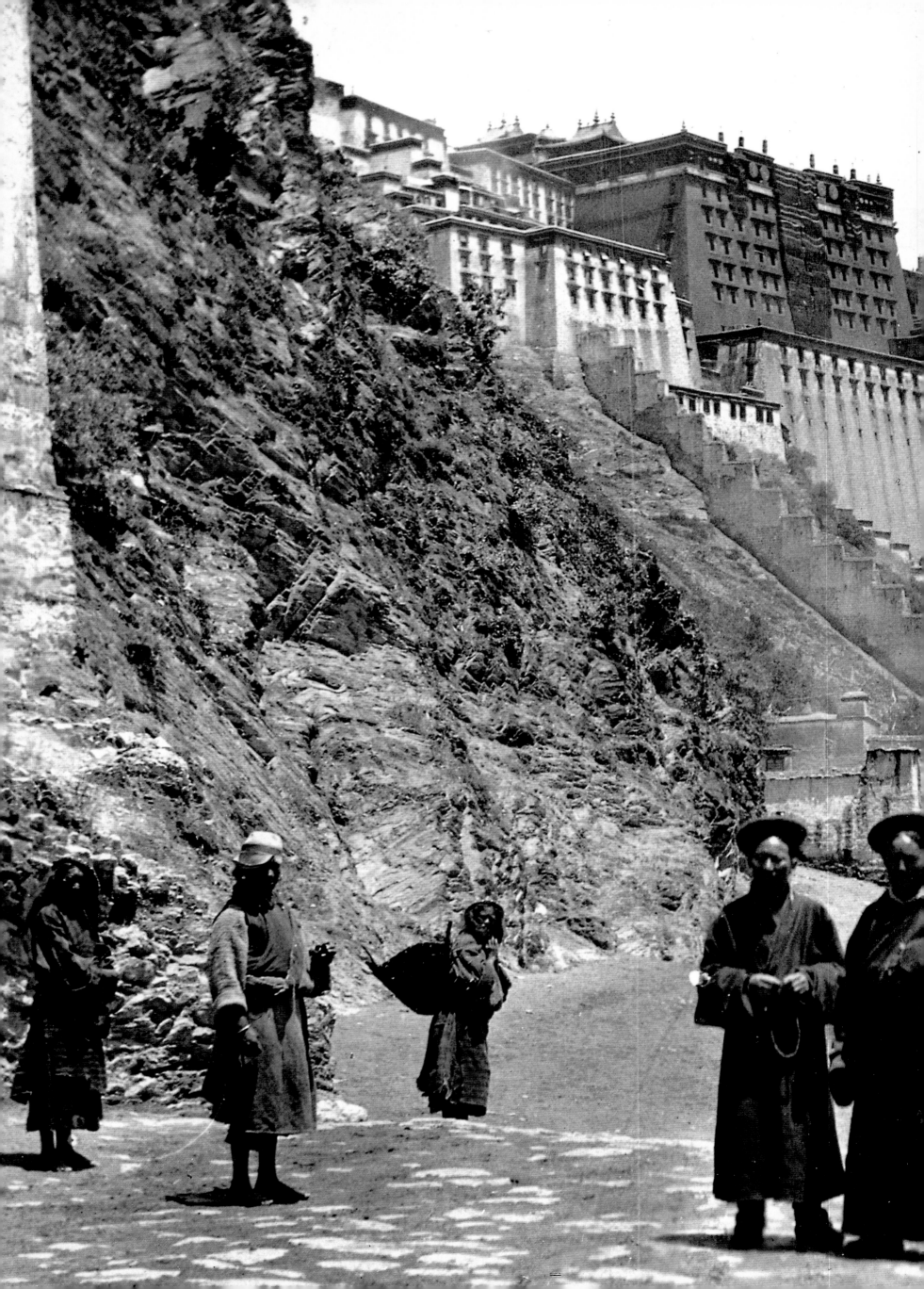

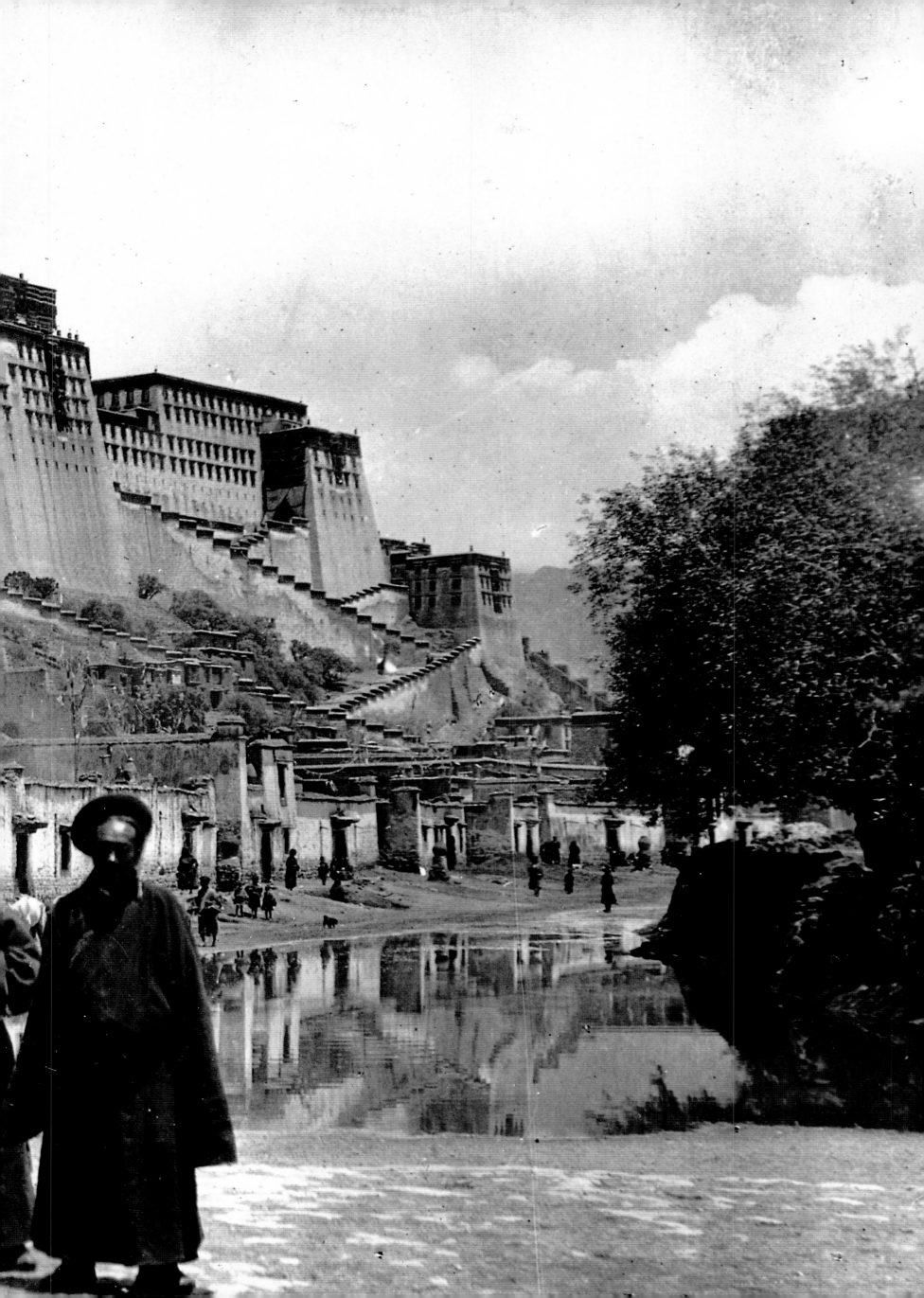

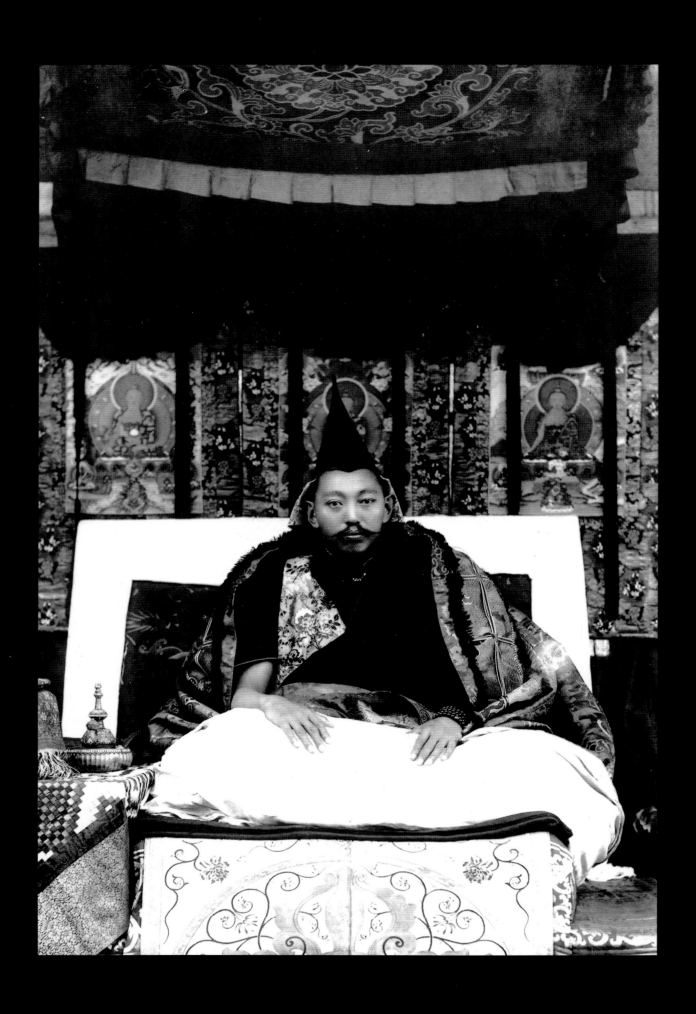

LAND OF SNOWS

The telegraph office at Gnatong lay under winter's seige. Snow drifts engulfed the wooden huts and icy winds blew down from the Jelap La, the mountain pass dividing Sikkim from Tibet, eight miles to the north. The desolation was broken by fists pounding the office door. "Who the hell are you?" demanded Bill Luff, one of two ex-army sergeants manning the outpost that linked British India's trade marts in Tibet to Calcutta, the then capital. "The Dalai Lama," came the reply.

So, in February of 1910, the Thirteenth incarnation of Tibet's supreme leader, eluding a pursuit party of Chinese troops, stepped on Indian soil for the first time – and slept soundly that night in Sergeant Luff's bed. Forty-nine years and one month later, in March 1959, his reincarnation, the Fourteenth Dalai Lama, slipped out of his palace in Lhasa disguised as one of his own bodyguards and fled before Chinese troops and spotter planes to take refuge once more in India. Since then he has spent most of this life in Dharamsala, in the western foothills of the great Himalayan range that divides the Indian subcontinent from the high plateau of Tibet.

Long before recorded history, the first human contact between the two lands would have been through nomadic herders, driving their sheep and yak to new pastures as the Himalayan snows melted on spring meadows; then through traders, braving treacherous weather and daunting mountain passes to sell their goods on the Tibetan tableland and in the plains of north India. Next came military incursions, when Tibet was a mighty conquerer in the later tradition of the Mongols, harrassing India from the north. And finally, with Indian Buddhism, came the two-way trade of saintly teachers and scholars, the *pandits* and *lotsawas* (translators), who risked their lives crossing the Himalayas, hearts filled with religious fervour and backs bowed under palm leaf scriptures.

When the first of Tibet's Three Religious Kings, Songtsen Gampo, came to the throne in AD 630, uniting warring tribes and conquering neighbouring lands, India, China and Nepal were already Buddhist, and turning their energies from the battlefield to amassing spiritual merit. We know this era from the journals of Hsuan Tsang, a Chinese monk who travelled and studied in north India for sixteen years to bring back to T'ang China a vast collection of *sutras* (the Buddha's teachings). In India Hsuan Tsang visited the Gupta King Harsha and under his patronage studied at Nalanda, one of four great monastic universities flourishing since the fifth century in the eastern areas of northern India. Two years after Hsuan Tsang's return, the Buddhist emperor of China sent a goodwill mission to Harsha's court, but, since the king was dead and the minister who usurped the throne was anti-Buddhist, the envoy and his retinue were robbed and narrowly escaped death. From Nepal, then under Tibetan domination, the Chinese envoy appealed to Songtsen Gampo for help, and two thousand armed Tibetans led seven thousand Nepali soldiers down what was known as "The Stormy Nepal Road" into India to capture the usurper and deliver him to the Chinese court at Ch'angan.

King Songtsen Gampo's regional military domination won him marriages of alliance with a princess from Nepal in AD 632 and, nine years later, with the Chinese emperor's daughter, Princess Wen Ch'eng. The two consorts are said to have influenced the warrior king towards Buddhism. Both brought magnificent statues of the Buddha in their dowries and built temples in Lhasa. The Nepalese queen was later worshipped as Green Tara, the Chinese as White Tara, two of the Tibetan pantheon's most popular deities.

In the reign of the Second Religious King, Trisong Detsen, who inherited the throne in AD 755, Tibet dominated Asia from its high ground. The country was perpetually at war, rampaging through the region and taking territories, from the Gilgit and Baltistan regions of today's Pakistan and northwest India, to Singkiang in northwestern China. But Tibetans prefer to honour King Trisong Detsen for a far more precious contribution to their history. He invited one of India's leading scholars to bring the Buddha's teachings to Tibet. This was Santarakshita, Abbot of Nalanda, the monastic university where – so Hsuan Tsang tells us – ten thousand monks studied in buildings and parklands of surpassing "magnificence and sublimity". The gentle *pandit* soon realised he was no match for the Bon priests intent on preserving their privileges at the Tibetan court. This indigenous religion conjured up a terrifying world dominated by demons, and placated them with human and animal sacrifice and elaborate shamanistic rituals.

Left In 1879, when the three-year-old Thirteenth Dalai Lama was enthroned, Tibet was already a pawn in the "Great Game" - a political balancing act between British India, Russia and China. The lessons of two exiles turned the Thirteenth incarnation into an astute and absolute ruler and the Tibet he administered from 1912 until his death in 1933 was peaceful and independent. Previous page *The seventeenth-century Potala, winter palace of the Dalai Lamas.*

So scholarly Santarakshita suggested inviting another teacher from India, from Uddiyana (or Swat, in today's Pakistan), a valley renowned for its exorcists, sorcerers and magicians. The choice was masterly. Padmasambhava, Tibet's revered Guru Rinpoche (Precious Teacher) was an accomplished tantric, a controller of nature and tamer of evil spirits. With displays of magic and much bravado, Padmasambhava overwhelmed the country's demons and bound them to become protectors of the Buddha *dharma*, the teachings. Having subdued Bon opposition, Guru Padmasambhava and Santarakshita started building Tibet's first monastery, Samye, in AD 767. Completed twelve years later, it became a prototype for later Tibetan monastic architecture and a symbol of India's growing influence in Tibet. Study and the process of interpreting the Buddhist canon flourished, and soon differences came to a head between Chinese and Indian monks living at Samye and translating texts from their languages into Tibetan.

In AD 792, King Trisong Detsen ordered that the disputes over different interpretations of the Buddha's teachings should be thrashed out in a public debate. The Great Samye Debate brought out the different viewpoints within Mahayana Buddhism, one of the two major schools of today's Buddhism, which had itself emerged from a schism in the third century AD. The debate was a turning point for the Mahayana philosophy in Tibet. A student of Santarakshita, Kamalashila, journeyed from Nalanda to argue the Indian viewpoint: that the goal of enlightenment could only be achieved by accumulating knowledge and merit and taking the graduated path through certain defined stages. His Chinese adversary, Hoshang, argued the Ch'an – or Zen – philosophy of repose, contemplation on emptiness and the possibility of enlightenment being realised in a momentary flash (sartori).

Victory went to the Indian interpretation, although the Chinese path is also found in Tibetan meditative and tantric practices. In Mahayana Buddhism, a commitment is made to strive not only for your own liberation, but the liberation of all sentient beings from samsara (the cycle of wordly suffering and rebirth). Mahayanists see this as a more altruistic path than the Hinayana vow, which entails the liberation of the individual only. Today, Tibetan, Japanese, Vietnamese, Mongolian, Chinese and Korean Buddhists practise Mahayana; Thai, Burmese, Sri Lankan and Cambodian Buddhists are followers of the Hinayana philosophy.

During the reigns of Trisong Detsen and the Third Religious King, his grandson Tri Ralpachen, Indian *pandits* and Tibetan *lotsawas* sat together to translate palm leaf texts, testing the flexibility of the new Tibetan alphabet which had been devised from the Indian Brahmi-Gupta Nagari script during Songtsen Gampo's reign. Today, the Fourteenth Dalai Lama describes this as "an outstanding epoch in the history of mankind. One is struck by the accurate, faithful and literal nature of these translations."

Ralpachen had enemies at court and was assassinated in 863 by one of his ministers. The throne went to his elder brother, Langdarma – a name synonymous with all that is evil for Tibetans. He persecuted monks, desecrated monasteries and reimposed Bon. The story of his death is the theme of the Black Hat Dance performed by monks during *cham* (religious dance festivals). Langdarma's death was considered a "mercy killing" to protect the *dharma* and a meditator monk took on the task, dressed in a broad-brimmed sorceror's hat and brocade robe concealing a bow and arrow. Having mesmerised the king with his dance, he let loose the deadly arrow and escaped on a white horse rubbed black with soot. Then he restored his steed's colour in a river, reversed his cloak from black to white and sped to his cave to turn meditator once more. The tale has a characteristically Tibetan quality – the blend of magic, piety, heroism and cunning that runs through both folk and epic religious legends.

After Langdarma's death the empire disintegrated, with feudal lords ruling pockets of land and Buddhism greatly weakened. The focus of Tibetan history moved to Western Tibet and neighbouring Ladakh, Zanskar, and Spiti, regions that today fall within the map of India but culturally are part of "Greater Tibet". Eventually, from the Western Tibetan kingdom of Guge, emerged another spiritually-minded ruler who reached out to India once more to purify the *dharma*. Around AD 970, King Yeshe-od sent twenty-one clever youths to Kashmir and India to bring back original scriptures and invite India's best pandits to teach in Guge. One of the only two survivors, Rinchen Zangpo, collected and

The British telegraph operator, Bill Luff, who gave his bed to the Thirteenth Dalai Lama during his flight from Chinese troops to take exile in India in 1910.

translated thousands of volumes of *sutras* (the teachings of the Buddha) and *tantras* (the later commentaries by disciples and scholars). This 'Great Translator' is credited with building 108 monasteries and temples along pilgrim and trade routes in the Western Himalaya, including the temple complex at Alchi in Ladakh, today a magnet for students of early Himalayan art.

It took yet another great Indian teacher, Atisha, the Abbot of Vikramashila – another of the four Buddhist monastic universities in medieval north India – to lay the groundwork for Tibet's spiritual renaissance. Atisha was sixty when he reached Guge in 1042 and devoted the twelve last years of his life to teachings of such profound effect that, it is said, Buddhism was never again seriously threatened in Tibet. He taught the disciplined path of Perfection of Wisdom, the Prajnaparamita, which stresses the importance of laying a solid foundation of study, of monastic discipline, and obedience and devotion from students to their teachers. These are still the ideals for Tibetan monks today.

At the same time that Atisha's teachings were stimulating new schools of thought in Tibet, Muslim invaders were already beginning to overrun Buddhist north India, destroying the great universities, the monasteries and stupas dating from the reign of Emperor Ashoka in the second century BC. The *dharma* withdrew behind the snowy Himalayan barrier and Tibetan scholars became the sole inheritors of the entire corpus of Indian Buddhist teachings, custodians of the scriptures that had been carried across the mountains for five hundred years and translated with such single-minded zeal. Thus ended the first illustrious era of Indian influence on Tibet. The emphasis now moved to growing contacts with Mongolia and China, and a web of politics and religion so complex that communist China could claim in 1950 that Tibet had always been part of the "Great Motherland", and India, against the evidence of early history, could choose to side with China.

The eleventh and twelfth centuries were so spiritually fertile in Tibet that teachers and ascetics inspired new schools, which in turn developed into separate sects. Atisha's followers became known as the Kadampa, or "Bound by Command", to distinguish them from the Nyingmapa, the "Ancient Ones", who practised Guru Padmasambhava's tantric path. Then the

Sakya sect emerged in the mid-eleventh century, followed by various Kagyud schools in the twelfth. The latter two lineages were the first to develop priest-patron relationships with the rulers of China; the Sakya with the Mongol Khans of the Yuan Dynasty and the Karma Kagyud with the emperors of late Yuan and early fourteenth-century Ming.

Through the years, as the sects and feudal rulers struggled against each other for power, ritual and studies continued in monasteries across the farflung provinces. Hermits and yogis sealed themselves from the world, striving for the goals of a *bodhisattva*, one who has developed such a high level of wisdom, love and compassion that, having attained enlightenment, he elects to return to the cycle of rebirth to help other beings reach enlightenment too.

Then, from distant Amdo province, near Tibet's northeastern border with China, emerged a man of outstanding intellect and moral force. Tsongkhapa took Atisha as his inspiration and dedicated his life to restoring the purity of Buddha's teachings, reimposing discipline and nobility of purpose on those who took robes. His ascetic vision had such strong appeal that by the first decade of the fifteenth century, the Kadampa had become, in essence, Gelugpa, "The Virtuous Ones", ultimately the dominant sect of Tibetan Buddhism.

Tsongkhapa established Monlam, the annual Great Prayer Festival held in Lhasa for three weeks at the start of each lunar new year to rededicate the nation to the *dharma*. He also built Lhasa's three famous monasteries of Gaden, Sera and Drepung, which emphasised excellence in studies and strictness in keeping vows. But the paramount role in Tibetan history went to his foremost disciple and nephew, Gedun Drub, who spent more than twenty years in meditation retreat and built the Tashilhunpo monastery at Shigatse, Tibet's second largest city. Before passing away in 1474, he left predictions for his own rebirth, thus beginning a long line that leads to the Fourteenth Dalai Lama. This was not the first and only case of reincarnation in Tibet. These *bodhisattvas*, or reincarnates, are known as *tulkus*, or "emanation bodies", and they are given the respectful title of *rinpoche*, or "precious body".

The title of Dalai Lama was bestowed on Gedun Drub's third incarnation by Mongolia's premier chieftain, Altan Khan, after the Khan's conversion to

Buddhism. Since then, each Dalai Lama – literally Ocean of Wisdom – has taken the second name of Gyatso, the Tibetan word for ocean. Although the Mongols were no longer united and ruling China, they still exerted political power in the region. It was apparent the Gelugpa had gained a strong ally when the Fourth Dalai Lama was discovered to be a great-grandson of Altan Khan. His tutor was named Panchen Lama, or Great Scholar, later to become the second highest rank in the land. His seat was Tashilhunpo.

Despite the political support, honorifics did not equal political power until the time of the Fifth Dalai Lama. He became the first to rule Tibet, in 1642, when the Mongols helped him to seize the throne from the King of Tsang. The Great Fifth, Lobsang Gyatso, unified the feudal factions, set up medical care and education nationwide, travelled and taught extensively, writing as much as all the other Dalai Lamas before him, and took teachings from lamas of all sects. The incredible Potala dates from his reign, a symbol of Tibet's power then, when Lhasa was the hub of Mahayana Buddhist civilisation and monks from all over the region vied for admission to its three monastic universities. In 1652, the Fifth Dalai Lama travelled to Peking (Beijing) as a guest of the Ch'ing emperor, and was honoured as an equal.

But his greatness also exposed the danger that came from rule by reincarnation. There is inevitably a hiatus until the new body assumes power at around the age of eighteen, and the Fifth was so venerated that the regent concealed his death for fifteen years, fearing a return to civil strife. So the Sixth Dalai Lama was well into his teens when he came to the throne. Handsome, intelligent and already worldly, he refused to take vows, dressed as a layman and taught in the parks of Lhasa sitting on the grass with his people. At night he was a roistering member of lay society and the poems written in his short life may be interpreted either as sonnets to his lady loves or as spiritual ecstasy of the Sufi type. But without a politically astute leader, Lhasa fell prey to Mongolian invaders backed by China. When another Mongol force came to the rescue, China seized the excuse to send in a seven thousand-strong army to enthrone the Seventh Dalai Lama in 1720, declaring Tibet a protectorate of China and installing two officials called Ambans in Lhasa.

The Seventh and Eighth Dalai Lamas were devoutly spiritual and left administration to laymen. Their successors, from the Ninth to the Twelfth, lived no more than twenty-one years, and so the role of the regent beca-

me all-powerful. Lhasa in the nineteenth century was a scene of convoluted political intrigues, provoked by China whenever possible with an eye to controlling its one million square miles of sparsely inhabited land.

By the time of the Thirteenth Dalai Lama's birth in 1876, Tibet had learnt to mistrust her neighbours, particularly the Christian colonial administrators of an expanding British India. The British had set their sights on trade with Tibet, and were also caught up in the intrigues of the "Great Game" of the balance of power in Central Asia. When Tibet snubbed the advances of the Viceroy, Lord Curzon, he began to suspect a secret alliance with Russia. Lord Curzon sent Colonel Francis Younghusband first to the border to force negotiations in 1903, and, when that failed, to invade. Tibetan broadswords and protection mantras were no match for British bullets. The British advanced steadily.

The Thirteenth Dalai Lama was twenty-eight years old and completing a three-year solitary meditation retreat when the colonel marched towards Lhasa. The Tibetan government turned to the State Oracle, Nechung, for guidance and the answer in trance was that the British forces would penetrate to the Forbidden City but the final victory would go to Tibet. The young ruler broke his retreat and headed north towards Buddhist Mongolia, the traditional and trusted ally. During this first five-year exile, he toured and preached, then accepted an invitation to Peking, where he attended the funeral of the Empress Dowager and witnessed the enthronement of the last emperor of China.

Meanwhile, the British had negotiated a trade pact with the regent and left a favourable impression on Lhasa. But the city made a much more profound impression on Younghusband. In 1904, on his last day in Lhasa, this battle-tried British officer stood in the hills overlooking the Potala and experienced what must have been a moment of spiritual ecstasy: "This exhilaration of the moment grew and grew till it thrilled through me with overpowering intensity. Never again could I think evil, or ever again be at enmity with any man … that single hour on leaving Lhasa was worth all the rest of a lifetime." After Lhasa he spent his days in spiritual pursuits and in trying to bring reconciliation between the world's great religions.

Less than two months after returning from China, the Thirteenth Dalai Lama was fleeing once more, this time from Chinese troops firing in the streets of Lhasa and another 20,000 bearing down fast. Only British India now offered a border close enough for emergen-

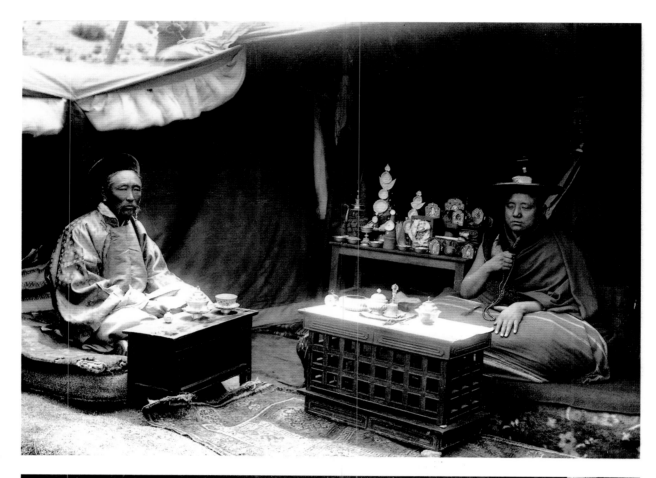

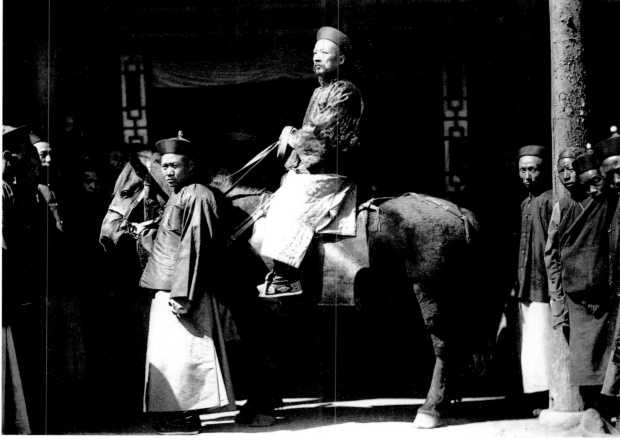

With thousands of square miles of sparsely populated territory, travelling in Tibet was a slow and rugged undertaking. High lamas and officials, like those photographed left, were accompanied by straggling caravans of yaks and ponies laden with splendid tents, rugs, folding tables and piles of cushions. Bottom Although the priest-patron relationship between Tibet and China dated back to the thirteenth century, it was not until the early eighteenth century that two Chinese representatives - or Ambans - were stationed permanently in Lhasa, bringing with them a small garrison of Chinese troops. In 1912, after the collapse of the Ch'ing Dynasty, all Chinese were evicted from Tibet. Here, an Amban in Lhasa, 1904.

cy refuge. The 270-mile route normally took three weeks on horseback, but with a price on their heads, the Dalai Lama and his officials reached the safety of the telegraph office at Gnatong in only nine days.

Exile in India exposed the Dalai Lama to new ideas that would influence him and the future of Tibet. The Political Officer in charge of British interests in Sikkim, Bhutan and Tibet, Charles Bell, was the tall, urbane Englishman who greeted the Dalai Lama in Darjeeling and cared for him during his exile. Bell spoke Tibetan and understood the culture, and he and the Thirteenth Dalai Lama soon developed a deep and lasting friendship. From this privileged position, Charles (later Sir Charles) Bell wrote *Portrait of a Dalai Lama*, the first sympathetic and detailed look at daily life in Lhasa and inside the Norbulinka, the ruler's summer palace.

During the two-and-a-quarter years of exile, the two men met privately in a secluded colonial bungalow in Darjeeling. The Tibetan leader asked for British help against the Chinese, who were beginning to consolidate control in parts of the country. He told Bell that, unless the British government intervened, "China will occupy Tibet and oppress it: she will destroy Buddhist religion there and the Tibetan government, and will govern the country through Chinese officials..." In Eastern Tibet General "Butcher" Chao was then leading his troops on a rampage, killing monks, destroying monasteries, melting images to forge bullets and ripping up sacred texts to sole army boots.

Within a month of arriving in India, the Dalai Lama and his ministers travelled to Calcutta, and on March 14, 1910 he repeated his plea to the new Viceroy, Lord Minto, warning that China also had designs on Sikkim, Bhutan and Nepal. Asked whether he knew the contents of the numerous treaties involving Tibet drawn up recently between Britain and China and Britain and Russia, the Dalai Lama replied he was just then studying the documents. A few weeks later, when Bell delivered Whitehall's refusal to help Tibet, he recalls that the Dalai Lama was speechless; his eyes showed "the look of a man hunted to his doom". Tibet was a pawn in the power game between British India and Russia, both flexing their might to maintain the vast Tibetan plateau as a buffer while watching to see which way the wind would blow the tottering Ch'ing Dynasty. Within a year it blew in Tibet's favour.

By October 1911 news reached Darjeeling that Dr Sun Yat Sen and his Republicans had toppled the last dynasty and China was in turmoil. Young government officials left for Tibet to join the fray and soon the Dalai Lama moved his headquarters to the border town of Kalimpong to direct the freedom movement. By June 1912, with Lhasa almost cleared of Chinese and the route considered safe, astrologers were consulted to fix a date and hour for the journey home. Charles Bell watched that morning as daylight broke over Kalimpong and he describes, "a gorgeous procession of men, joyful and determined, returning to govern their own land, very different from that forlorn arrival of tired men on tired ponies that was witnessed two years before". The Dalai Lama's triumphal return to Lhasa coincided auspiciously with Losar (lunar new year) festivities for the Water-Ox Year of 1913, driving out the bad of the old year and ensuring all that was good for the new. On the eighth day, a huge congregation of lay people and monks listened as the Dalai Lama declared that Tibet was now an independent sovereign state and detailed clearly what was needed to keep it so: preserving the faith purely, governing fairly, defending the country and plenty of all-round hard work.

One of the political lessons he had learned was the need to be involved in all international legalities concerning his country, so he began to press British India to help define the borders of Tibet and China. By the autumn of 1913, the Tibetan Prime Minister was sitting at a conference table at Simla, summer capital of the Indian empire, with representatives of Republican China and the Secretary of the Indian Foreign Department, Sir Henry McMahon, aided by his man-on-the-spot, Charles Bell. The Simla conference dragged on for six months and the differences seemed irreconcilable. China's Ivan Chen recounted Mongol conquests, their enthronement of the Fifth Dalai Lama and various calls for China's army to go to Tibet's aid, to support his claims on the country. Prime Minister Shatra presented fifty-six volumes of Tibetan government documents which produced a very different picture of history. Finally, McMahon decided to create two territories, Inner and Outer Tibet. Inner Tibet would be opened to China "to a large extent", with the Dalai Lama retaining religious control. This was a vast territory bordering China and including large portions of Tibet's eastern Kham and Amdo provinces. Outer Tibet, including the remaining provinces of central and western Tibet, would be ruled by the Dalai Lama, but China would be suzerain overall. Tibet had asked for full independence and restitution of the areas termed Inner Tibet, on which Chinese settlers had already been encroaching

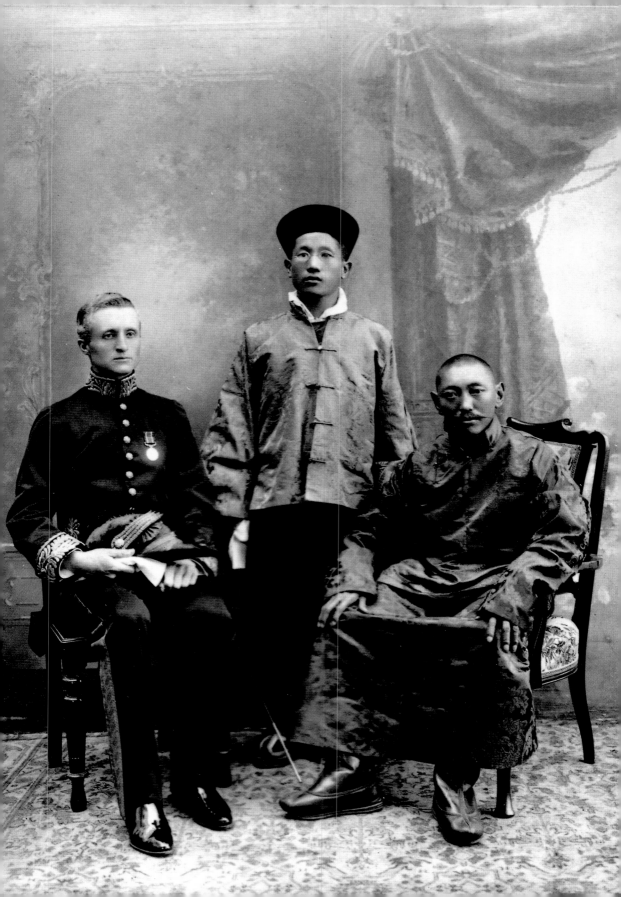

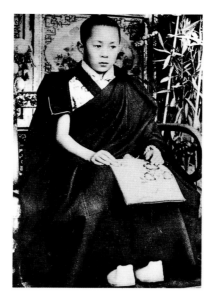

for the past two hundred years. Chen initialled the agreement but two days later China telegraphed repudiating the draft. After three months of procrastination by China, McMahon and Shatra signed an agreement that unless the Simla Convention was ratified by China, their countries would in future deal with each other directly. China never did sign the Convention, and Tibet still cites this document as proof of her independence.

Other modernisations were well underway in Tibet. After much experimentation, its rag-tag army of primitively-armed conscripts were to adopt the British model, and officers were sent down to the plains for artillery training with the Indian army. A police force created for Lhasa was also British-India trained. Experiments with more general Western education were less successful. A boys' school started in the southern city of Gyantse in 1923 was closed three years later because of opposition from Lhasa's three powerful Gelugpa monasteries. Another school, opened in Lhasa in 1945, was closed within three months as claims had been made that teaching English would threaten the country's religion.

Charles Bell and his wife were guests of the Thirteenth Dalai Lama in Lhasa in 1920, where they recorded every unfamiliar sight and custom. Apart from Younghusband and his troops, and the intrepid French Buddhist scholar and meditator Alexandra David-Neel, who journeyed to Lhasa disguised as a Tibetan pilgrim-beggar, hardly any Westerner had travelled in Tibet for a century. The Potala palace and the city below had acquired a mystique that intrigued the world.

The Great Thirteenth was less impressed with his winter palace. He considered the Potala something of a prison and later in life would make the ceremonial return journey there in autumn - and then, when the crowd-lined streets were clear, slip back to the Norbulinka in one of his three cars. It was the Norbulinka, or "Jewel Park", that he showed Bell, taking him on a personally conducted tour which made his guest the first white man to step beyond the walls.Within its parks was a private zoo of leopard, tiger and deer, peacocks and monkeys, dazzling flowerbeds and a greenhouse where the Dalai Lama planted seedlings and cuttings. In his later years he worked endlessly, rarely delegating decision-making. His intellect and temper were quick, and he was often impa-

tient with desultory officials. But he was admired by his people for his strength and simplicity, and the reforms he introduced. But by 1932, overwork had taken its toll. During his new year trance, the Nechung Oracle warned that the Dalai Lama's life was in danger. The Dalai Lama's response was to compose a short text, a Final Testament, in which he warned that "between me and the next incarnation there will be a period in which you will all have to fend for yourselves". The ancient Buddhist texts teach that the twentieth century is a degenerate period of wars and diminishing spirituality. "If we do not make preparations to defend ourselves from the overflow of violence, we will have little chance of survival. In particular, we must guard ourselves against the barbarian Red Communist..."

The last twenty years of his reign was a period of rare peace and stability, but within weeks of the Thirteenth's passing, scapegoats were found for his death and sent into exile to the borderland with India. The Nechung Oracle was imprisoned and a ceremony quickly held to appoint a regent. Since the choice was to be left to divine forces three names were encased in balls of *tsampa* flour, weighed to ensure they were equal, and rolled vigorously inside an urn until one ball popped out. Inside was the name Rating Rinpoche, a *tulku* who was then nineteen. Within a year one of the Dalai Lama's favourites was plotting to overthrow the government and when he was arrested, Black Bon paper spells were said to have been found in his boots. They were cast to kill a minister who opposed him. Intrigue and back-stabbing ran rife in Lhasa.

Rating Regent was said to be modern and sociable and, despite his later downfall, Tibetans remember him with affection for his role in discovering the Fourteenth Dalai Lama. The search began when the regent and his attendants journeyed southeast of Lhasa to Lhamoi Latso, the Lake of Visions. On the lake's surface they saw Tibetan letters and landscapes which indicated that the Fourteenth incarnation would be found in a village near a monastery with green and gold roofs which they recognised as being in northeast Tibet.

Eventually, the search led them to the two-year-old son of a peasant in Tibet's remote Amdo: he showed an uncanny familiarity with the disguised high lamas from the city, and unerringly picked out personal

The Fourteenth Dalai Lama was ten when this portrait was taken in Lhasa in 1945. He had begun intensive study with his tutors four years before.

belongings of the Thirteenth, even though they were mixed with other similar, and in many cases more attractive items. By the time the new Dalai Lama reached Lhasa he was four and the city had been in a frenzy of preparation for months. When the enormous procession moved into the capital from the reception camp three miles outside the city, the brocade costumes, silk banners,

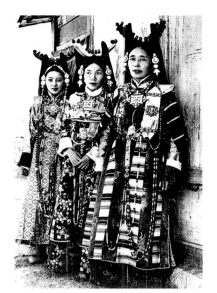

gold and silver horns and jewellery produced such a pageant that painter Kanwal Krishna did not know whether to sketch or take photographs. He recalls today at his home in Delhi, "People talk about the colours of Rajasthan, but they are nothing compared with Lhasa that day." When he was enthroned in the Potala, foreign dignitaries noticed with amazement that the child never fidgeted or lost attention for one moment during the formal all-day ceremony.

So, with their new ruler to protect them, Tibetans settled back into their contented rhythm of life. Despite some attempts at further reforms, and the introduction of new political ideas from outside, the 1940s were an era of leisure and complacency in Lhasa. "Everybody in the country relaxed and the officials and their ladies played mahjong for high stakes," writes Mary Taring in her autobiography, *Daughter of Tibet*. As aristocrats who had a Western education in Darjeeling, she and her husband Jigme were well-placed to observe the country's inner circle at work and play.

Meanwhile, Khampas, tough eastern Tibetans who wore ostentatious silver and gold relic boxes slung on one shoulder and bandoliers of bullets on the other, still swaggered into the cosmopolitan border town of Kalimpong, their mules laden with wool, musk pods, yak tails, salt, rare furs, blankets, carpets, medicinal herbs and borax, to exchange for silks, brocades, porcelain, brick tea, horses, kerosene, soap, copper, iron, serge and cotton cloth, cigarettes, sweets and rice. Large consignments of pearls, coral and turquoise were imported through the gem merchants of Calcutta and Bombay. When World War Two brought quota restrictions to India, prices spiralled in Tibet's newly-awakened consumer society, and profits became so tantalising that Tibetan traders were by then scouring every corner of India for goods to tempt their countrymen.

Kalimpong, with its multi-racial population of Himalayan travellers and businessmen, was a lively listening post for new political ideas, especially those of anti-colonial, independence-minded India and the Congress manifesto. Through watching Mahatma Gandhi's non-violent methods to bring British domination to its knees, Tibetans had begun to think of him as a *bodhisattva*; some even saw him as Guru Padmasambhava, returned to India to play another powerful political role. In 1947, Gandhi told a Tibetan delegation in Delhi that Tibet should break out of its isolationism and spread the Buddha *dharma* throughout the world. To a trade mission the same year he spoke of Tibet and India's shared religious and cultural history, and how vital it was to live as neighbours in an atmosphere of mutual understanding. When he was assassinated a year later, Tibet went into mourning, and when a portion of his ashes was scattered on Lake Manasarovar, a pilgrimage place for Buddhists and Hindus in southwest Tibet, the country felt blessed.

Tibet's own political leaders of the later 1940s had none of the Mahatma's stature, and the rivalry and petty self-interest which the Dalai Lama had warned of finally surfaced in an extraordinary palace plot. Shortly after installing the Fourteenth Dalai Lama, Rating Regent had resigned and chosen an elderly, quiet reincarnate as his successor. Taktra Rinpoche was in his mid-seventies and a Junior Tutor to the Dalai Lama, but rumours persisted that the arrangement was temporary and Rating Rinpoche planned to return to power. Ambitions and resentments among the staff of both regents finally erupted in 1947 in a bizarre scenario: a bomb parcel was sent to the Taktra regent's secretary, and exploded. When Rating Rinpoche was blamed and arrested, monks from his monastic college in Sera tried to rescue him. This sparked a twelve-day battle between government troops armed with howitzers and monks firing rifles and homemade cannon improvised from cylindrical churns used in the monastery for making buttered tea. Hugh Richardson, then chief of the British Mission in Lhasa, recalls that three hundred monks and fifteen soldiers were killed in the fracas.

The Dalai Lama was proving to be a pupil of great intelligence, working under carefully selected tutors who sought to release the young *tulku*'s enormous memory-bank of scriptural learning from his previous lives. Although most foreigners saw him as the lonely,

In Tibet both men and women wore wraparound chubas, *but lady aristocrats cut theirs from brocade and fine wools and wore them with heavy jewels.*

isolated little prince in the Potala's ivory tower, the stories told by the Dalai Lama himself and by his family are full of fun and childish pranks.

Even then, omens of disaster and war were gathering in warnings from nature, including one of the five worst earthquakes in history which devastated an area of Tibet near the Assam border in 1949. A year later in Lhasa, the pinnacle of a seventh-century stone pillar was found shattered: it recorded Tibet's conquests in Asia, including the T'ang Chinese capital of Ch'angan. The victorious Chinese communists were already poised to take Tibet. They were massing their forces, and Peking Radio reported in January 1, 1950, that Taiwan and Tibet were to be liberated from "western imperialists" at a time when there were six Westerners in Tibet. The entire strength of Tibet's army was 10,000. A plea was sent to the outside world for help but Britain, though sympathetic, said that since Independence, such dealings should be with India. America declined to receive a delegation, and India not only refused military support but advised Tibet to negotiate a settlement with the Chinese based on the Simla Convention.

When 40,000 Chinese troops crossed the border at six locations on October 7, 1950, it took ten days for the news to reach Lhasa because all offices were closed for a festival. Not a word appeared in the international press. By October 17, Chamdo, capital of Kham, had fallen and the state oracles were consulted in Lhasa. A medium fell before the fifteen year-old Dalai Lama and said: "Make him king!" One of his first diplomatic moves was to appeal to the United Nations to "intercede on our behalf and restrain Chinese aggression". But ironically, Britain, who had created Tibet's treaties during her rule of India, now told the UN that the legal status of Tibet was "unclear". India advised the assembly that a peaceful solution could be worked out by China and Tibet and discussion by the world body would not be wise. The question of Tibet was shelved.

The next shock came from Ngabo Ngawang Jigme, a Tibetan minister sent to China to negotiate with the new rulers. In May 1951, government officials heard Ngabo's solemn voice over Radio Peking reading out a Seventeen-Point Agreement signed by his delegation and stamped with forged government seals. Blaming "imperialist forces" for plunging Tibet into "the depths of enslavement and suffering", it spelt out terms for reuniting with "the big family of the Motherland – the People's Republic of China". The existing political system in Tibet would not be altered, it stated, nor would the status, functions and powers of the Dalai Lama. Monasteries would be protected and the religious beliefs, customs and habits of Tibetans respected. Agriculture would be developed, living standards improved, and reforms would not be enforced.

The Dalai Lama had heard of the realities of communist reforms from his eldest brother, Taktser Rinpoche, the Abbot of Kumbum Monastery, which already lay in Chinese-held territory. Since 1949, he had experienced the destruction and undermining of religious institutions, and cadres had admitted to him that their party's intention was to reclaim the whole of Tibet and convert it to communism. When Taktser Rinpoche was sent to Lhasa to persuade his brother to agree to Chinese domination, he brought instead an early warning of the tragedy that was to come.

Now the Chinese swiftly moved over 20,000 soldiers to Lhasa, almost doubling its population and pushing up the prices of its limited food stocks. The soldiers were initially disciplined and their behaviour exemplary. In rural districts, they helped in the fields, ignoring insults hurled by Tibetans. The brutal style of indoctrination meted out in Kham and Amdo was because they were considered part of the Motherland, the "Inner Tibet" of the Simla Convention. "Outer Tibet" was to be wooed by winning hearts and minds. In the early days, Tibet's aristocracy was courted most actively, but the peasants remained sceptical and in Lhasa, ordinary citizens began to sing increasingly derisive songs.

The first major confrontation between the Tibetan government and the Chinese occupation generals was over attempts to merge the Tibetan army with the People's Liberation Army in 1952. The Dalai Lama was forced to ask for the resignations of both his monk and lay prime ministers. For the next seven years, he dealt directly with the Chinese, assuming the role of mediator in an irreconcilable situation. Now seventeen, he began to apply the principles of non-violence that have remained his unwavering credo for over forty years.

The result of confrontation is anger, which leads to violence, suicidal for a people hopelessly outnumbered and without proper arms. The only option is patience and taking a strong moral stand. Buddhist logic and his own commonsense brought the Dalai Lama to this viewpoint. Since he was the embodiment of Chenrezi, the *bodhisattva* of compassion, the mission of his continuous rebirth was to protect all life and lead all beings to enlightenment, including the Chinese. The *bodhisattva* vow makes all political decision-making a convolu-

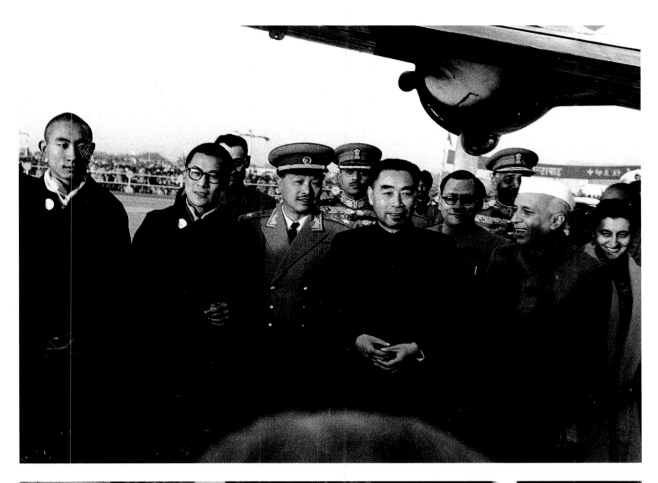

The Fourteenth Dalai Lama first visited India in 1956 to attend celebrations for the 2,500th birth anniversary of the Buddha. He was accompanied by the Panchen Lama (extreme left), and was able to discuss the untenable situation in Tibet with India's first Prime Minister, Jawaharlal Nehru (right) and Chinese Premier Chou En-lai (centre). Extreme right, Indira Gandhi, future Prime Minister of India. Bottom *Tibetan aristocrats with prominent roles in recent history. Left to right, Lukhangwa, the lay prime minister who resigned over clashes with the Chinese generals; Shakabpa drafted the appeal to the UN in 1950 and later wrote a definitive history of Tibet; Ngabo signed away his country's independence in 1951 and is still Beijing's most influential collaborator; Surkhang was prime minister in the early exile years.*

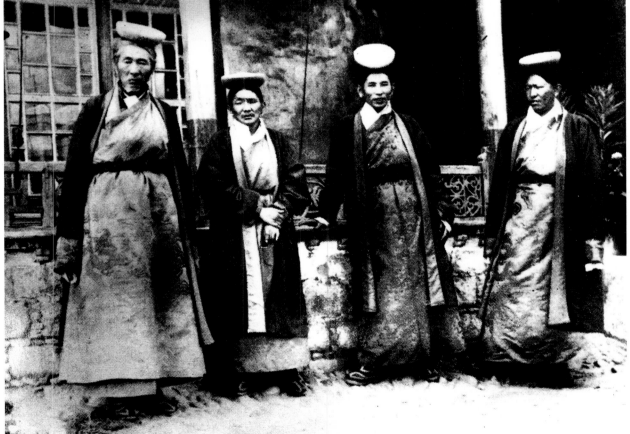

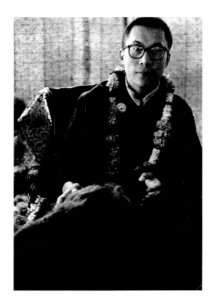

ted exercise and the outcome can sometimes look irresolute and weak. That was how the Chinese interpreted the situation as they began adopting a friendlier attitude after the prime ministers' dismissals.

They invited the Dalai Lama to visit China, where a paternalistic Mao Tse-tung outlined his plans for the Preparatory Committee for the Autonomous Region of Tibet, an alternative to China's earlier plan to rule Tibet from Peking. With all but five of the fifty-one members of the PCART Tibetan, it seemed like a victory for his policy of non-confrontation, so the Dalai Lama left China feeling more optimistic. But, from a three-month tour of industrial centres, cooperatives, workers' organisations and schools and universities, he also realised that "the Chinese would never succeed in reducing Tibetans to such a slavish state of mind. Religion, humour and individuality are the breath of life to Tibetans, and no Tibetan would ever willingly exchange these qualities for mere material progress, even if the exchange did not also involve subjection to an alien race".

On the long return journey overland through eastern Tibet, whenever members of the delegation could elude Chinese surveillance, they listened to horror stories of the occupation – selective arrests, public criticisms and executions of "enemies of the people". Monasteries were prime targets; gold, silver and jewel-encrusted statues and ritual objects were seized and sent to China; monks, high lamas and *tulkus* were jailed and sentenced to death on trumped-up charges. Selected youths were sent for indoctrination to special schools in China for the "Motherland's minorities".

When they returned to Lhasa, members of the delegation began privately to tell what they had seen and heard. Against this groundswell, it was soon obvious that the PCART was a sham, its members mostly appointed yes-men or collaborators. With the Dalai Lama perceived as puppet chairman, the Panchen Lama – discovered and raised by the Chinese – as vice-chairman, and Ngabo, by now a flagrant collaborator, as the secretary-general, the PCART was to rubber-stamp the contents of the Communist Party agenda.

By Losar 1956, popular leaders were politicising people in Lhasa and the first "Chinese Quit Tibet" posters and pamphlets appeared. While the Dalai Lama and his ministers worked to appease the irate Chinese

generals, on the beleaguered eastern border a guerilla movement was gaining strength and inflicting punitive ambushes and raids on the PLA. The Khampa guerillas were led by regional feudal aristocrats and government officials. Soon, more than 6,000 men were fighting from mountain hideouts. Morale in Lhasa was at an all-time low and the Dalai Lama realised with increasing concern that he was losing control of his people.

He considered for the first time leaving Tibet to fight from a base in exile. The chance came when he was invited to attend the 2,500th anniversary of the birth of Sakyamuni Buddha, the buddha of the current aeon. In Delhi, at a private meeting with Prime Minister Jawaharlal Nehru, he suggested he might be given refuge. But India had signed a trade pact with China two years before which agreed to non-interference in each other's internal concerns, and Nehru persuaded the young ruler he should return to Tibet and work peacefully to implement the Seventeen-Point Agreement.

Meanwhile, the Chinese Premier Chou En-lai had made an unscheduled stopover en route to Europe and told the Dalai Lama's elder brothers to dissuade him from any thoughts of remaining in India. The urbane Communist leader promised improved food supplies in Lhasa, that he would discuss the situation in east Tibet with Mao, and Chinese troops would be withdrawn "as soon as Tibet can manage her own affairs". When, at a final meeting, Nehru passed on Chou's messages about Tibet's absolute autonomy, and the remark that "it was absurd for anyone to imagine that China was going to force Communism on Tibet", the Dalai Lama wondered whether they were discussing the same reality.

But he bowed to the advice of the revered statesman. Nehru, an immensely sensitive man, according to those who served him closely, was said in later life to have been haunted by the realisation that he had helped install a genocidal regime in Tibet. The Dalai Lama and his large entourage returned to Tibet in April 1957. Within two years, many of them would be recrossing the Himalayan passes as frightened refugees.

In Lhasa, loudspeakers and lectures were ramming communist ideology down Tibetan ears. The people retaliated at night by defacing posters of Mao and Stalin with excrement. Hatred was erupting. Around 10,000 refugees from Kham and Amdo were camped on the

O*n his first morning in Delhi in 1956 the Dalai Lama stood before Mahatma Gandhi's cremation memorial and committed his life to non-violence.*

city outskirts, telling new tales of barbarity that defied belief. Towns, villages and monasteries suspected of collaboration with the guerillas had been bombed. Refugees told of neighbours and relatives raped, tortured and executed, sacred relics destroyed and desecrated, monks and nuns forced to copulate in public at gunpoint, children handed pistols and forced to shoot their parents, students to shoot their teachers. Many such stories were later verified in official reports by the Geneva-based International Commission of Jurists. The carnage was not all one-sided. It is estimated that around 40,000 Chinese soldiers died in eastern Tibet between 1956 and 1958. When Chinese officials tried to take a census of Kham and Amdo refugees camping around Lhasa, the Tibetans feared reprisals and took to the mountains to join the massive organised resistance. The people, if not their government, were at war.

Meanwhile, the Dalai Lama had continued his religious studies and training, and in March 1959, during Monlam, he was due to take his doctorate in metaphysics. This examination was the culmination of his intense education. Scholar monks usually took the *geshe* degree after twenty or so years of study; the Dalai Lama was still only twenty-three. During ceremonies prior to the examination, two Chinese officers delivered an invitation from their general for the ruler to attend a theatrical performance at the PLA headquarters. He replied that his mind was preoccupied at that moment and he would answer when the ceremonies ended in another ten days. All his life, spiritual exploration had absorbed him, and the results of that became apparent to the 20,000 monks who watched him on examination day. With quick wit and confidence, he faced relays of scholars quizzing him on logic, the Middle Path and Perfection of Wisdom teachings and finally, in the evening, the finer points of monastic discipline and metaphysics. The Dalai Lama's tutors were satisfied: their student's performance was breathtaking.

But the euphoria was brief. The Chinese invitation had raised fears that the Dalai Lama would be kidnapped and smuggled to Beijing, or worse, imprisoned and executed. The citizens of Lhasa took the law into their own hands. Thirty thousand men, women and children made their way to the Norbulingka to watch over the Precious Body Chenrezi. For seven days and nights they camped there. A series of letters between the Dalai Lama and the Chinese generals, and finally with Ngabo too, stalled for time and parried. But when Nagbo's letter of March 16 asked the ruler to identify exactly where he and his officials were within the complex, because "they certainly intend that this building will not be damaged", it was obvious that the end was near. Next day, at four o'clock, two mortars were fired at the Norbulingka, one landing in marshland outside the walls and the other reaching a pond inside its park.

At ten that evening, the palace door opened and a soldier was handed his rifle to join members of the bodyguard to march outside the Norbulingka walls. The soldier was the Dalai Lama. His mother, elder sister, youngest brother and an uncle and maid had all left an hour before in similar disguise. In his own "patrol" was the Lord Chamberlain, the Chief Abbot and the Commander of the Bodyguard, his brother-in-law.

The story of the escape has a miraculous quality, for in Tibet the paranormal is very much part of everyday life and nature has a hand in every important event. That night, the citizens keeping vigil outside the palace had to shield their eyes from a sandstorm, which also dimmed the Chinese searchlights scanning the escape route. Days later, when the generals realised their prize possession had fled from his palace, low cloud descended to hide the escape party from Chinese spotter planes. To devout Tibetans, this is the world as it should be, with the *dharma* protectors fulfilling their promises to Guru Padmasambhava. For Lhasa, there was no karmic protection. A three-day battle raged, leaving an estimated 12,000 dead and sacred sites in ruins. After eight years of occupation, the Chinese knew that ordinary Tibetans would always challenge their rule and had to be terrified into submission.

Although he had originally planned to set up government at a fortress-monastery near the Bhutan border, the Dalai Lama finally accepted that he and his entourage would be hunted like animals if they stayed in Tibet and his presence in the country would only inspire more fighting. A message was sent to New Delhi asking for asylum and on March 31, 1959, weak from fever, dysentery and days of battling through rain and snowstorms, the Fourteenth Dalai Lama crossed onto Indian soil on the sturdy back of a female yak.

Larger-than-life
statues, encased in gold and
silver, and filled with jewels, were
stripped from the monasteries
and sent to China even before the
Dalai Lama escaped.

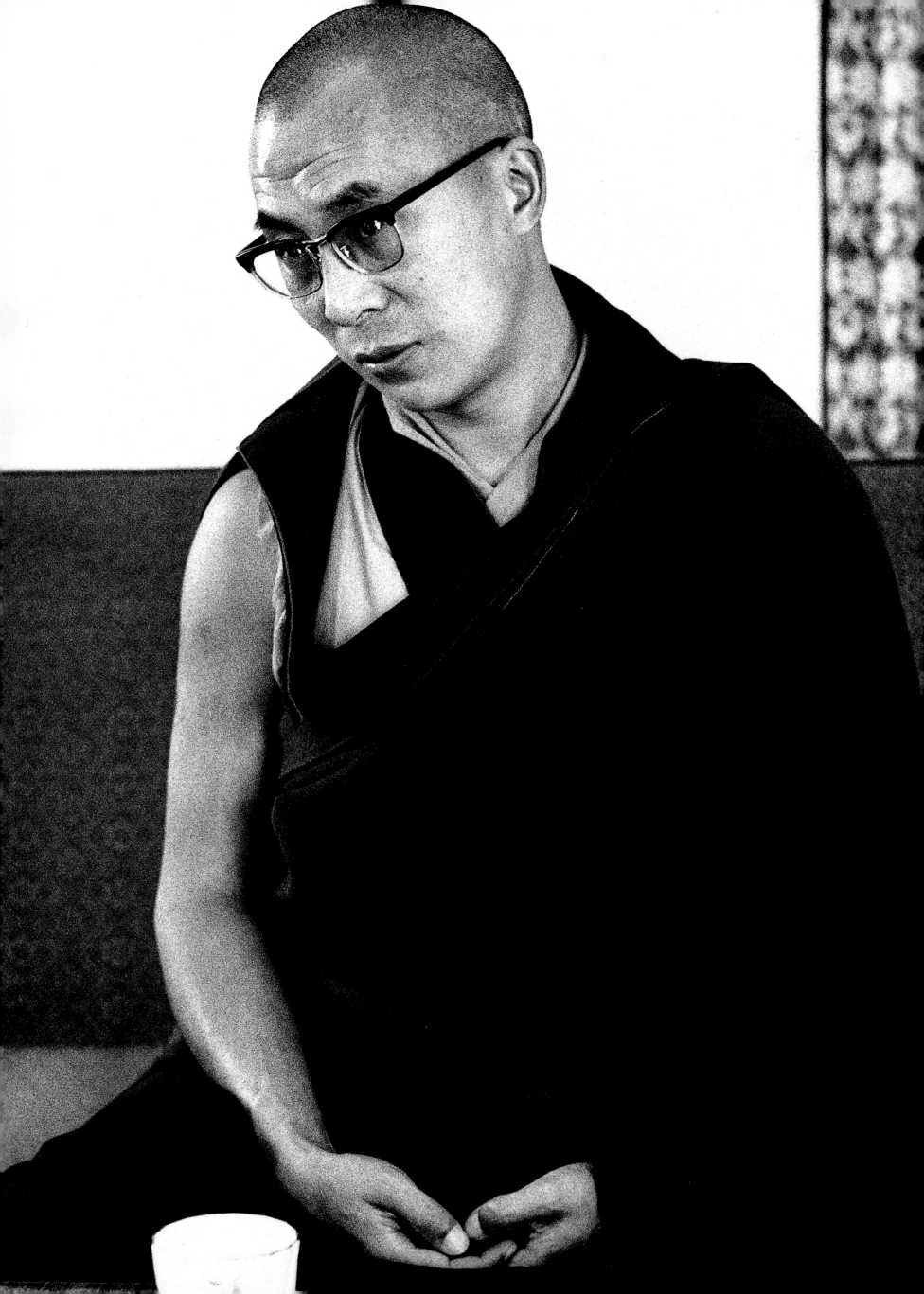

REFUGE IN INDIA

An icy wind from the Dhauladhar Range of the Outer Himalaya blew through the crowd: monks drew burgundy wool shawls more firmly around bare arms, schoolchildren huddled for warmth, foreigners gripped poles carrying their multilingual protest banners while ministers and officials surveyed the scene from the podium with expressions of unflinching gravity. The weather echoed the mood of the day: grim, grey, chilled.

Each year since 1959 Tibetan refugees living in far-flung pockets throughout India have rallied to commemorate March 10, the day Lhasa challenged her Chinese "liberators". Emotions always run high. But on March 10, 1989 the cold winter air at the main rally in Dharamsala was charged with an added current of solemnity. Three days before, international news bulletins had announced that Lhasa was clamped under martial law by Beijing. Each heart in the three thousand-strong crowd was heavy with foreboding: what new repressions would this mean for Tibet?

The Dalai Lama rose to speak. The audience, sitting cross-legged on the courtyard that leads to his "palace" gates, strained in pin-drop silence to catch every word. Every eye was fixed on his face, every hope at his feet. As he reminded them that the situation in Tibet was now more critical than ever, and that the 120,000 in exile must intensify their efforts for the six million who remained behind, and who have no avenue to voice their suffering, silent tears began to flow. The pain is ever-present. Each and every adult Tibetan in the audience could project the faces of dead relatives, friends, monks and nuns, the human shadows that haunt them in India. No family has escaped the holocaust. No Tibetan, both inside and outside Tibet, has sidestepped the direct experience of the Buddha's teaching on suffering and impermanence: the basic tenets of their faith have been put to the most gruelling test.

The suffering began as they struggled across the 1,000-mile range that divides Tibet from India in the wake of their leader. Through the early Sixties a steady stream of starving, frightened and exhausted men, women and children trudged across barren, snow-bound Himalayan passes of 16,000 feet and higher - avoiding the traditional trading routes where PLA soldiers lay in wait to ambush them, or open ground on which they were an easy target for Chinese bombers.

Some formed into groups of up to a hundred, led by reincarnate lamas from the monastery that had formed the hub of their district's daily life. Stories abound from this period of clairvoyance practised by their lamas - dream visions or *mo* divinations that pointed out a safe route to India. Others set out in small family groups at night to avoid neighbours who could claim a reward by reporting their escape to the Chinese. A little jewellery, a favourite statue, gold dust - if they were fortunate - was stowed into *chuba* pouches (the natural stowage area formed across the chests of Tibetan men and women by tightly belting their wraparound gown). Down the pouch went provisions too, for food often had to be carried bodily since a laden pack animal would reveal the journey to be serious and long. Many pretended to be going out to gather firewood or visit their *gompa*, and never returned home. The provisions were staples of *tsampa* flour, strips of dried yak or sheep meat and *dri* butter, which quickly ran out.

Along the escape routes they begged to buy milk and butter when they met a fellow countryman they felt they could trust. Some regions were notorious for collaborating with the Chinese occupation forces. But, conversely, many Tibetans in India recall acts of almost suicidal kindness from strangers who hid, victualled and guided them. Why did these brave benefactors choose not to flee themselves? Protecting property was one major reason: another was that in the Fifties and early Sixties Chinese genocidal pogroms were mainly centred on strongholds of Tibetan resistance in Kham and Amdo. A certain complacency still reigned, bolstered by a firm belief that it would "all be over soon and the Dalai Lama will return as the Great Thirteenth did from India". As Charles Bell and other early travellers in Tibet observed, the twin pillars of unshakeable faith and of living in a rugged environment had made Tibetans brave, resolute and uniquely hardy. Fleeing to inhospitable foreign climes was not in their innate nature. But a fierce loyalty to their homeland was.

For every Tibetan who successfully pursued the Dalai Lama into exile, it seems another probably perished en route. Few Amdowas managed to elude Chinese vigilance on the two month-long horseback journey from their remote northeastern province of McMahon's

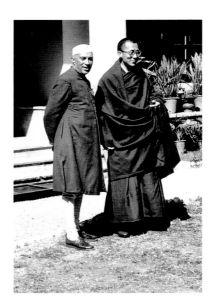

"Inner Tibet". With 300,000 PLA troops entrenched throughout the vast plateau, and a high proportion of them policing militant Amdo and Kham provinces, escape was only possible for the very determined. The most viable migration was from the southern districts of U-Tsang, bordering on India, and southwestern Kham on the Assam border and stretching west to Buddhist Bhutan.

When Tibetans cross the apex of their lofty mountain passes under normal circumstances they pick up stones and add them to cairns, shouting joyfully "*lha gyalo*" ("victory to the deities"). But the only relics they left on the passes that divide Tibet from India were the corpses of the old, the sick, those too weak to struggle another pace forward, and small babies who died in their mothers' *chuba* pouches. "I remember when my baby sister died," recalls the wife of a senior officer in the government-in-exile in Dharamsala. "*Amala* couldn't accept that she was dead and carried her on for days. Then one night my father took the little body away while she slept and placed her in some rocks."

A scholar lost his nomad chieftain father on the last evening of their long trek to the Indian border. With a gesture of typical Khampa bravado, the father attempted to steal horses from a Chinese army camp to speed the last stage of his family's journey to freedom. He was caught and shot. And so, stunned by fear, desperation to escape, grief, fatigue and starvation, his family crossed the last stretch of Himalayan no-man's-land to surrender to Indian border guards and begin a tenuous new life as penniless strangers in a strange new land.

Prime Minister Jawaharlal Nehru's Congress government could never have anticipated the tidal wave of ragged humanity that was to sweep across the Himalaya in the wake of the Dalai Lama. In 1910 British India had hosted a small and principally aristocratic entourage accompanying the Great Thirteenth. The Fourteenth was followed by Tibetans from all stratas of society. By 1965 they numbered 85,000. In the first months following the Dalai Lama's escape around 20,000 Tibetans reached India. Since the main routes brought them down into remote northeastern states, it was here that the Indian government set up temporary camps. In the steamy jungle of Assam, Misamari transit camp accommodated around 12,000 refugees in 300 flimsy bamboo huts. And further west, in Bengal, a for-

mer British prisoner-of-war camp at Buxa Duar sheltered Tibetans in thirty concrete barracks surrounded by high barbed-wire fences.

Overstrained Indian officials, doctors and nurses battled against epidemics that raged through the camps. Cholera, dysentery, hepatitis and malaria turned crowded huts of refugees into makeshift hospital wards overnight. Fur-lined *chubas* encrusted with ancient *dri* butter and dirt were wrested from their owners and burnt. What worked admirably as clothing at 12,000 to 18,000 feet in the cold, dry air of Tibet was a health hazard in these leech- and mosquito-infested jungle clearings of north India. Scraps of dried meat eked out during the journey quickly sprouted maggots and stank out the shanty huts. The time-honoured habits of Tibet did not adapt to India. The refugees began learning first principles of their new and alien life: that cleanliness is rewarded by good health, that their traditional diet was a thing of the past in this land of rice, vegetables, dhal and spicy masalas, and that Western medicine bore no resemblance to the pills compounded from herbs and minerals by their own doctors. The diseases striking them down were so different from anything they had known that their doctors would have been stumped even to diagnose them.

A high proportion of the first exodus was in robes. Where escape was possible, the *tulkus* left with their teachers and a protective entourage of lay followers from their region. But in India the lamas and monks were separated from their countrymen and reassembled at Buxa Duar camp. If religious scholarship and practice was to be preserved, it was decided, the lamas must be given a supportive environment. The situation today proves that this decision was wise: from this nucleus of 1,500 lamas and monks - some of whom stayed at Buxa for the entire eleven years of the camp's existence - came many of the scholars and pioneers who have rebuilt Tibet's monastic tradition in exile.

Here the senior lamas who had practised meditation and mind-training in Tibet were an inspiration to the younger monks: the equanimity with which they settled into their new milieu was a powerful teaching. As a venerated meditation master advised a young disciple before they both fled: "He who would light a torch must do so from within himself. There is no need for disturbance of mind; the worthwhile minds will win."

A *month after leaving Lhasa, the Dalai Lama moved to a temporary home at Mussoorie; three days later Prime Minister Nehru paid a welcome visit.*

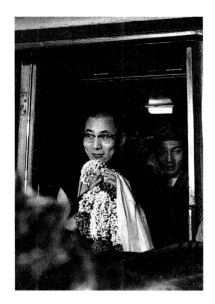

The greatest inspiration of all to the refugees is the Dalai Lama. At the age of twenty-four, he faced a new and desperate challenge: to turn the tragedy of being a homeless beggar into a period of positive activity, and to bolster the hopes and spirits of his fragmented followers. His first temporary Indian home was in Mussoorie, a Himalayan hillstation in northwestern Uttar Pradesh province. Here he started to formulate plans to provide basic welfare for his people and to discuss these with Indian government officials handpicked by Nehru. The host government was sympathetic and enormously generous, considering the subcontinent's own poverty level as well as its indigenous refugee problem, resulting from Partition and the unhappy creation of Muslim Pakistan only twelve years before.

Prime Minister Nehru personally selected Dharamsala to be the Dalai Lama's permanent home in exile. The hillstation was already well-established when the Viceroy of India, Lord Elgin, died there in 1863, and a Gothick stone memorial still marks his grave in the Protestant cemetery. Dharamsala was originally suggested as the summer capital for Delhi (itself only India's capital since 1911), but when a major earthquake devastated the pine-clad ridges in 1905 Simla was seen as being safer. Thereafter Dharamsala lowered its sights to remain a sleepy district administrative headquarters and a modest resort for those who could afford to move to the hills in scorching late spring and autumn. With several ancient temples in the vicinity, Dharamsala has always been a place of pilgrimage for Hindus.

The Dalai Lama moved to Thekchen Choeling (Land of Mahayana Buddhism), on the southern end of a 6,000-foot ridge straddled by the small bazaar town of McLeod Ganj, in 1968. The first eight years in Dharamsala had been spent higher up the pine, larch, rhododendron and Himalayan oak-clad hillside in a sprawling, colonial bungalow complex called Swarg Ashram. A short walk away through the Himalayan forest his Senior Tutor and mentor, Kyabje Ling Rinpoche, lived in a stone Edwardian-colonial bungalow - a home more redolent of memsahibs and afternoon tea than maroon-robed Tibetan reincarnates discussing ancient Pali and Sanskrit texts. Always open to innovation, the Dalai Lama now absorbed useful ideas from the more modern world around him so that the

future Tibet could never again be accused of being backward, medieval and ripe for invasion.

The Tibetan government-in-exile offices were sited a mile below the Thekchen Choeling compound, and here the first modest stone-and-concrete "ministries" began to rise around a dirt compound. These offices now function as "departments" for Home Affairs, Health, Security, Finance, Education, Religious and Cultural Affairs, and Information and International Relations, and today employ a permanent staff of over two hundred. In the first decade in exile key government positions went largely to the old-established aristocracy and administration in Lhasa. Some were scions of wealthy aristocrat-traders, sent to the *pukka* Protestant and Jesuit private schools and colleges of Darjeeling and Kalimpong in the 1940s and 1950s, and exposed to the British Christian education rejected by Lhasa's monastic hierarchs in the Thirteenth Dalai Lama's reign.

To communicate with the host authorities in Delhi, and win friends for Tibet overseas, fluency in foreign languages was considered essential. Soon a new generation of Tibetan children found themselves tracing letters of the unfamiliar English alphabet with their fingers and scratching the curlicue letters of Hindi script on their slates. Education was a primary and immediate concern for the Dalai Lama. The 100,000 who pursued him into exile were largely illiterate and in the first decade the Indian Government employed them to build Himalayan border roads, paying young, old, men and women a few rupees a day. Tuberculosis rampaged through the encampments and, after so many deaths in the flight to India, many families were stricken again by fatal accidents and illnesses.

The numbers of orphans and semi-orphan children spiralled and from this tragic situation the necessity for residential Tibetan schools emerged. "I am still in awe of His Holiness' wisdom in devising the Tibetan Children's Village system," says Tenzin Geyche Tethong, the Dalai Lama's Private Secretary. "What could he have known about education and his people's emotional needs when he was still so young himself? Yet the schooling system has been so effective."

The prototype Tibetan Children's Village (or TCV) was founded on 43 acres of densely-wooded hillside around three miles from McLeod Ganj on a higher, iso-

Crowding
stations and shouting "Long Live
the Dalai Lama", Indians gave
their guest a tumultuous welcome
during his train journey to
Mussoorie in 1959.

lated ridge. To duplicate a family environment as closely as possible, accomodation is on a "homes" system with house parents or a house mother caring for children of mixed ages and sexes. By the late 1980s a further four TCVs had been established, from Karnataka in the far south to Ladakh in the high Himalayan northwest. The TCVs, and the other major residential school complex, Tibetan Homes Foundation Mussoorie (or, simply, Homes) put special emphasis on keeping young Tibetans literate in their own unique script and language, well-versed in their country's history and culture - including the performing arts - and equipped with a solid foundation of Buddhist philosophy, manners and ethics. The curriculum also covers science, mathematics, English and Hindi, plus world history and geography. Students must pass Indian Central Education Board exams to progress to higher studies.

In addition to TCVs and Homes, Central Tibetan Schools were set up in conjunction with the Indian Government across the Himalaya, and wherever Tibetans had been settled in large enough numbers. The academic record has been high by nation-wide standards and today it is not unusual for young Tibetans to hold two degrees. After thirty-one years in exile 43,529 children had passed through the exile government's schools and around a dozen Tibetans had been awarded doctorate degrees.

Alongside education, another first priority of the Dalai Lama and his government was to find a solution to the vicious circle of poverty, rootlessness and life-endangering hazards faced by road construction workers. In consultation with Delhi a solution was found: for the bulk of the refugees the answer would lie in farming, since around sixty percent of Tibet's population had traditionally been nomad herders and the remainder largely agricultural labourers and independent smallholders. A plea went out for land to state governments and by December 1960 a first batch of settlers set out for terra incognita in Karnataka, south India. They felled virgin jungle to make way for the first farming communities which now total 11,964 cultivated acres supporting around thirty thousand refugees. The South Settlements, clustered to the west of Mysore, are today the largest and the most self-contained of the fifty-seven Tibetan communities scattered throughout India.

Adjusting to farming conditions in India was deeply unsettling. The old were entrenched in their Tibetan ways and this new demand upon them caused further tensions: in the south they felt exiled once more, far away from their Dalai Lama, the familiar snowy mountains and the great Buddhist pilgrimage sites of the north. Many died from sheer despair and the tropical jungle diseases took a further toll. The soil and climate was like nothing they had known before, tractors replaced *dzo* (crossbreed yak) for ploughing, and the crops they were taught to grow yielded unfamiliar harvests. The most successful produce, after twenty experimental years, are maize and millet: in good years, when the monsoon blesses India, and locusts and wild boar leave their seedlings to mature, the cash crop from the two-acre allotment per five family members can sustain settlers at a subsistence level. Most households also keep a cow or two and sell any surplus milk to cooperatives.

All produce from the settlements is sold by cooperatives although, as Tibetans become more integrated in India and fluent in the diverse dialects of their host states, some prefer to sell directly to Indian middlemen. These more entrepreneurial Tibetans often farm fields for absentee acreage-owners, those itinerant Tibetan sweater-sellers who migrate to cities and towns the length and breadth of India from early autumn to spring to sell woollen goods at pavement bazaars. Tibetans have been instinctive traders since ancient times and their enterprise has surfaced even in exile with these teams of seasonal sweater-sellers. The most successful combine their winter trading with pilgrimage to Bodhgaya, Sarnath, and Lumbini and Kathmandu. Such money- and merit-making migrations echo the way of life across the high plateaus of their homeland.

Smaller agricultural settlements exist in the plains states of Orissa, Madhya Pradesh and Himachal Pradesh and in Himalayan Sikkim, Bhutan and Arunachal Pradesh. Crafts are often produced alongside crops and dairy produce, and carpet-weaving on large, vertical looms forms a commonplace and steady occupation. Wood-carving, statue-making and *thanka*-painting remain viable occupations and these skills are practised to a high degree of competence in many craft centres.

By 1990 nearly five thousand Tibetans had travelled even further afield. Switzerland took the largest community and today 1,700 Tibetans live in and around Rikon and Winterthur, close to Zurich. Originally the Swiss government intended its new guests to farm in high valleys but, given the opportunity to succeed, Tibetans (like most Asians, and many other refugee communities) soon find the paths to prosperity. Younger members of the Swiss-Tibetan community prefer shiftwork in local factories to farming, speak fluent

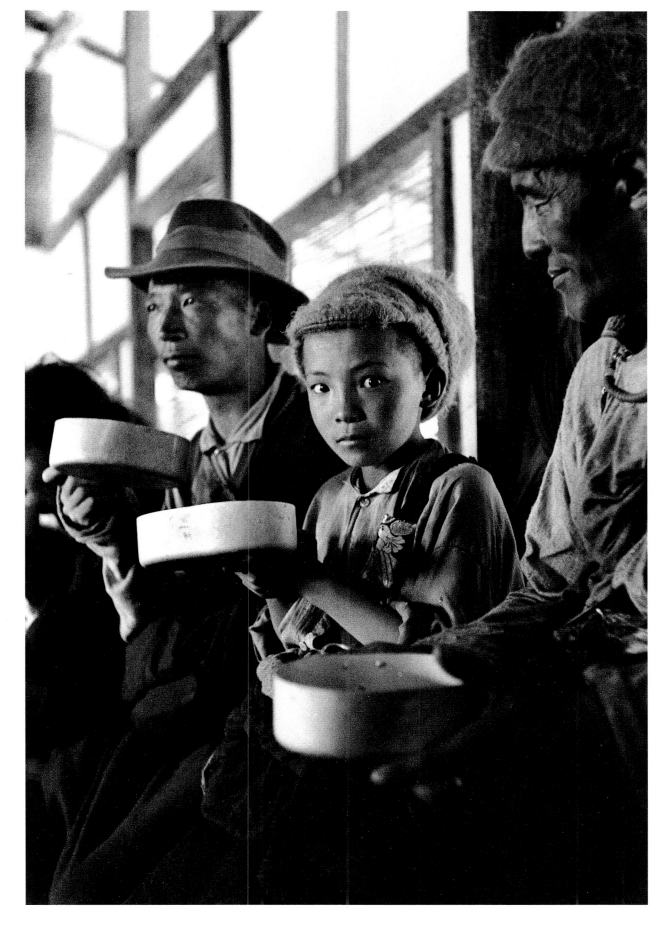

Within
three months of the
Dalai Lama's esca-
pe, almost 20,000
Tibetans had pur-
sued him across the
mountain passes to
northeast India.
There, in rudimen-
tary transit camps
surrounded by tro-
pical jungle, they
faced the daunting
realities of their
new refugee status.
With the rising heat
of the monsoon,
diseases swept
through the make-
shift camps. Despite
the massive relief
effort organised by
Indian politicians
from both ruling
and opposition par-
ties, the death rate
was high.

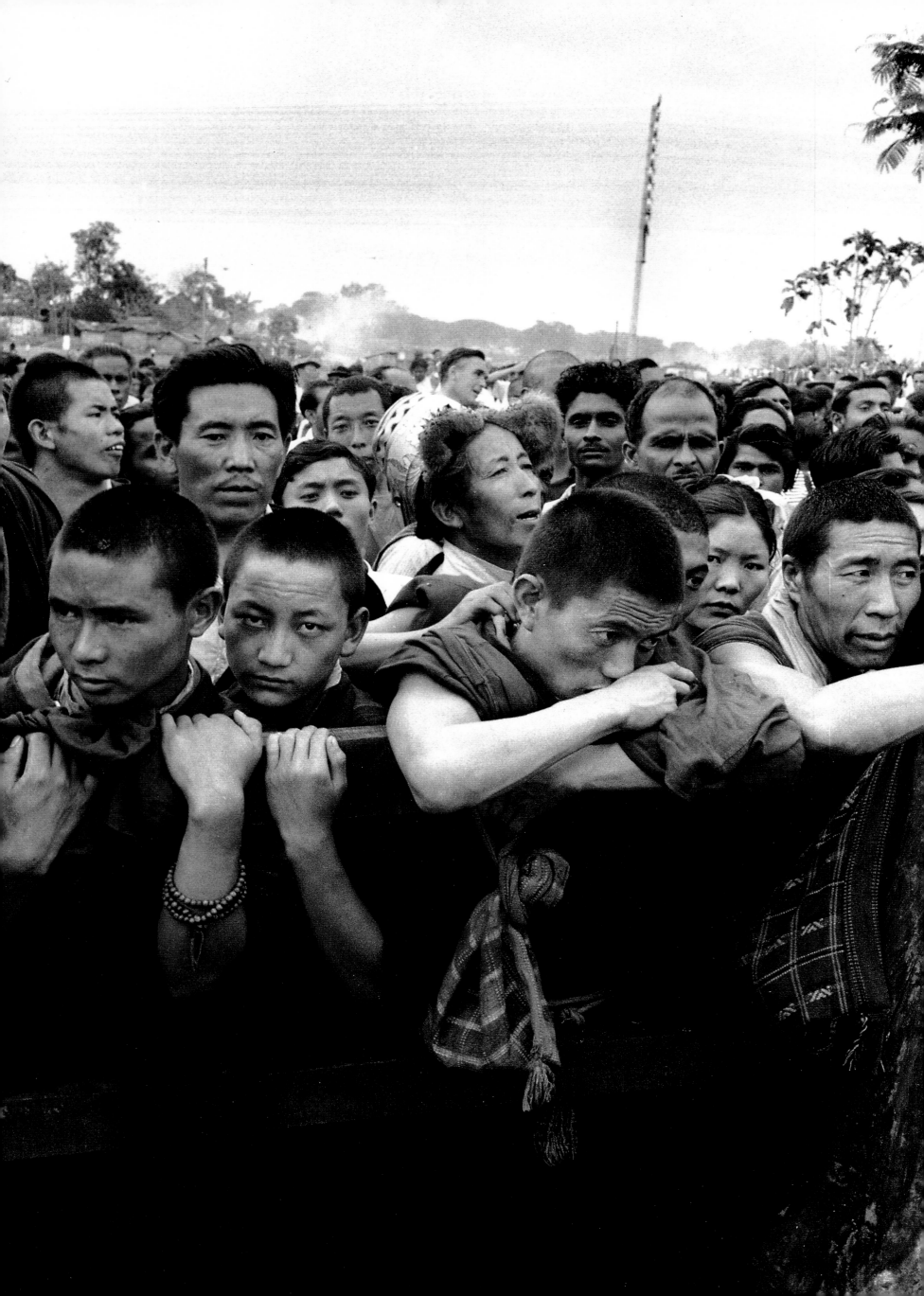

Swiss-German, own their own apartments and cars and enjoy the European way of life. But, in parallel, they work hard to preserve their Tibetan identity and culture and provide financial and political support for the freedom movement in India. To marry a child to a Swiss-Tibetan is the dream of most Indian-Tibetan parents.

The other major Tibetan force abroad wears burgundy robes. To call these *rinpoches, geshes* and monks missionaries would be misleading. Buddhism is a philosophy, a way of life and a science of the mind and, unlike in other religions, its teachers are not expected to set out to convert. But, as a result of the mass travelling movement of the Sixties, young Westerners roaming India and Nepal linked up with Tibetan refugees and many were drawn to Buddhism. These early contacts resulted in a new flourishing of Western interest in Tibet, and by the Seventies Tibetan Buddhist teaching and retreat centres were well-established in North America and in Europe. The oldest, Samye-ling in Scotland, dates from 1967, and in 1976 a small group of practitioners entered their cells in France for the first three-year solitary meditation retreat in the West.

By the close of the 1980s around six hundred Buddhist centres representing all four Tibetan sects were flourishing throughout the world. Many have one or more resident monks to teach and lead rituals, and some are permanently headed by a *rinpoche* or a *geshe*. Not everyone in the exile community is happy with this burgeoning evangelism. Many mutter about a "brain drain" and fear that their monasteries and institutes in India cannot sustain a high standard of scholarship if key teachers are lost to the West and Asia. Others fear that Westerners are not stable students and that Tibetan Buddhism is merely, for them, a fashionable and passing fad. They suspect their *geshes* and *rinpoches* would be better employed at home.

But the Fourteenth Dalai Lama and other religious leaders in exile view the trend from a different perspective. As *bodhisattvas* their recurring mission on earth is to benefit all sentient beings, and that vow does not discriminate Westerners from Tibetans - nor from the Chinese, their traditional disciples. Wherever the need for teaching arises, their vow determines that they will be there. And if they cannot personally fulfil all the global requests for ceremonies, initiations and teachings, they will send their most able lieutenants. The "army" in robes is dispatched from India's airports on demand.

The training grounds for the younger teacher lamas has been the re-established Tibetan monasteries in exile. Sera, Drepung and Ganden, the three famous Gelugpa monastic universities in Lhasa, have risen once more in modest buildings amidst the maize and millet fields in Karnataka state. It was logical that they should resurface at the heart of the biggest Tibetan community in India and, from humble beginnings in 1970 the largest, Sera, today houses 1,560 monks. The total enrolment at Sera, Drepung and Ganden was 4,124 by early 1990 (and that number includes 282 reincarnate *tulkus*): the monk body in India has expanded by 2,500 since China opened Tibet's borders in late 1978 and Tibetans were free to travel legally to India once more.

For twenty years, from the Lhasa Uprising in 1959 to what contemporary historians dub the "First Delegation" in 1979, Tibet was veiled behind the bamboo curtain of Chinese communism. As 100,000 Tibetans struggled physically and emotionally to establish a life in exile, the six million left behind lived through the nightmare years of "days and nights passing slowly with great suffering and terror" predicted by the Great Thirteenth in 1932. When the International Commission of Jurists probed the situation in Tibet in 1960 it ruled that China was already guilty of religious genocide. But that investigation was conducted in the early years of the Chinese occupation: for Tibet the most damaging decade was still to come.

On a human level it is estimated that more than 1.2 million Tibetans have died as a result of Chinese "liberation". The greatest carnage dates between 1966 and 1976 - the decade of Mao Tse-tung's Cultural Revolution when young Red Guards rampaged across China, ridding the country of "reactionaries", "bourgeois intellectuals" and purging "old green minds" at "struggle sessions" in public squares. Mao-madness spilled over into Tibet. The purge swept everyone connected in any way with the Dalai Lama and his former government into prisons: all aristocrats and landowners (except those who blatantly collaborated with the Chinese authorities) were submitted to public trials and accused and beaten by their former "serfs". If the "serfs" failed to show enough hatred or enthusiasm while beating, they themselves were also jailed. The educated were ripe for re-education through Mao's "Little Red Book": only Marxist literature was allowed in prison cells. *Rinpoches*, young *tulkus, geshes* and other more educated monks were Public Enemy Number One. Prison camps across the country and in northwestern China became tombs for many thousands of robed scholars and practitioners of old Tibet. Mao and Marx reigned

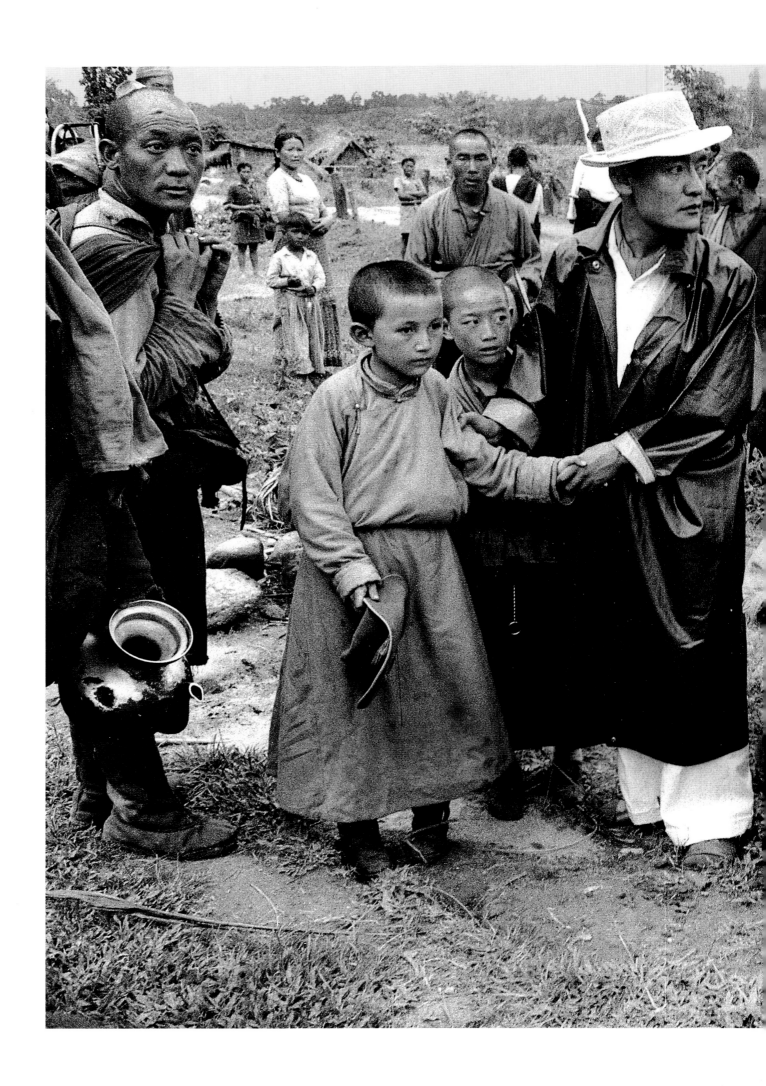

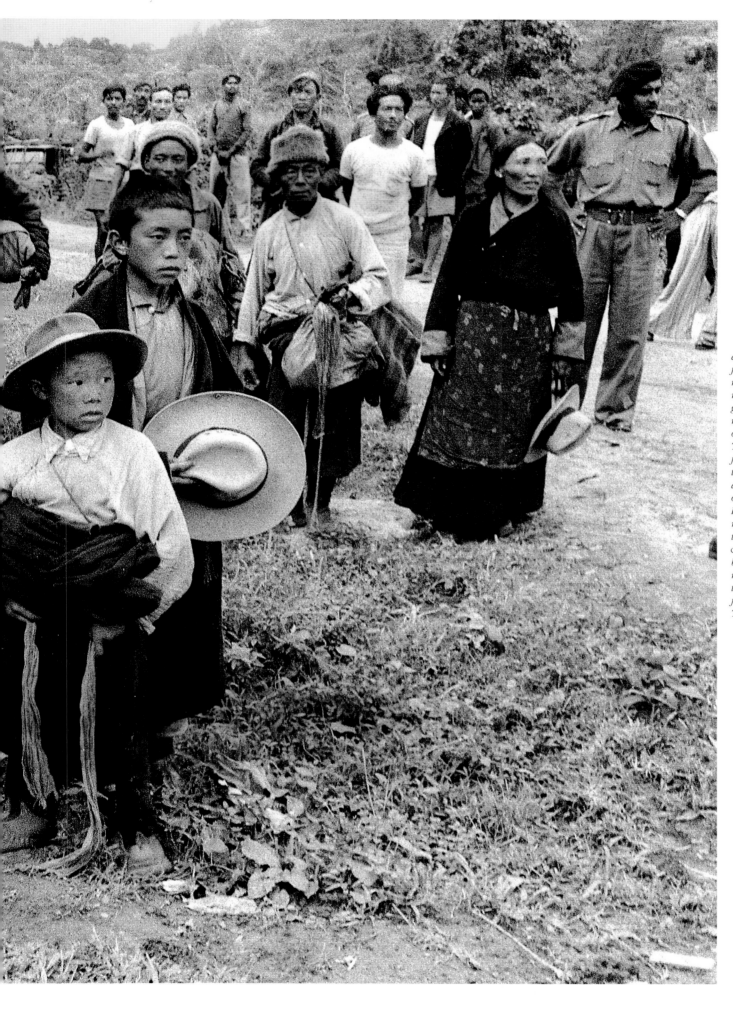

In 1959 disorientation and fear were the natural responses of the newly arrived refugees to the enormous culture shock of being in India. Today new arrivals from Tibet register the same emotions as they first face the outside world. Rural Tibetans and nomads still wear thick, homespun chubas and broad-brimmed hats, attire which easily distinguishes them from India-born Tibetans.

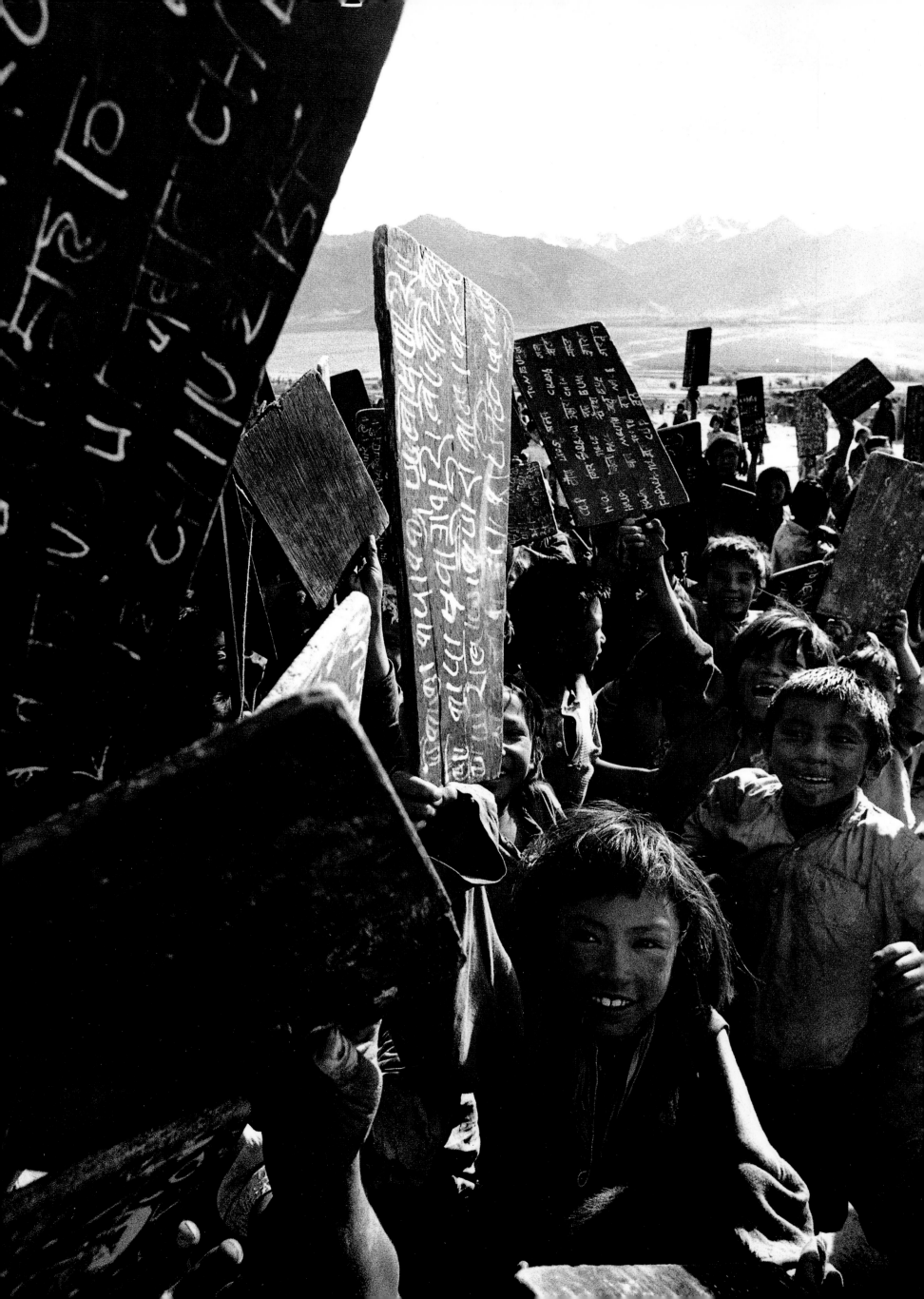

and governed the fate of six million terrified Tibetans.

The first account of life inside Tibet came from a young Swiss-Tibetan who spent twenty days in Lhasa in May 1979. After Mao and Chou died in 1976 rightist leaders came to power in China and by 1978 they were calling for the Dalai Lama's return. In turn His Holiness demanded freedom for his people to travel in Tibet and investigate conditions, which the new leadership claimed were greatly improved under their Liberalisation policy. Tsultrim Tersey returned to the exile community with the news that young underground leaders claimed that 99 percent of Tibetans inside Tibet were ready to lay down their lives for independence.

The Dalai Lama's First Delegation toured Tibet for five months in the second half of 1979. Its report sent shock waves through the administration and communities in exile. The physical destruction of what is now estimated to be 6,254 monasteries and temples was worse than anyone had anticipated. The great monastic universities in Lhasa lay in rubble. Samye, all but razed to the ground. Rating, an exquisite monastery belonging to the ill-fated regent *rinpoche*, gone. The site of Tsurphu marked by the stones of its once-proud walls. Sakya, devastated. Sacred carved *mani* (prayer) stones laid as footpaths, drains and toilets. And the ransom of gold, silver and jewelled statues and ritual instruments from all Tibet's monasteries stripped, smashed or gone. Ancient *thankas* and statues were shipped to China from the earliest years of Communist occupation and entered the international antiques market through Hongkong. A heritage of fine monastic frescoes, some dating back four, five and six centuries, were smashed and defaced since they had no commercial use.

A second fact-finding delegation was due to arrive in Tibet in May 1980 when CCP General-Secretary Hu Yaobang visited and sacked the senior Chinese hierarchy in Lhasa after seeing how appalling conditions were. Still smarting from the spontaneous outbursts that met the First Delegation, Chinese officials issued codes of public behaviour for the second visit. No rallies, no criticisms of the all-benevolent Motherland, and anyone who dared to shout "Tibet is Independent" - as one women had to the First Delegation - would also, like her, be jailed for life. But 2,000 Lhasans ignored the threats and orders and congregated in front of the Second Delegation's guest house. The Chinese government had a party of foreign correspondents touring Tibet and lodged in the same guest house. Its members then witnessed and photographed this emotional crowd chanting "Long Live the Dalai Lama" and responding with wild abandon when one of the delegates talked to them. John Fraser, the Toronto Globe and Mail's Beijing correspondent, later wrote that Tibet "is certainly the worst example of a national minority area with which to hit the Chinese. But it exists and it is a shocking indictment of a country that professes antipathy towards both colonialism and racism."

As a third delegation, selected to look into education, toured rural areas of Tibet, the irrepressible Second Delegation was expelled. It was five more years before the fourth and last fact-finding mission left Dharamsala for China and Tibet in 1985. Their doctrinaire Chinese hosts could not comprehend the delegations' horror at witnessing the plight of their countrymen. Everywhere they went ragged, half-starved Tibetans crowded their bus and struggled to touch representatives of their Dalai Lama, crying out disjointed stories of their suffering. The delegates' clothing was shredded by desperate fingers and the threads were kept in *gau* (or relic boxes) as precious talismans of hope. Blessings and photos of the Dalai Lama were begged for: thirty years of Marxist indoctrination had apparently done nothing to alter their hearts nor extinguish Tibetan faith.

The reports of these four delegations hardened resolve among the 120,000 Tibetans in exile. A renaissance of political activism swept through the communities scattered throughout India and overseas. The heavy-hearted realisation that they must be mouthpieces for their brothers and sisters north of the mountains came home in one devastating lesson. Video film footage and still photographs taken by the delegations were scanned again and again for glimpses of familiar faces. Slowly information on who had died, and when and how, came trickling across the border to Dharamsala.

In 1978 China began to issue six-month exit permits to Tibetans to visit their families in India and tour the Buddhist pilgrimage sites. Individuals were screened and their stories recorded; the testimony was so bizarre and the experiences so brutal that the few journalists who interviewed "new arrivals" were incredulous. But, as more and more evidence corroborated the early interviews, the free world began to sit up and listen.

One of the most celebrated of those newly-released Tibetans was Dr Tenzin Choedak, a Junior Physician to the Dalai Lama and his family in pre-1959 Lhasa, and today his Senior Physician in Dharamsala. The story of his seventeen years in Chinese prisons in both Tibet and China, of his *thamzing* ("struggle sessions") and

Left
Education is a precious bonus of exile, since children in Tibet have little chance of schooling. Even if they get through primary school, secondary level teaching is entirely in Chinese. In India their curriculum is trilingual and in addition to being literate in Tibetan, Hindi and English, Tibetan children often speak their local Indian dialect.

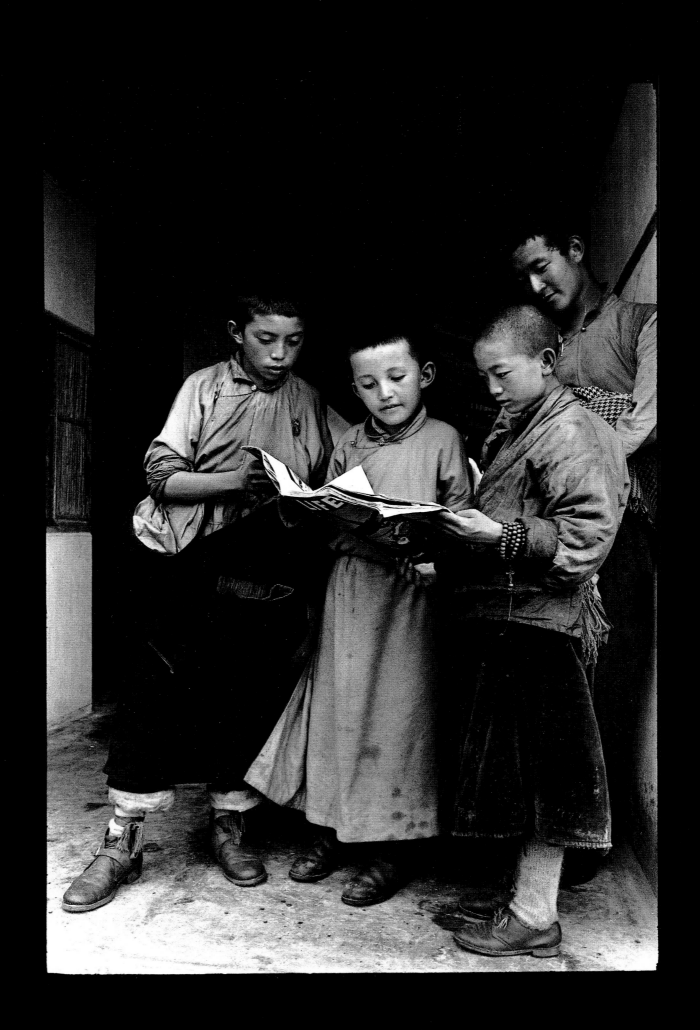

starvation diet, are eloquently told in John Avedon's *In Exile From The Land of Snows*. The most horrifying testimony covers a two-year period in one of the hundreds of prison and hard-labour camps in China's barren northwest - the Siberia of Chinese Communism. Of his seventy-five Tibetan companions, only twenty-one returned to Lhasa in 1962: the rest died, slowly and excruciatingly, from starvation and brutal conditions. Dr Choedak, recognising the symptoms of digestive failure, and knowing that more stomach heat would help, turned secretly to the ancient yogic practice of *tummo* (or generating inner heat). The result was a life-saving increase in emotional as well as physical stability. And later, when apparently studying Mao's Little Red Book in a Lhasa prison during the Cultural Revolution, he and his cellmates were mouthing silent mantras.

One man has listened intently to hundreds of equally painful litanies. Above considerations of seeing family or going on pilgrimage, every Tibetan who has visited India since the bamboo curtain lifted has had one urgent desire: to be blessed by the Dalai Lama. These "new arrivals" are identifiable by their totally traditional - and sometimes unkempt and ragged - clothes. The women often wear long, greased braids; the men have the mien of wild Himalayan cowboys. But most telling of all is the look of childlike wonderment and anticipation in their eyes as they queue for an audience. Most break down in floods of tears as His Holiness the Fourteenth Dalai Lama greets them, warmly and informally, in his audience room. In the spacious hall, lined with *thankas* and furnished with overstuffed 1950s sofas and armchairs hidden under white cotton loose covers, he encourages each visitor to tell his or her own story. An alarming and tragic composite has emerged. The Dalai Lama is particularly shocked to observe even young children striking attitudes of antagonism and hatred when asked about the Chinese.

In all the thirty years in exile, and throughout the varying regimes holding power in Beijing and Tibet, the Dalai Lama has been at great pains to keep a pipeline of communication open to China's leadership. Until the official 1979 delegation this was largely informal contact. The most active emissary has been Gyalo Thondup, the Fourteenth's businessman older brother who lives with his second Chinese wife in Hongkong. In spite of all the destruction and death in his homeland, the Dalai Lama has never given up the hope that one day a negotiated settlement can be reached with China over Tibet. "With optimism and great patience even the impossible becomes possible. But without optimism you cannot achieve even the simplest task," he often tells his people. This gentle philosophy has always been the Dalai Lama's unwavering strength.

Over three decades in exile the India-based Tibetans have risen to ever-changing challenges. The first concern was practical - to physically survive and then to rise above starvation and an animal level of existence and ensure better futures for their children. This has been achieved through a combination of their own hard work and uncomplaining resilience, practical help wherever possible from the Government of India, and limited, specifically-allotted aid from overseas.

The second stage of the exile struggle was to salvage what little they could of their religion, scriptures and treasures. Three outstanding institutions in India work to keep the very best of religious scholarship, cultural history and the performing arts alive. At Sarnath, site of Sakyamuni Buddha's first teaching, Professor Samdhong Rinpoche heads the Institute of Higher Tibetan Studies. Here monk and lay successors to the *lotsawas* of eight and nine centuries ago amass ancient texts, and translate Tibetan scriptures back into the original Sanskrit; today they work on computers and their scriptural treasures are stored on hard disk. The Institute awards degrees and many of today's most outstanding scholars in traditional Indian and Tibetan Buddhist philosophy have graduated from Sarnath. In addition, Samdhong Rinpoche has bridged the gap between Buddhist and Hindu saint-scholars and attracted some of India's most respected academics and sages to his door.

Dharamsala is synonymous with "The Library" for Tibetologists and international students involved in various fields of Himalayan research. The Library of Tibetan Works and Archives was designed by Delhi architect, Romi Khosla, to evoke a Tibetan monastery. The ground floor divides into a reading room offering around 5,000 titles, primarily in English but also displaying books and periodicals in European and Asian languages, and a superbly-stocked library of 30,000 Tibetan manuscripts, the oldest of which date back to the twelfth century. On the first floor, a museum with rare statues and *thankas* is flanked by administrative offices and classrooms where foreign students enrol for intensive three-month courses in various aspects of Buddhist philosophy and for Tibetan language lessons. The Library is a magnet and meeting place for foreign travellers interested in any field of reading on Tibet.

The third famous Tibetan institution in India is also

Left *In olden days in Tibet it was customary for at least one son to become a monk. These young monks changed out of their robes to escape to India. Many were given a secular education and live there today as laymen.*
Overleaf *Both the Thirteenth and Fourteenth Dalai Lamas had felt the need to bring modern education to Tibet. From humble beginnings in rundown or abandoned buildings or tents, the refugee schooling system now has firm foundations and is an outstanding result of early support from India.*

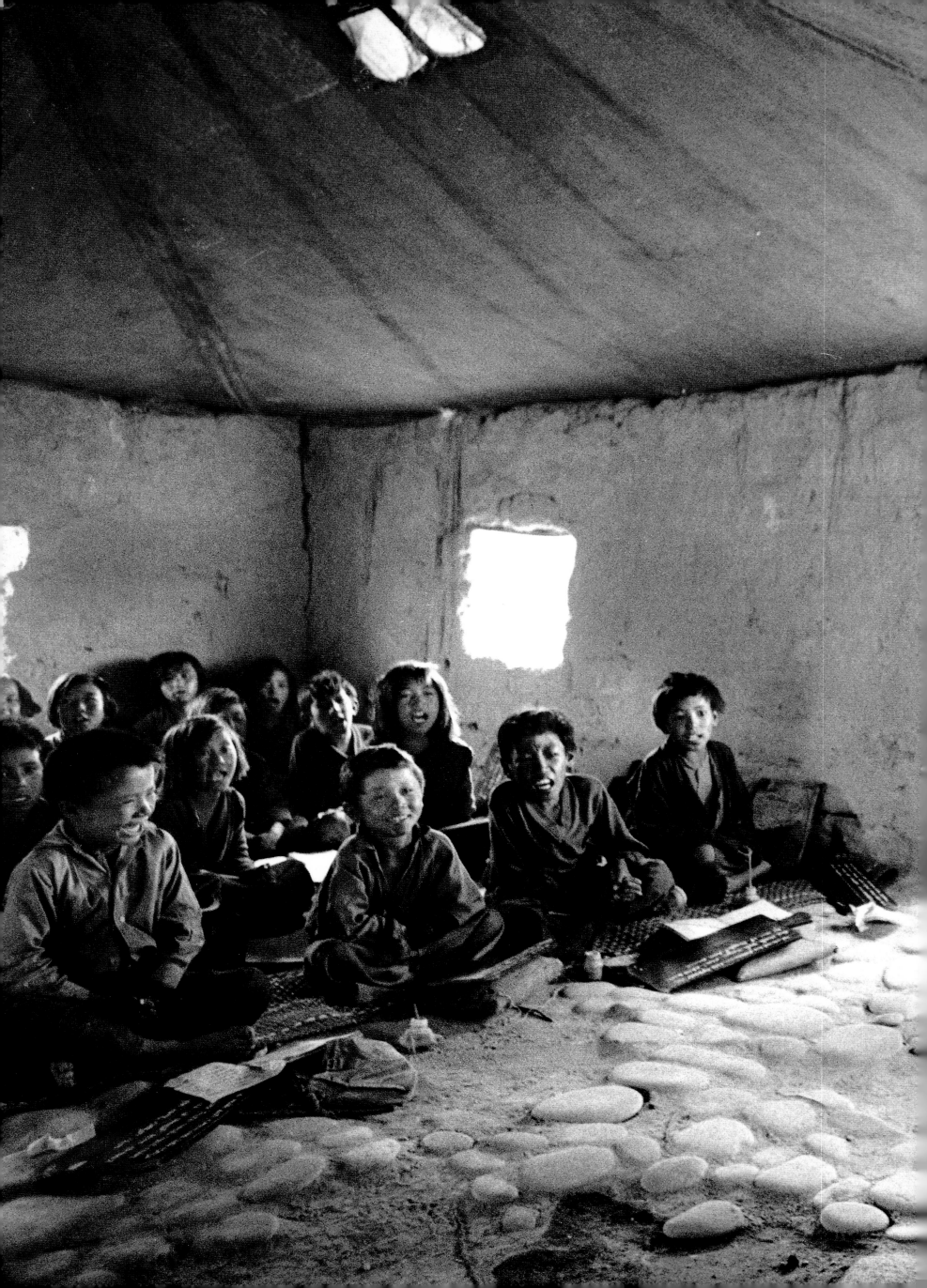

based in Dharamsala - and life around the government-in-exile would be far less colourful and exotic without it. The Tibetan Institute of Performing Arts has preserved a style of opera (or *lhamo*) which was unique to the Snowy Land, folk dancing, acrobatics and singing from the various regions of Tibet, and the haunting melodies of the nomads. TIPA artistes are an important entertainment item at every festival and celebration. Whether it is ushering in the Tibetan New Year by performing a court dance for the Dalai Lama, or striking up "Marching Through Georgia" on drums and flutes to liven a prayer-*puja* on the Holy Walk, the TIPA troupe is always there - resplendent in head-turning silks, satins, brocades, embroidered boots and furs.

Another spectacle that fascinates visitors to Dharamsala - and this includes bus- and car-loads of Indian tourists on whistle-stop Hindu pilgrimage tours - is debate. In the afternoon and evening monks from the 170-strong Namgyal Dratsang, the Dalai Lama's personal monastery, and the 80-strong neighbouring Institute of Buddhist Dialectics, gather in the courtyard outside the palace and pit their wits again each other in highly stylised disputation. The monks range in age from high-spirited teenagers to refined old *geshes* who supervise long sessions to probe the relative and absolute truths inherent in the Buddha's teachings, and the voluminous commentaries by later scholars which those teachings inspired. Debate is often raucous and even humorous - an insight into the true Tibetan temperament. The newcomers from Tibet have injected fresh vigour into monasteries and schools in India: highly motivated, they challenge their Indian-born companions and often top their classes. Over a thousand new arrivals now swell Tibetan schools in exile.

But the 1980s brought fresh worries about the survival of Tibet itself. With foreign tourists in newly-opened Tibet, with representatives of Amnesty International and other human rights organisations compiling statistics from first-hand observers, and with evidence from Tibetans visiting India, a new picture emerged.

The Chinese are now imposing their "final solution". Since Tibetans have been obdurate in clinging to their identity, 7.5 million Chinese have been persuaded to settle in "Outer" and "Inner" Tibet: their rewards include good housing, preferential schooling for their children, medical care, bonus wages for living in an inhospitable climate and social atmosphere, and the pleasures of being first-class colonisers alongside second-class "peasant natives". Their superior lifestyle is shored up by an armed Chinese force of 500,000 and in major Tibetan cities Chinese settlers well outnumber native Tibetans. Today, migration from China to Tibet is at its peak.

With Liberalisation China had decided to open Tibet to tourists. Monasteries were partially and hastily restored. Hotels built. Chinese guides trained. And foreign currency soon flooded into Lhasa. But China has also paid a crippling price for her gains. Tourists talked to Tibetans and brought out distressing stories and photographs of the country's rape. What they took in with them was information on the outside free world and such sympathy for Tibet's people, religion and culture that a new wave of hope swept the snowy wastelands.

The Dalai Lama often refers to these foreigners as his "friends" and listens carefully to their first-hand observations when they visit him in Dharamsala or request to see him on his journeys overseas. The influence level of his "friends" rose considerably in the later 1980s and today he has the backing of several Washington senators and congressmen, members of the British Parliament and House of Lords, and European MPs. He also numbers other world religious leaders, scholars, scientists, judges, top professionals, film and even rock stars among his close friends and benefactors.

The combination of new resolution and confidence in India, and courage, hope and faith inside Tibet, erupted to make world headlines in autumn 1987. On September 21, the Fourteenth Dalai Lama stood before the House of Representatives of the American Congress and proposed a Five Point Peace Plan for Tibet. Using Mahatma Gandhi's word for non-violence, "*ahimsa*", he outlined elements for a settlement with the Chinese. The whole of Tibet should be transformed into a zone of peace: the Chinese would abandon population transfer, respect Tibetans' human rights and freedoms, stop environmental destruction and cease using Tibetan soil for nuclear weapons testing and dumping nuclear waste. The fifth point was that earnest negotiations should begin on the future political status of Tibet.

Within three days of this proposal the Chinese rallied 15,000 people in Lhasa and showed their anger by

After the Dalai Lama, the two most revered Tibetans in exile were his teachers. The Junior Tutor, Trijang Rinpoche, died in 1981 aged eighty-one.

publicly executing two Tibetans. And on September 27, 1987, around two hundred monks and lay people took to the streets of Lhasa shouting "Tibet is Independent" - a thought that is tantamount to suicide. For the next eighteen months Tibetans sprang a series of sudden freedom demonstrations and troops from Lhasa's Public Security Bureau retaliated with sniper fire from rooftops, bloody baton charges, mass arrests and subsequent torture, trials and prison sentences. Unlike the wholesale slaughter of the Cultural Revolution decade, when Tibet and China herself were closed to the eyes of the world, Tibetan demonstrations and deaths on the streets of Lhasa in the later Eigthies were filmed and photographed by the occasional visiting journalist. More often it was the tourist "friends" of Tibet who smuggled video film, photographs and notes to Nepal and Hongkong.

By March 1989, faced with the thirtieth anniversary of the Lhasa Uprising and with Tibetan blood running dangerously high, Beijing imposed martial law and once again evicted all foreigners from Tibet. When China invaded Tibet in 1950, the Tibetans discovered that they had no friends to help repel the Communist forces, and countries they once considered close called Tibet's legal status "unclear". Today the situation has reversed. A powerful international lobby of informed and militant friends represent her interests abroad.

One man's charisma has inspired this support system: one man's patience and optimism laid the groundwork to make it possible. Through accessibility and masterly skill with the media the Dalai Lama has countered the vast resources of China's propaganda machine. The Fourteenth Dalai Lama would be the first to deny such public relations skills. He does admit, though, that his previous body did not have the personality to cope with television talk show interviews, probing reporters and the political rebuffs and setbacks that he has taken easily in his stride over recent decades. With his dominating character, impatience and serious mien, the Great Thirteenth may have "lost many friends and become lonely" if he had lived in today's world.

Tibetans believe that the personality of each Dalai Lama is suited to his era and the role he must play. "If someone accepts the theory of reincarnation, there is a karmic force linking the Dalai Lamas." So, just as the Great Fifth was able to unify and rule Tibet because of

the activities of his previous bodies, so the Fourteenth Dalai Lama feels he may have a similar link with the Thirteenth's activities. "These are mysterious things," he says quietly. "When I was in Tibet I was not fully convinced. But then later I came to realise that the Thirteenth's Last Testament is a remarkable thing."

In the solitude of his palace and grounds the Dalai Lama has time to reflect on these questions. Although naturally outgoing and gregarious, like the Thirteenth he also chooses to spend periods of each day alone, with nature and with his own thoughts. Just as the grounds of the Norbulinka gave the Thirteenth privacy amid the beauty of trees and flowers, the Dalai Lama's small garden on a hill within Thekchen Choeling's three fenced and wooded acres is a haven of peace and plantlife.

Jawaharlal Nehru decided the Himalayan foothills, which he so loved himself, would be a conducive climate for his special guest, and the Dalai Lama continues to find the slopes and scenery surrounding his home very beautiful. The panorama from his garden is breathtaking, viewed through pines, larches, rhododendron and Himalayan oak that cover the rocky hillside surrounding three sides of Thekchen Choeling. To the south, 4,000 feet below, the Kangra Valley's fields and sharp-hewn hills change colour with the seasons and the time of day. And to the north, rising to 15,000 feet, the close-by Dhauladhar Range comforts Dharamsala's refugees with its snowy crags and peaks and reminds them that their own snowy land is almost within reach.

This is the world that the Dalai Lama wakes to each morning - at around four in summer and five in winter. The moment that he rises he says a mantra to bless his speech throughout the day and shape his motivation: "You think, this whole day I must spend in a meaningful way and serve to benefit others as best I can." The main statue in his bedroom is Sakyamuni Buddha: "So, first thing I look on his face as a teacher and a friend." After washing and exercising, the Dalai Lama then makes prostrations "as a reminder of ones mistakes and negative actions" and begins reciting prayers.

If the weather is clear he recites while walking along the neat paths and across the kempt lawns of his garden and, sometimes, when the stars are still bright in the sky he will gaze up at them and contemplate impermanence. "In the unlimited world of the stars our

The Senior Tutor, Ling Rinpoche, also tutored the Great Thirteenth in his previous incarnation. An incomparable scholar, he died in 1983 aged eighty.

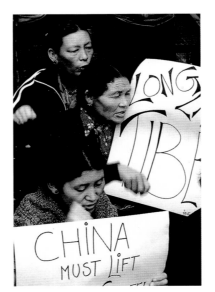

known world becomes a very small fraction. These thoughts are helpful to minimise suffering: when you look at a problem close it appears very big, but that same thing looked at from a distance becomes smaller. In Buddhism we count in aeons, not hours and days, or even centuries. This becomes helpful." Sometimes, as a moon fades in the dawn light, he ponders on waking to his life of freedom in exile while under the same moon his people are facing a day in occupied Tibet.

Before breakfast he prays for his people and country, and for himself, and repeats the Indian *pandit* Shantideva's *bodhisattva* vow: "As long as space exists, As long as sentient beings exist, May I remain until that time, And solve the suffering of sentient beings." Reciting this vow gives "some kind of inner strength".

While digesting an early breakfast his ear is tuned to the BBC World Service. A high-tech radio is one of the few personal possessions the Dalai Lama allows himself. He feels that in terms of non-materialism being a refugee has advantages for a monk because in Tibet he had inherited the possessions of all his previous bodies: "I couldn't throw them out or give them away". He reflects wistfully on the early exile months in Mussoorie when all his belongings fitted into four trunks.

From the dining table he moves to the house's main room and seats himself on a large wooden platform. And for three hours, from six to nine a.m., he enters into undisturbed meditation. These hours are precious and necessary, for those closest to him say that the Dalai Lama's natural inclination would be to lead an entirely spiritual life and his political burden is shouldered only to serve and care for his people. "It is my karmic link to carry that responsibility, and my honour. And that work itself is *dharma* work," he says, simply and humbly. Meditation is followed by what His Holiness calls his "homework", studying scriptures and philosophical texts. For several years he has been working his way backwards through the huge corpus of work of the *pandits* and *lotsawas* to reach to the very roots of Buddhism. Having completed the voluminous commentaries by Tibetan sages on the teachings of the Buddha, he moved to the even earlier works of the Indian scholar-saint philosophers. His final phase will be to study the Sakyamuni Buddha's thoughts.

The same early enthusiasm for learning that gave

such pleasure to his tutors is still unabated in middle age: "He finds it very exciting whenever he discovers new meaning in texts he read in his youth," says a member of his private staff. And of all the precious heritage that Tibet has now lost, the destruction of Indian palm leaf scriptures and handwritten Tibetan religious autobiographies and the histories of leading lay families is hardest for the Dalai Lama to contemplate. Only one copy of each record existed. Even during lunch he will sometimes continue his scripture reading, balancing the loose leaves of *pejas* on a specially designed stand.

After the midday meal he strides across the private inner garden, past a wire security fence and down a flight of steps that brings him into the main Thekchen Choeling compound. Here, in an immaculate single-storey bungalow, the Dalai Lama receives an unremitting schedule of visitors. He enjoys meeting people, and whether he is dealing with his own government officials, foreign guests and journalists, or public audiences, he generates astonishing energy, humour and curiosity. He also disarms his visitors with warmth and naturalness and often mystifies them with unexpected knowledge of their own specialist fields - from politics to science and other academic disciplines.

Paradoxically, those working close to the Dalai Lama are often the most overawed by him of all. "His open, natural, simple, humble attitude never fails to amaze me," says secretary Tenzin Geyche Tethong. "His other qualities are being very determined and disciplined: it is a discipline that comes from his honesty and sincerity, not for its own sake. He lives what he teaches: the real ethics of being a Buddhist and a monk. I believe that the simplicity of his lifestyle has had a great impact on Tibetans and contributed to higher standards of values."

The Dalai Lama's evening routine illustrates that discipline and simplicity. After audiences he returns to the palace, plugs in his battery chargers, reads Indian dailies and then tunes in to Voice of America or the BBC over a pot of tea. Sometimes tea is served with a few biscuits but for the Dalai Lama there is no evening meal. "As a monk, no dinner" he says with a hearty laugh, knowing full well that very few Tibetan monks follow this *vinaya* - or disciplinary - vow.

Evenings may be spent watching local television, videos on nature, science, history and ancient civilisa-

In democratic India everyone has the right to demonstrate. Tibetans regularly voice their hopes , fears and anger through placards and slogans.

tions from a small library provided by friends, or tuning in to international news through a satellite tracking dish given recently by one of his close American friends. But generally the hours between 6.30 and bed at 8.30 or 9 p.m. are spent in prayer and investigating the nature of mind. Then, in a state of half meditation and half slumber, he falls into deep untroubled sleep.

The Thirteenth Dalai Lama worked on problems of state until late into the night: the Fourteenth prefers to delegate more administrative responsibilities and is, by his own admission, "mentally happier and easier going". Although for most of his life Tibet's political situation has been a tragic turmoil, he says that his inner emotions are at ease. Again, he turns to Shantideva's ancient wisdom for equanimity. The Indian *pandit's* philosophy says: "What need is there to be sad and depressed, If there is a way to solve the problem? What benefit is there in being sad and depressed, If there is no way to solve the problem?"

The burdens of the Fourteenth's reign have been physically harder and politically more complex and insuperable than those faced by the Thirteenth. As Tibet's leader and protector he has had to watch, impotently, from exile as his country has been devastated, his people tortured, starved and killed and, according to first-hand accounts from foreigners and Tibetans, almost all wildlife in Tibet has been extinguished. By China's own admission the country's vast forest tracts have been felled and shipped to the Great Motherland for domestic use and for re-export to earn foreign currency. Tibet's immense mineral wealth is claimed to constitute forty percent of China's reserves. The world's largest uranium deposits lie untapped in Tibet, according to Chinese leaders, and Tibetan iron ore feeds China's missile, defence and ship-building industries.

Maybe it is this very destruction of life, nature and beauty in his homeland that has made every creature in his own garden more precious. Like the Thirteenth, he spends many happy hours in his potting shed, growing seeds, bulbs and cuttings. But Dharamsala is deluged by the second heaviest monsoon on the subcontinent, and just before the rains another hazard descends on his garden: butterflies present a moral problem to the living embodiment of Chenrezi. "Once the eggs are laid, I have to protect them. I watch them and for four days their colour keeps changing and then they become small, defenceless caterpillars. The mother has gone away permanently and has no opportunity to see her young. I become sad. I cannot destroy them, so then they destroy my flowers!"

This losing battle in the garden led him to a new hobby: feeding birds and studying their habits. Here the rational, scientific, modern-day world of the Fourteenth Dalai Lama overlaps with the sort of mystic phenomena that gave birth to the myths and legends of bygone Tibet. Birds have always held a special place in Tibetan spiritual folklore and the Thirteenth Dalai Lama had an unusual connection with a species of blackbird whose song delighted him. Large flocks of these *jolmo* lived around a hermitage belonging to Tema, a woman oracle through whom Tibet's fierce protectress deity, Palden Lhamo, gave advice to the Dalai Lama. After these trance-consultations with Tema, *jolmo* would fly from her hermitage in the hills near Lhasa to the grounds of the Norbulinka where the Great Thirteenth would keep them for a while in cages and enjoy their singing. Today these same blackbirds, which are non-native to India, visit the Fourteenth Dalai Lama in increasing numbers each winter.

The Dalai Lama leaves Dharamsala frequently each year. His overseas trips cover a wide spectrum of invitations, from peace and science seminars to religious and political forums, and giving teachings or presiding over spectacular Buddhist ceremonies. And in India he often visits his people in the large agricultural settlements near Mysore and gives teachings during winter either under the *bodhi* tree at Bodhgaya or at Sarnath. In summer his preference is to migrate north to escape the monsoon, and in 1986 the Tibetan refugees in Ladakh and local Ladakhis, both Buddhist and Muslim, presented the Dalai Lama with a new palace just outside the capital, Leh. Here, away from modern communications, administration and audiences, and surrounded by majestic scenery that resembles Tibet, he has partially realised his dream of retiring to a mountain hermitage. For twenty-five days in the summer of 1987 he retired into solitary retreat there - the first time in twenty-eight years of exile that life has allowed him this luxury.

These journeys away from Dharamsala sometimes give opportunities for the moments of impromptu informality that the Dalai Lama has relished since his boy-

P*hotographs smuggled out of Tibet by foreign "friends" show recent riots and demonstrations in Lhasa against Chinese rule. Monks and nuns were leading participants.*

hood. In America it may be the chance to simply walk a whole city block and drop into the electronics section of a ritzy department store. "I like to admire the display and look at all the new and very beautiful designs - particularly watches and small radios with lots of bands. But when you say, do I really need this thing, the answer is no. The desire is superficial." In India, Ladakh has provided several chances to sidestep formality in a setting that reminds all Tibetans of home.

The almost two million Ladakhi, Zanskari, Lahouli, Spiti, Sikkimese and Bhutanese Buddhists living in the Himalaya have gained from Tibet's loss. Not only has their religion been revitalised by scholar-lamas being driven into exile, but they also know the Fourteenth Dalai Lama as an accessible human being. "Before it was beyond our wildest dreams to visit Lhasa," said an elderly Zanskari carpenter who donated his skills to building a small palace for the Dalai Lama near Padum, his region's village-like "capital". "Even if we could afford to go there, we would never have seen him. Pilgrims like us just walked around the Potala looking up at the golden roofs where Yishi Norbu lived. We are so lucky. He has come twice to visit us here in Padum."

Even more fortunate on the Tibetan value scale are the 7,000 or so refugees living in his protective shadow in Dharamsala. At Tibetan New Year, which usually falls around February, the terrrace of the Tsuglakhang (the central cathedral) is packed to capacity with monks, nuns, lay residents and foreigners taking a ten-day series of teachings. The Dalai Lama's deep and powerful voice expounds on a chosen theme from the vast Buddha *dharma*: across the amplifier system comes the wisdom of 2,500 years, delivered in a vocabulary that reaches even the least educated of his audience. Then, on the second morning of the New Year the whole community forms a queue stretching half a mile from the palace gardens to the bazaar of McLeod Ganj. Slowly the head of the queue passes before the Dalai Lama and each person bows, offers a *khata* and receives a blessing and red protection thread. Intermingled with Tibetans, foreigners and other Himalayan Buddhists, are local Indians: they also embrace the "*guru-ji*" living in their midst as a saint.

When news reached Dharamsala on the afternoon of October 5, 1989 that the Nobel Committee in Oslo had awarded the Dalai Lama the Peace Prize for 1990, local Indian shopkeepers were as proud and jubilant as the Tibetans themselves. "Now you will go back to Tibet" they told their friends and customers. "Of course, we will miss you. You have brought us good business. But we promise we will come and visit you in Tibet."

The combined world political events of 1989, the Year of the Metal Snake and the 2116th year of the Royal Tibetan Calendar, brought with them a surge of new hope for the Tibetan struggle to regain at least a form of semi-autonomy for their country. The combination of China needing to impose martial law on Lhasa in March to muzzle unrest, followed by her own gruesome public suppression of the Tiananmen Square student demonstrations in June, weakened China's floundering image in the eyes of the free world. Then the Nobel Committee's decision gave high visibility to the very man who strives in this lifetime to reunite his divided country. Moreover, the liberalisations in Russia and crumbling edifice of Communism in Eastern Europe all point to a strong cycle of change in the world.

Will the Fourteenth Dalai Lama return in triumph from this protracted Indian exile when change comes about in China, just as the Great Thirteenth did in 1912? Political pundits would probably reply no. But for questions such as this the Tibetans themselves would turn to clairvoyant *tulkus* or consult the Nechung Oracle in trance. One *tulku* whose oracular powers are much-respected in Dharamsala is Khamtrul Rinpoche, a middle-aged Nyingma scholar and tantric master. When he was eighteen, and had just completed his first solitary cave meditation retreat in Kham, he had a dream which covered forty Tibetan loose-leaf folios when he later recorded it. In it Chenrezi, Tibet's *bodhisattva* protector, predicted the Chinese invasion and occupation of Tibet. And because of this warning Khamtrul Rinpoche was able to escape to India from his monastery bordering the Chinese province of Sichuan. Chenrezi went on to describe how freedom would be regained before the end of the century, with the help of America and Italy. "The strange thing is that I had heard of America at that stage of my life, but I didn't even know a country called Italy existed."

The mysteries of the high Tibetan plateau have exercised a powerful fascination on both physical and spiritual explorers since the days when intrepid merchant-travellers and missionaries first penetrated the massive barriers erected around her by nature. Today the seeds of that mysterious storehouse are nurtured in the monasteries and lay communities scattered across India. The land that gave Buddhism to Tibet is again guru-protector to its precious *chela* (disciple) and from this ancient spiritual bond a new Tibet will one day rise.

Opposite
A few days after the Dalai Lama outlined a peace proposal in Washington in September 1987, riots broke out in Lhasa. In response he called his first-ever press conference in Dharamsala. International journalists were greeted there by crowds of demonstrating refugees . Overleaf On October 1, 1987, the ancient streets of Lhasa were the scene of the most dramatic confrontation to Chinese rule since the Lhasa Uprising of March 1959. Led fearlessly by monks from the great monastic universities, over two thousand men, women and children stoned and burned a Chinese police station and gutted Chinese vehicles.

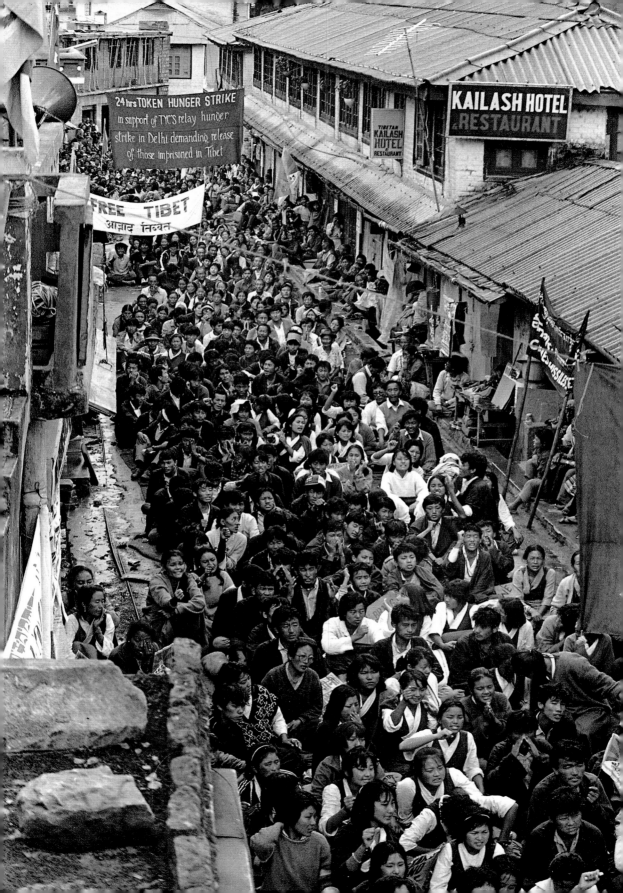

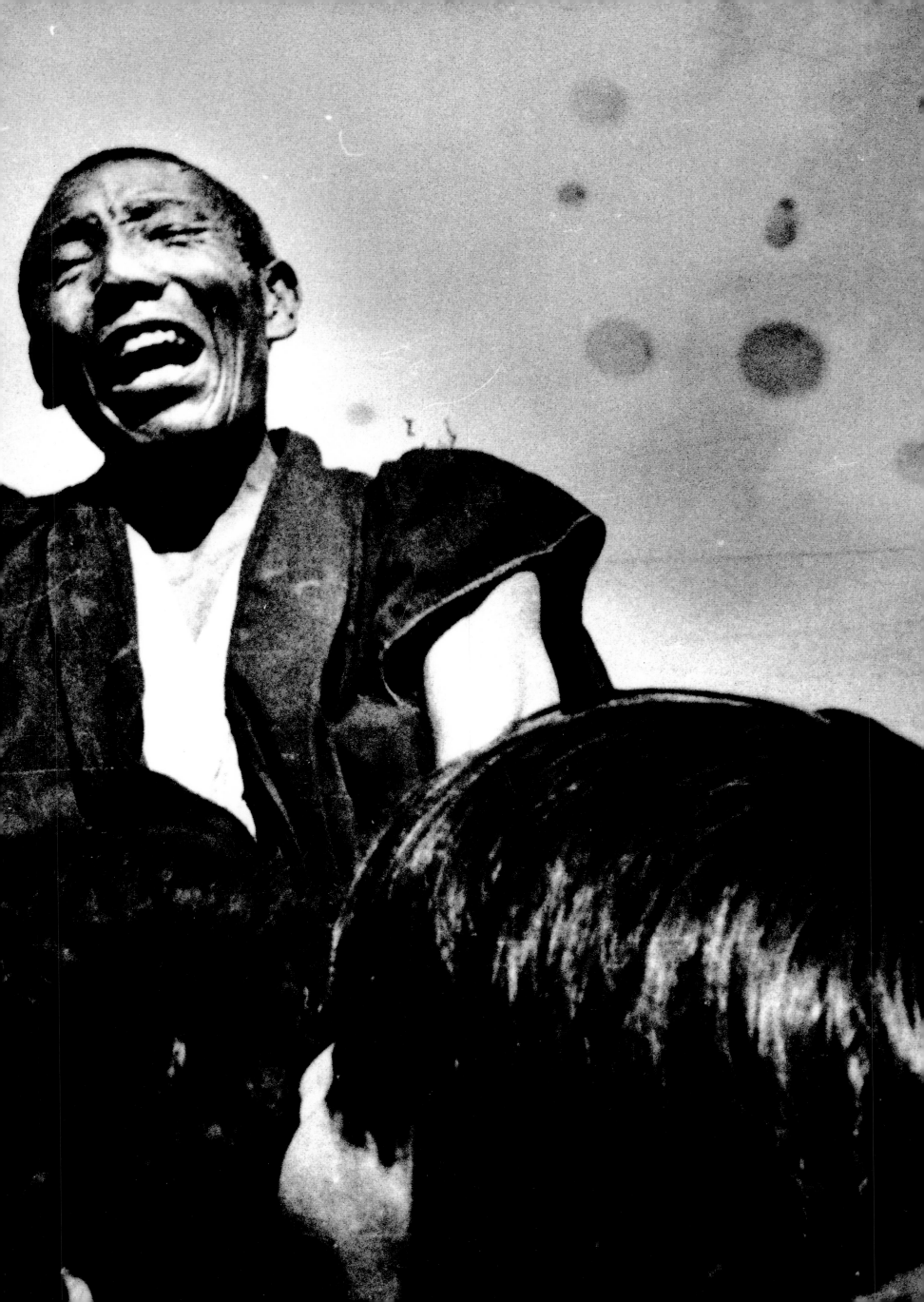

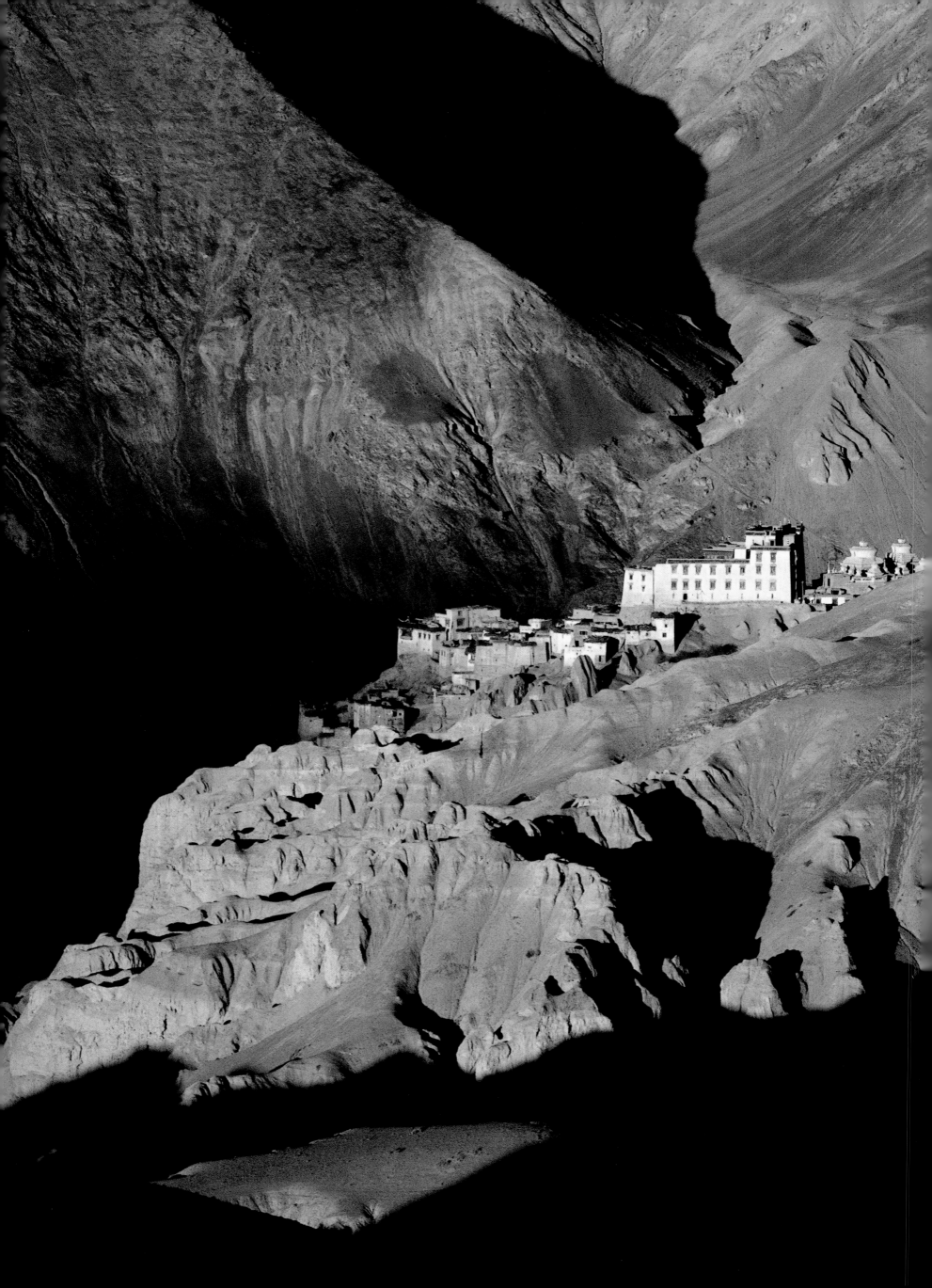

THE
LEGEND
LIVES

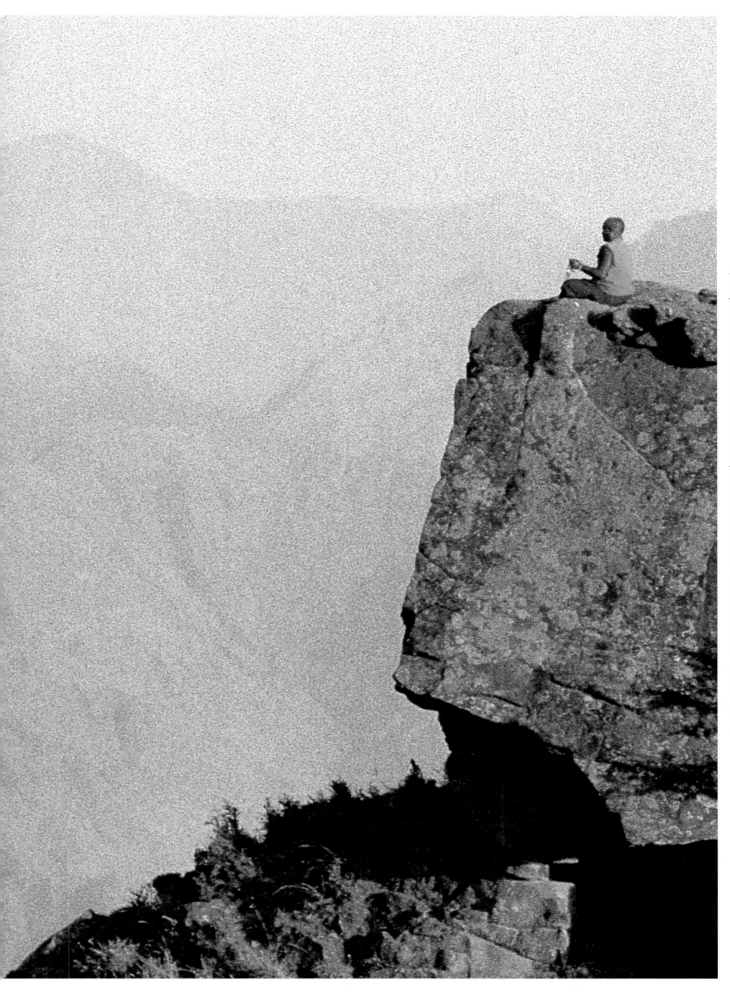

A_t *pilgrimage places in the Himalayan foothills the Tibetans can experience the same solitude and oneness with nature that gave a special spiritual quality to their homeland.* Previous pages *A thousand years ago Ladakh's high and barren valleys were a crossroads for the great scholars journeying from Western Tibet to Kashmir and India to amass Buddhist teachings and texts; ancient whitewashed* chorten *at Shey symbolise the days when Ladakh was culturally an area of Greater Tibet.* Overleaf *To provide the year's supply of* tsampa *flour for themselves and other hermits, these monks have carried sacks of barley up from Rewalsar, the lakeside town far below their retreat huts and caves.*

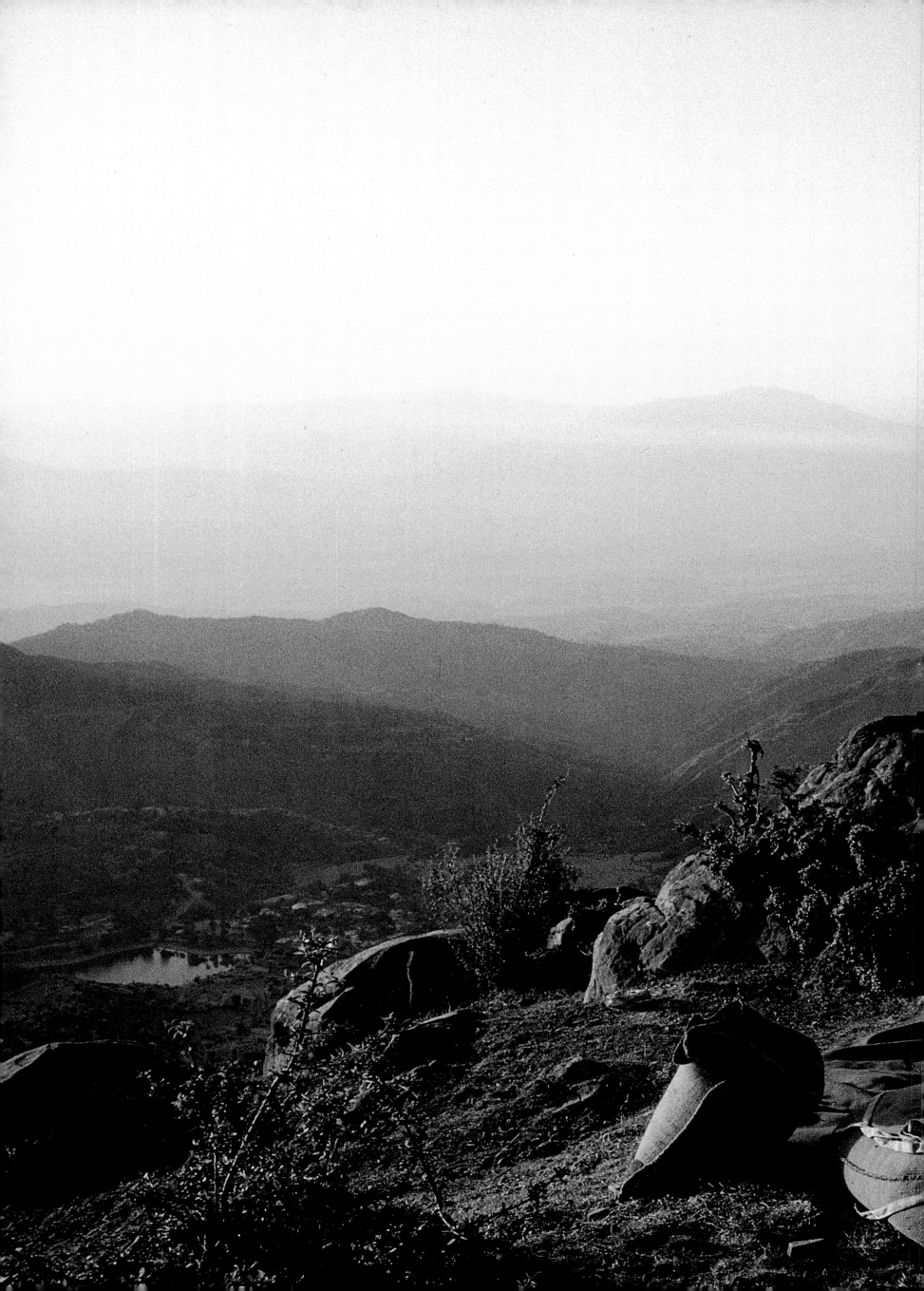

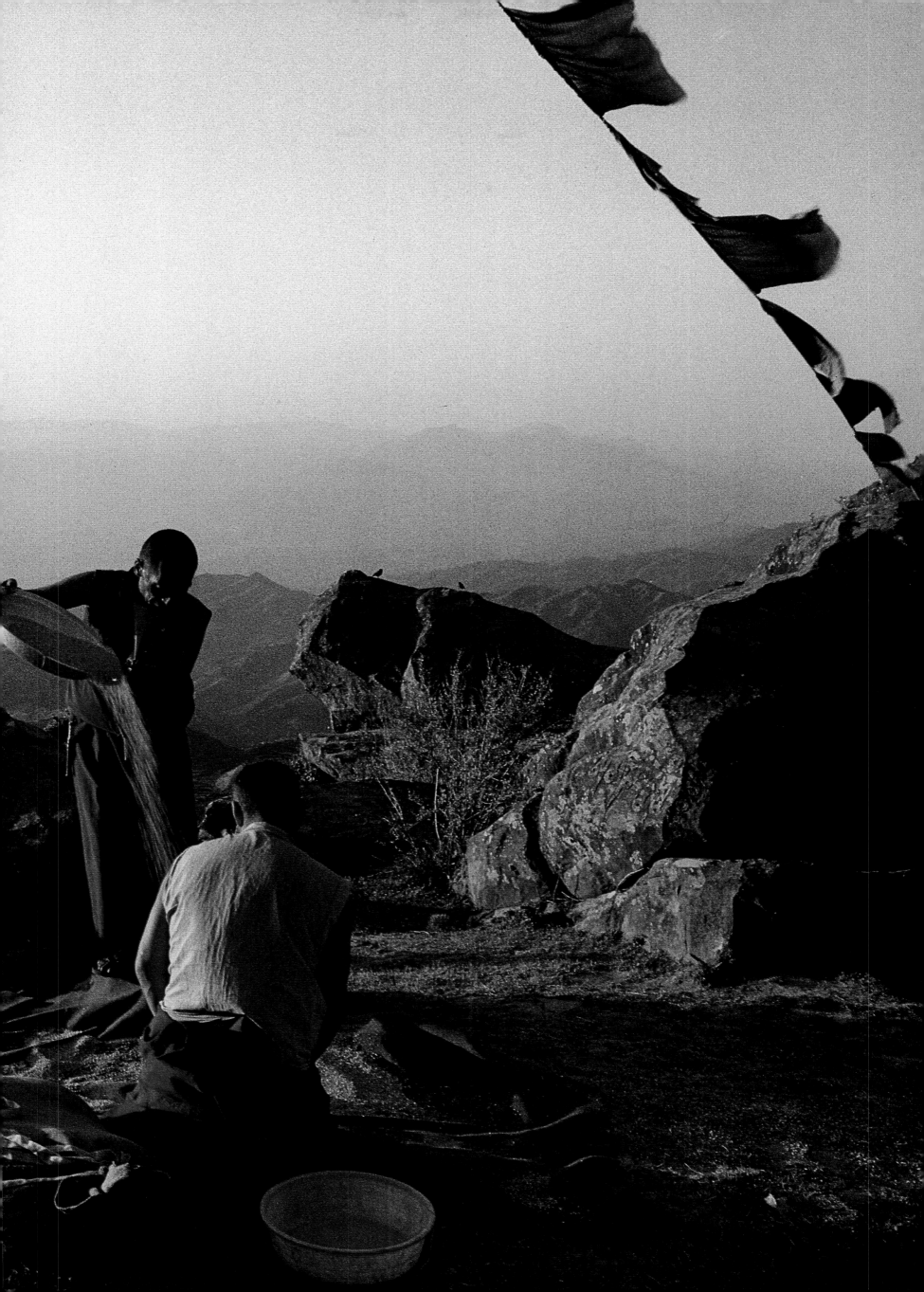

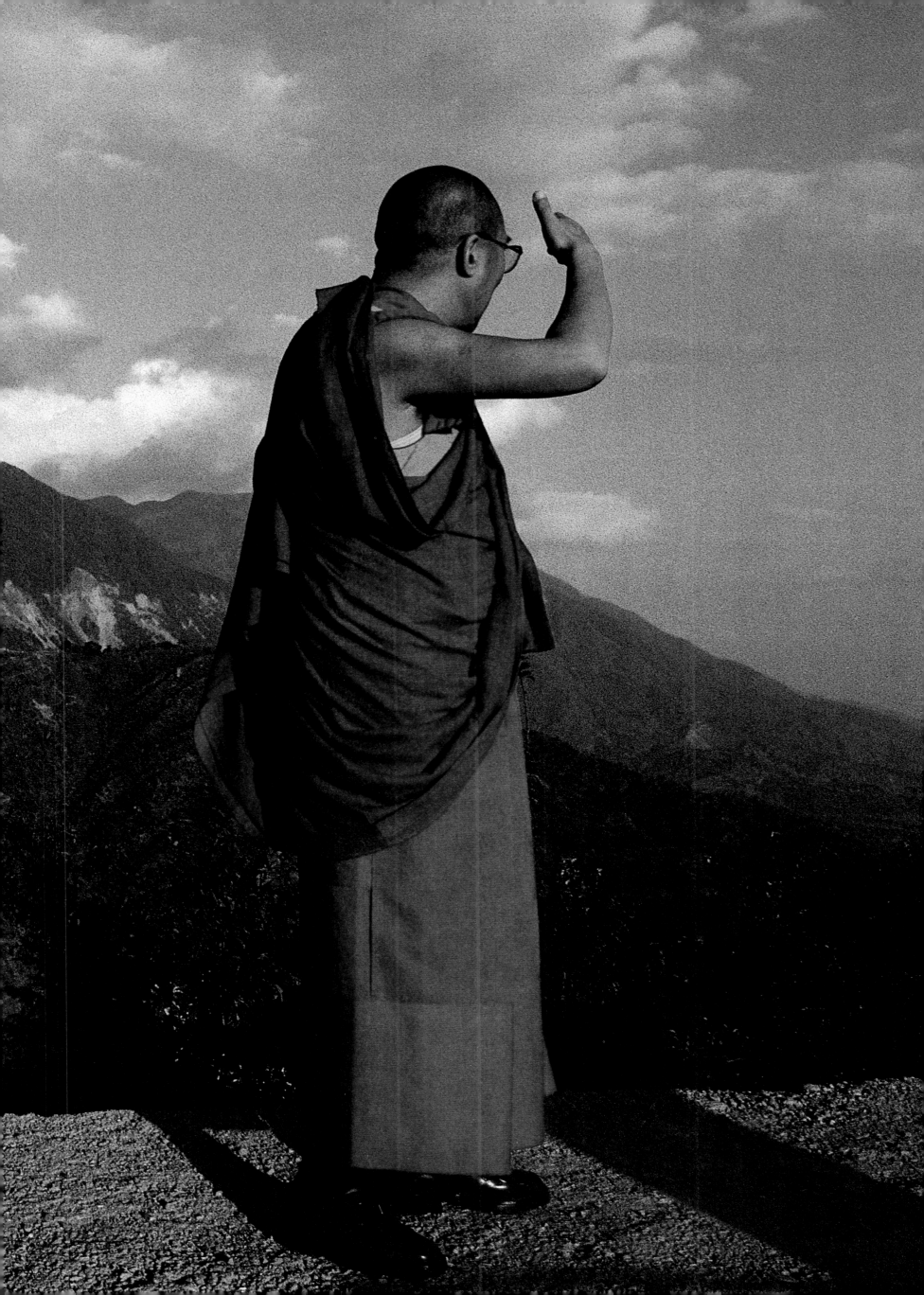

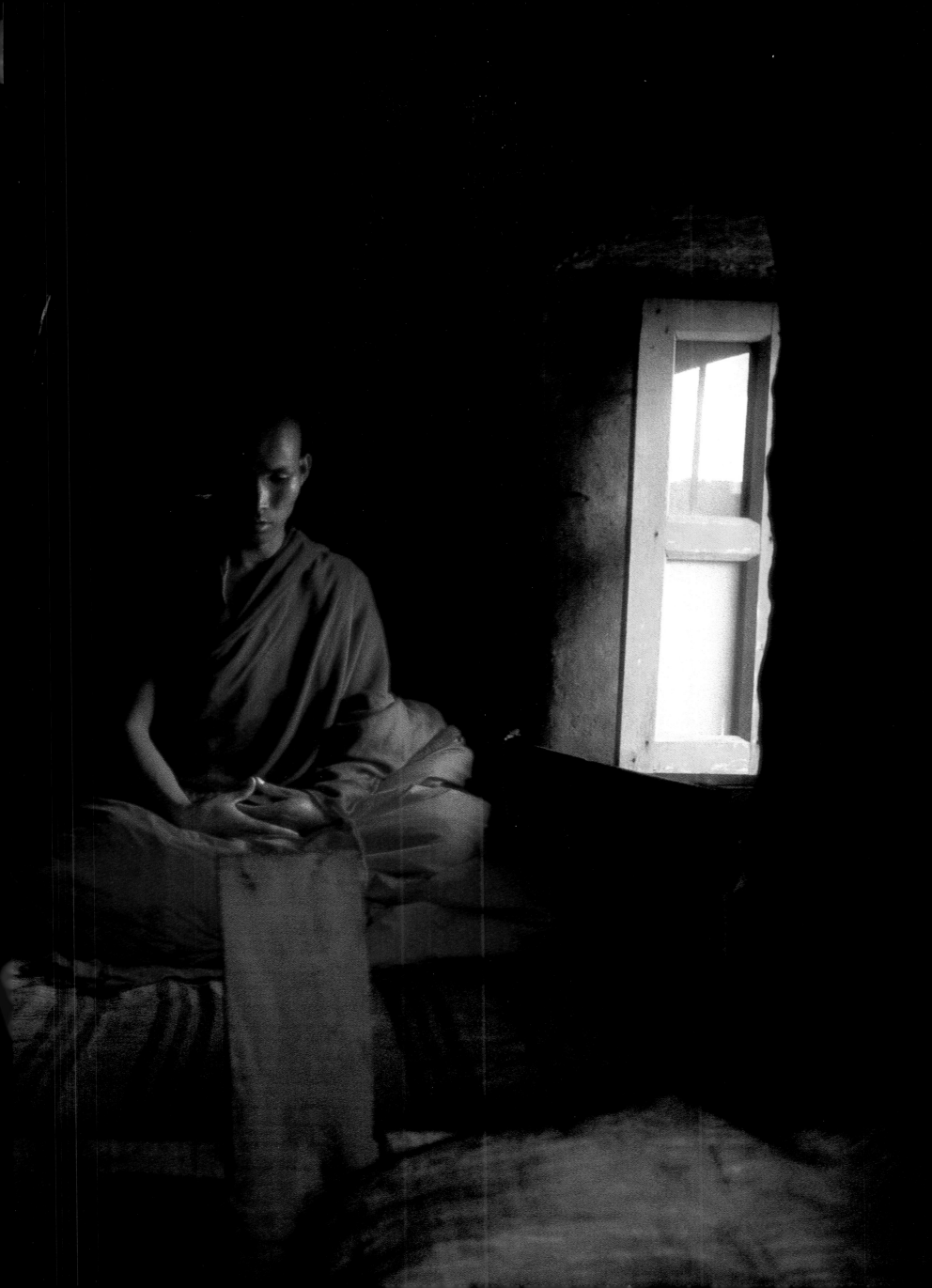

A cave
temple at Rewalsar
where Guru
Padmasambhava
(bottom) is said to
have meditated in
the eighth century.
The main statue on
the altar (left) is
Milarepa - a famed
eleventh-century
yogi-meditator who
recorded his free-
spirited teachings in
song and verse.
Opposite A modern-
day meditator
enclosed in his
retreat cell for three
years, three months
and three days.
Previous pages
Solitary retreats are
important stages
on the Tibetan
spiritual path.
Some committed
practitioners spend
many years in
solitude and a few
stay in meditation
retreat for a lifetime.
Despite the burdens
of his political work
the Dalai Lama
regularly withdraws
for short retreats in
Dharamsala. On the
hillside above his
garden a community
of solitary meditators
pray for his long life
and successful
endeavours.

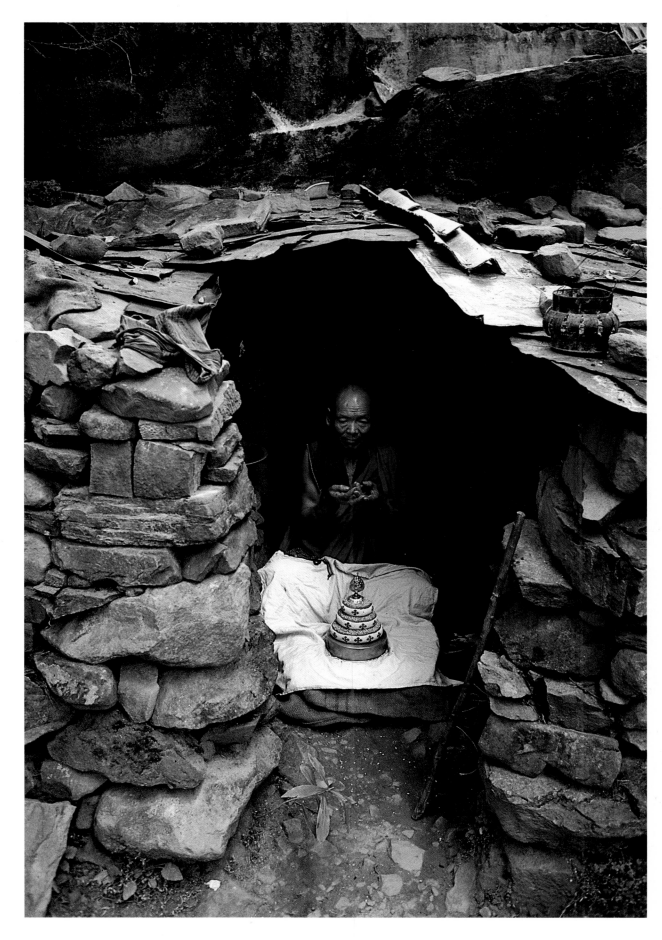

The
spiritual riches and
material poverty of a
hermit meditator's
life. Within his
makeshift hut of
rocks, with flattened
cooking oil tins for a
roof, this monk lives
a life of contented
fulfillment. Here he
makes a ritual
mandala offering
to a visualised image
of the deity he is
praying to.
The four-tiered
mandala represents
four continents and
upon these the monk
will project an
elaborate world of
symbolic mountains,
jewels, deities and
flowers. Opposite
Wherever Tibetan
Mahayana
Buddhism is
practised, prayers
and Buddha images
are carved and
painted on rocks.
Here the inscription
spells out Om Mani
Padme Hum - *Oh*
Jewel in the Lotus -
the mantra of
Chenrezi that hums
across the Buddhist
Himalaya.

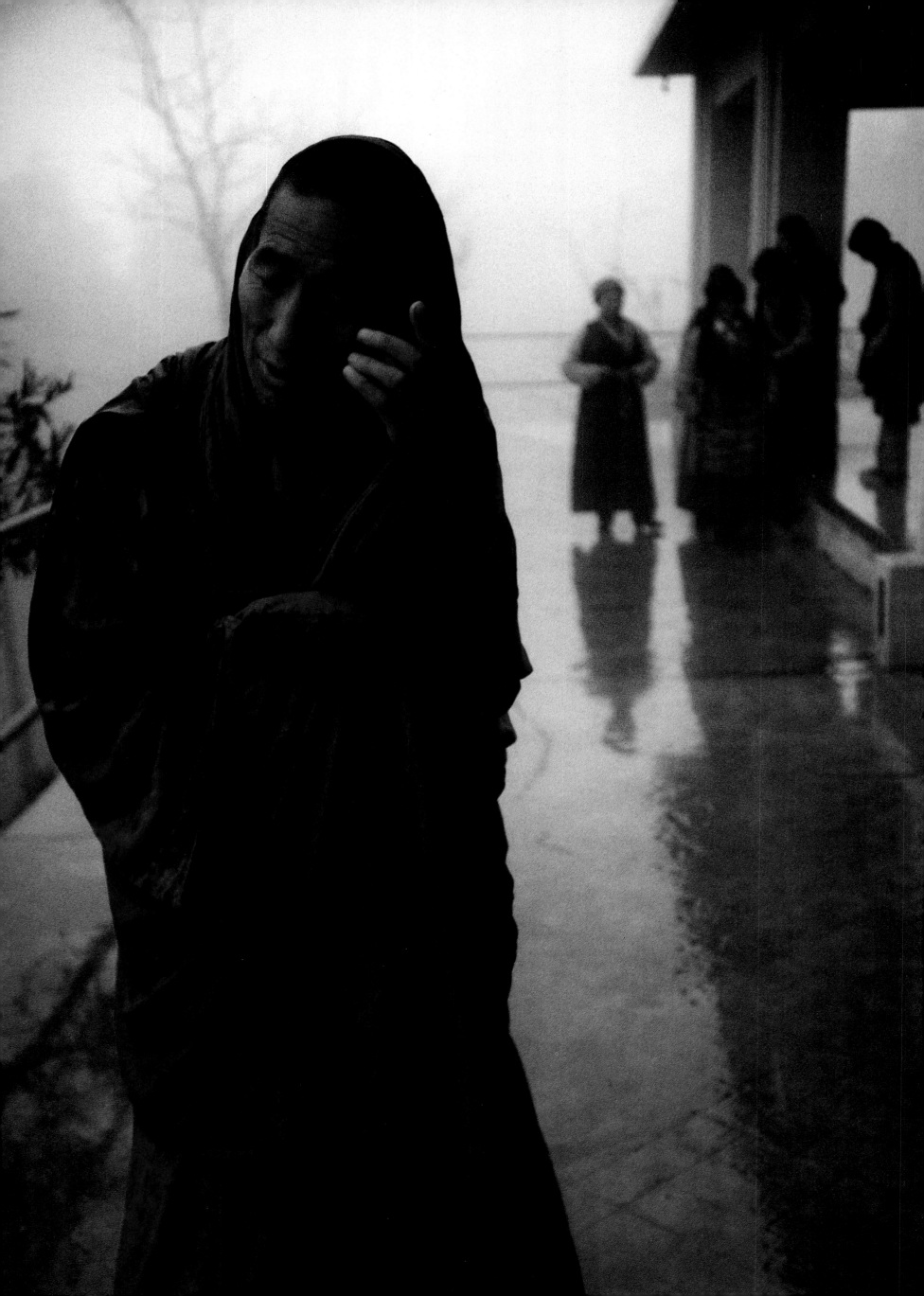

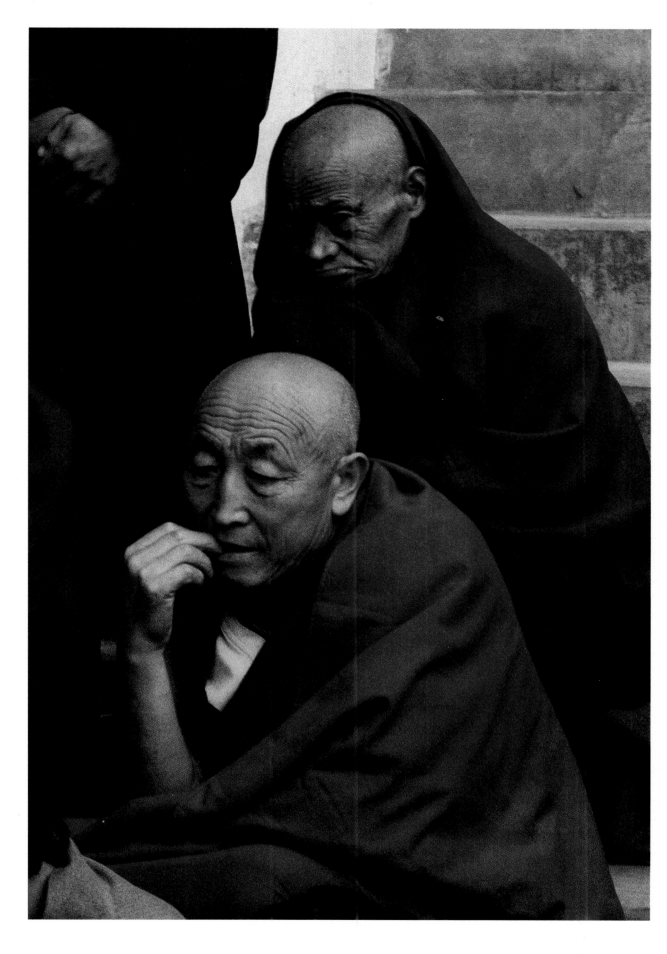

Monks who
are now in their later
life carried the initial
burden of keeping
their religion alive
when they arrived in
India three decades
ago. In transit
camps, and later in
spartan monasteries,
they preserved the
prayers, rituals and
practices which
communism was
then eliminating
in Tibet.

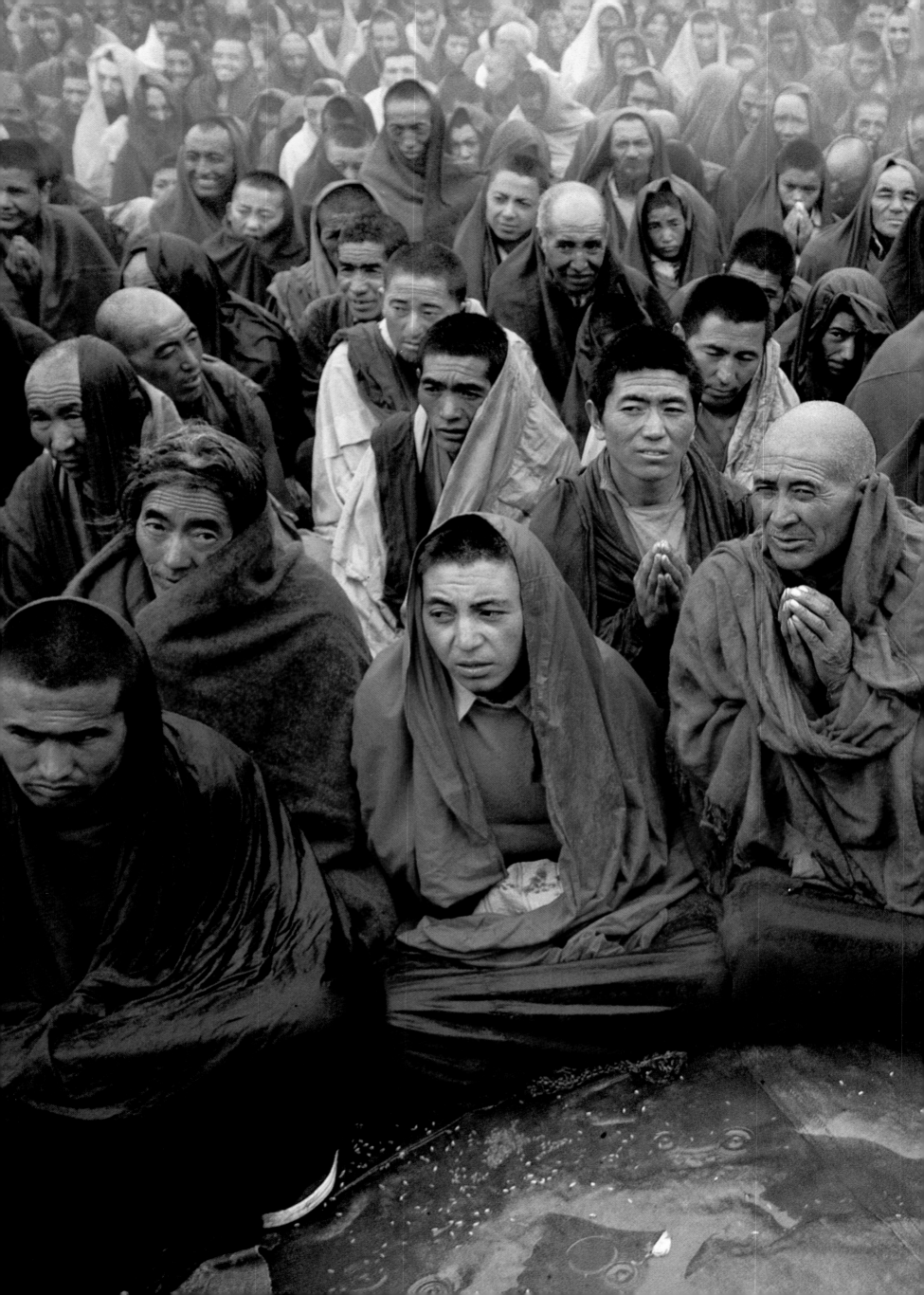

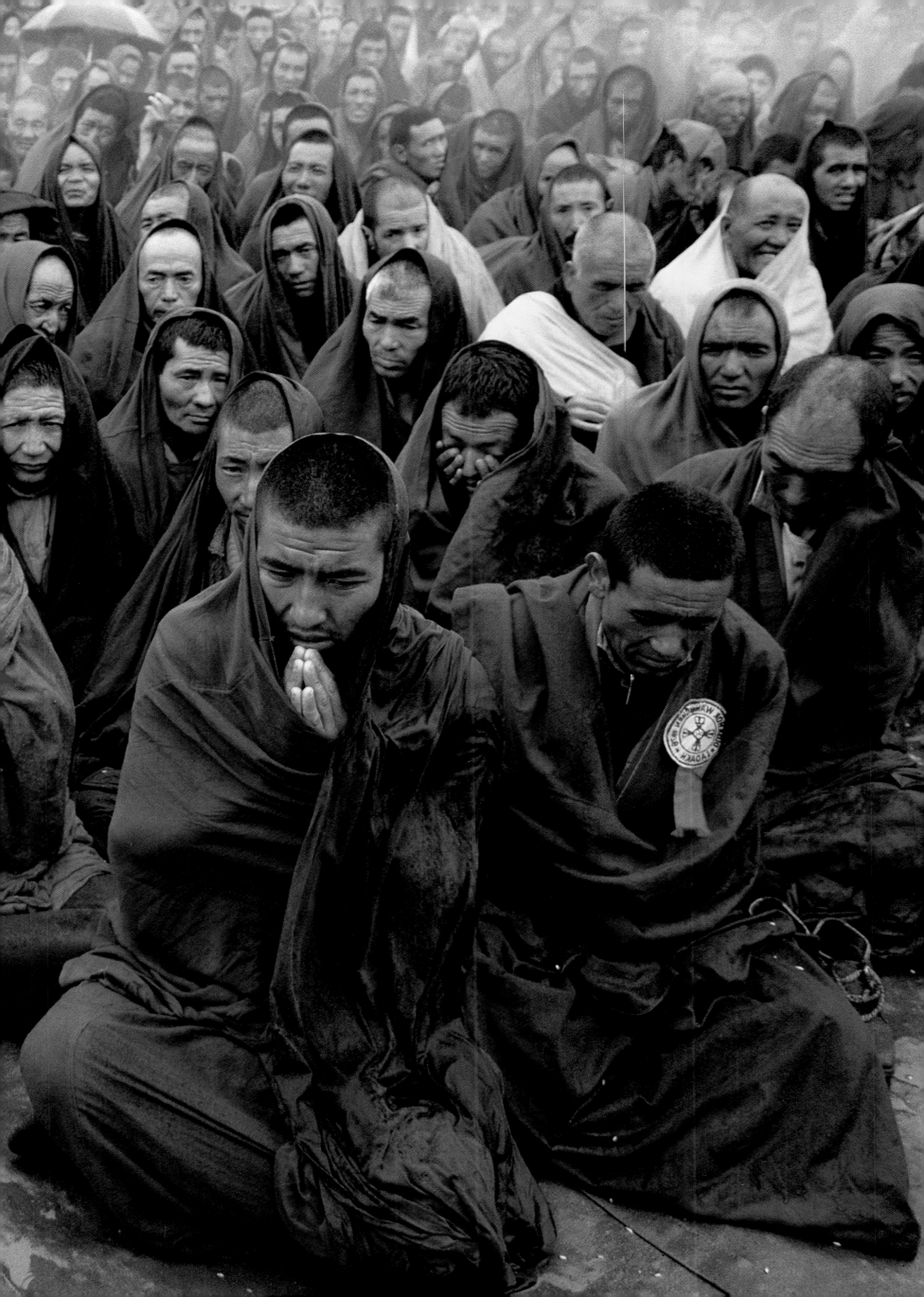

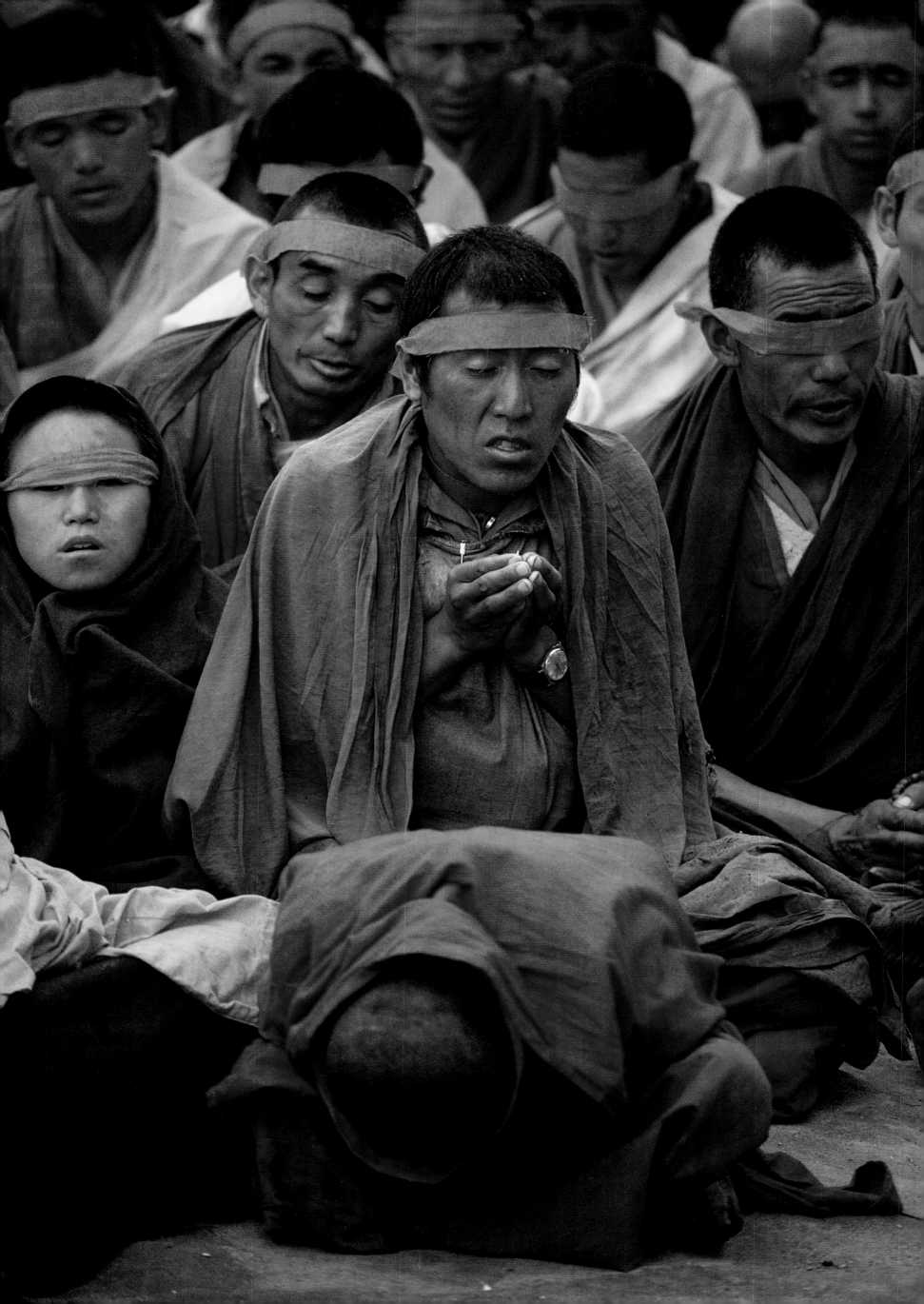

During *Tibetan rituals hand movements - or* mudras - *synchronise with the prayers and form complex symbols. Here the* mudra *represents a mandala offering.* Opposite and previous page *For Tibetans, receiving an initiation, or permission to practice, on the many deities that form the Tibetan pantheon, is a sacred moment. Here a devout audience receives the Kalachakra initiation from the Dalai Lama, a four-day transmission that permits them to practice the highest tantric yoga.*

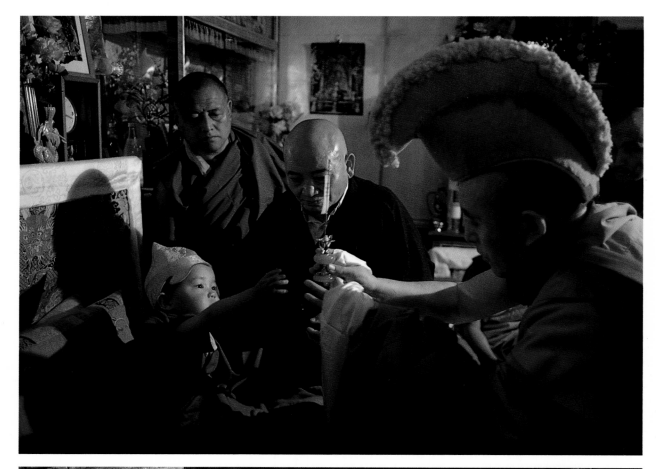

This child was tested and acknowledged by the Dalai Lama as the reincarnation of his Senior Tutor, Kyabje Ling Rinpoche, who died in 1983. Bottom A young tulku blesses a Western monk by touching foreheads, the most intimate Tibetan greeting. Previous page Tibetans place great faith in performing prostrations to a figure or object of veneration. Opposite A multi-coloured sand mandala forms the centrepiece of the Kalachakra initiation. After all initiates have viewed the mandala, and stepped through its four symbolic portals enclosing mansions of the deities, the sand is swept up and placed in flowing water - a reminder of impermanence.

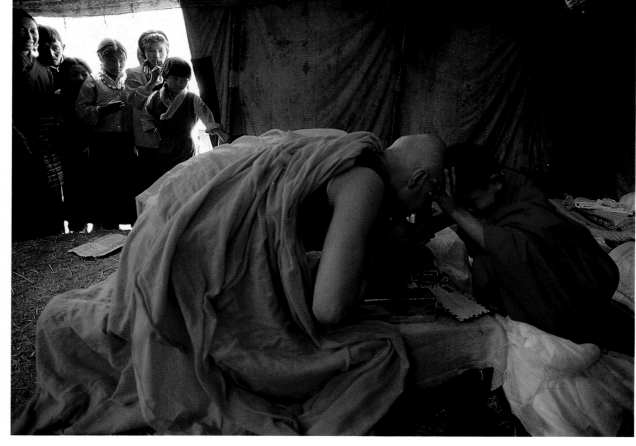

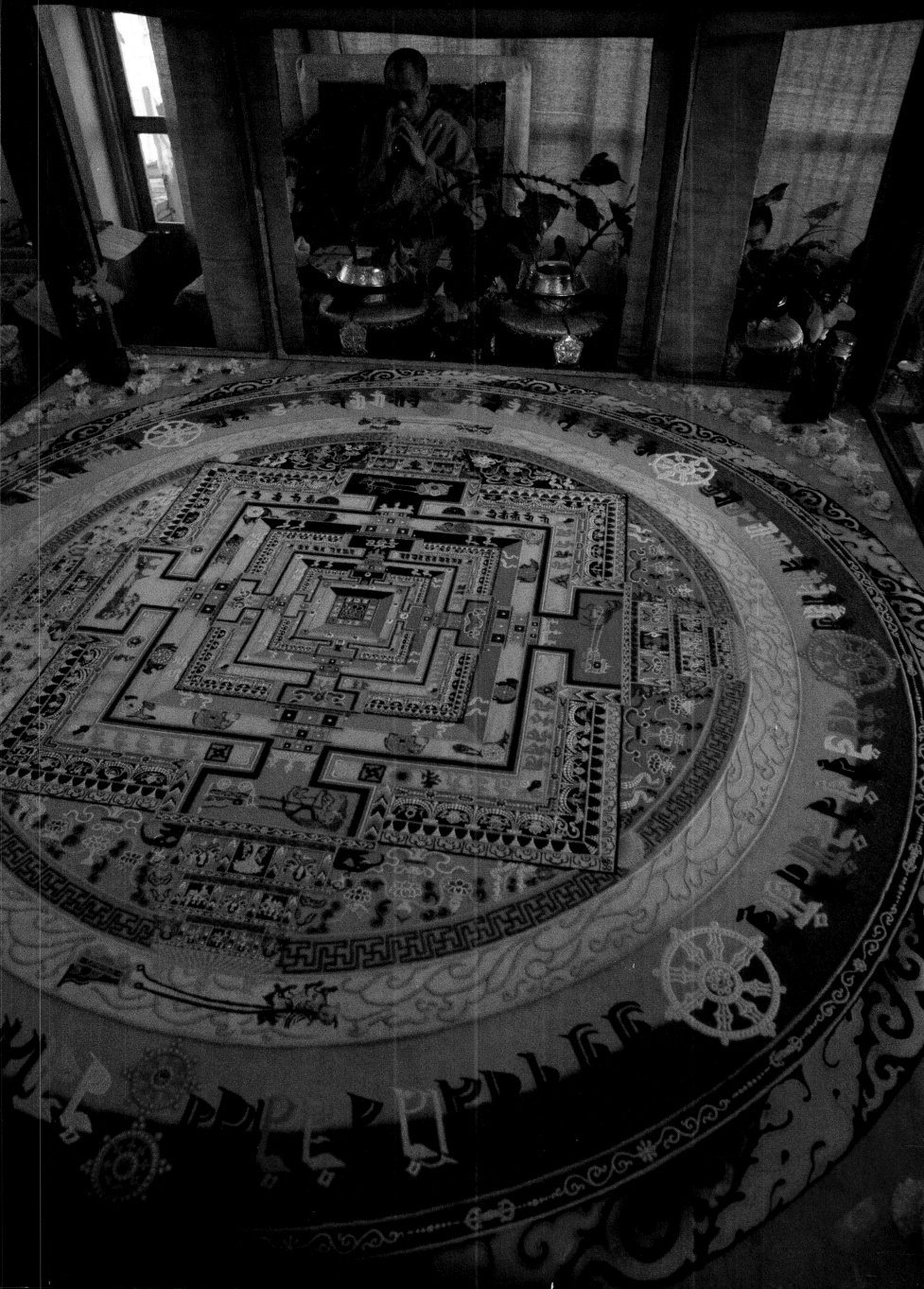

Previous page *The Nechung Oracle in trance. The spirit entering the monk medium is chief of the demons from pre-Buddhist Tibet who were bound to become protectors of the Buddha* dharma *in the eighth century by Guru Padmasambhava. Nechung became chief State Oracle during the Great Fifth Dalai Lama's reign and since then he has been consulted for all major political decision-making.*

Although Discipline Masters overlook the younger monks, and flouting monastic rules can lead to a severe beating, Tibetans are renowned for their good humour, tolerance and love of laughter. Even at the most solemn moments levity is permissable and the inventive games of bored young monks are viewed with indulgence by their seniors.

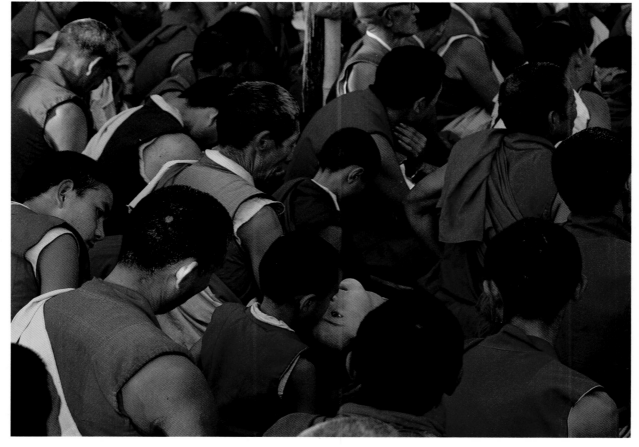

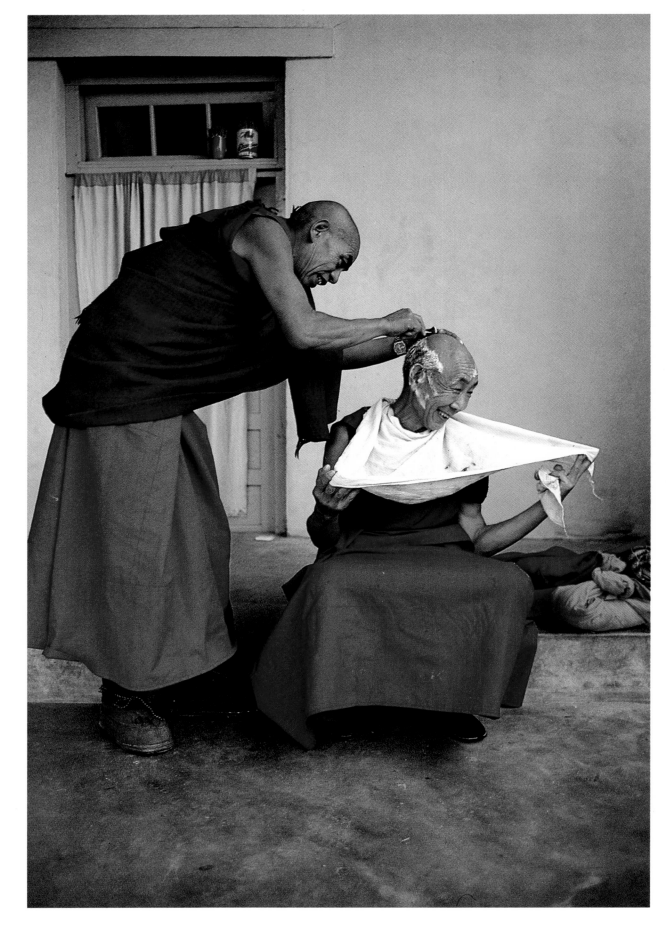

A *monk's day is divided into a demanding schedule of prayer assemblies, memorising texts and receiving explanations of those texts from his teacher, and lengthy debate sessions. Religious classes divide into fifteen subjects, each lasting a year, and the students' understanding is tested and stimulated each day in the debate courtyard.*

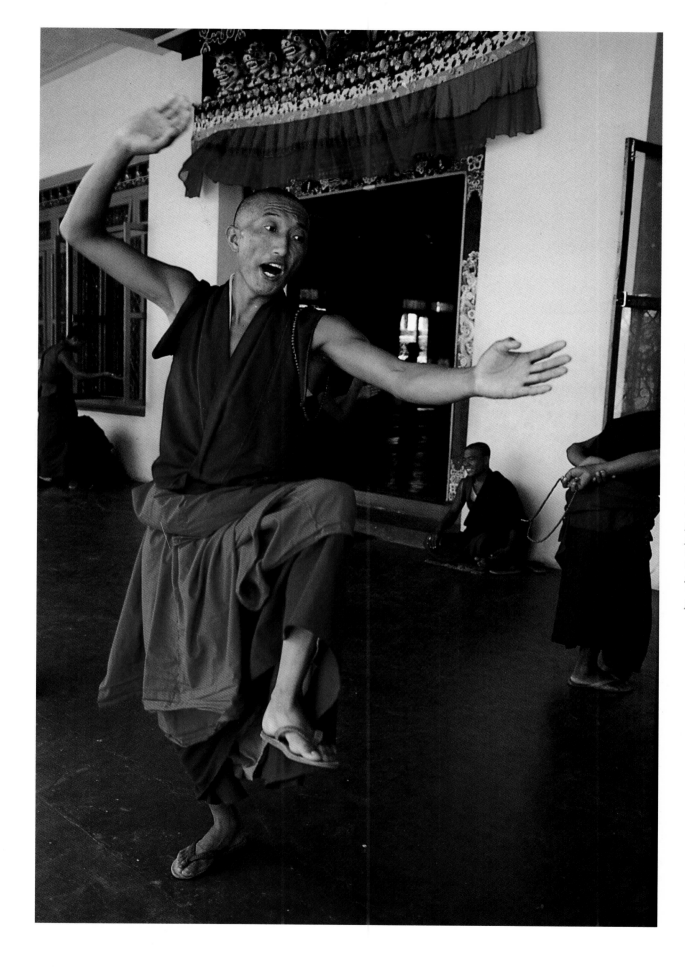

Left and overleaf *In debate standing monks are the challengers, tossing queries from Buddhist philosophy to seated monks who must respond with appropriate quotations and explanations. Lifting the left leg symbolises the liberation of sentient beings: as it is stamped to the ground the right palm slaps resoundingly on the left - a dramatic gesture known as "stimulating wisdom pearls".*

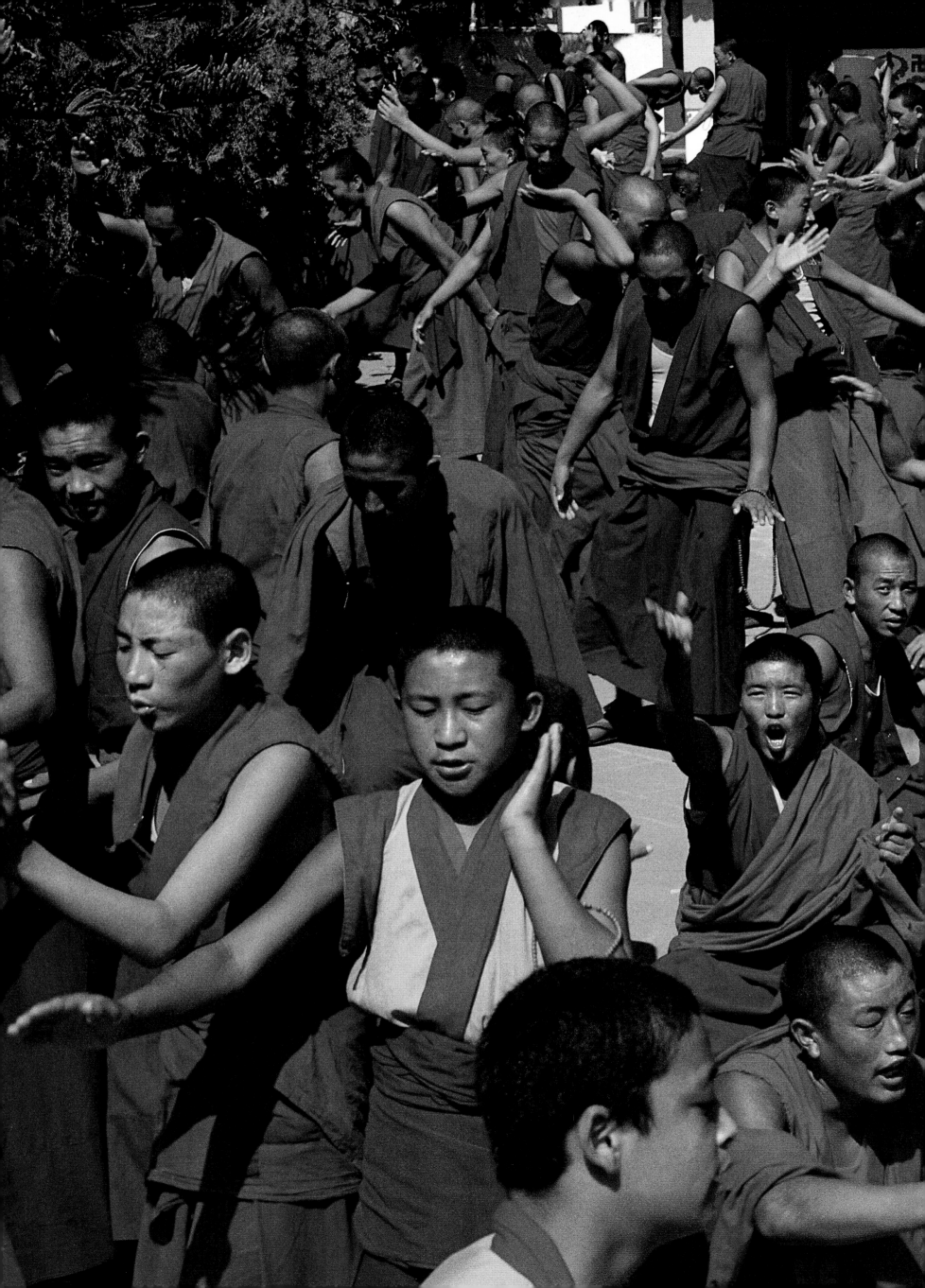

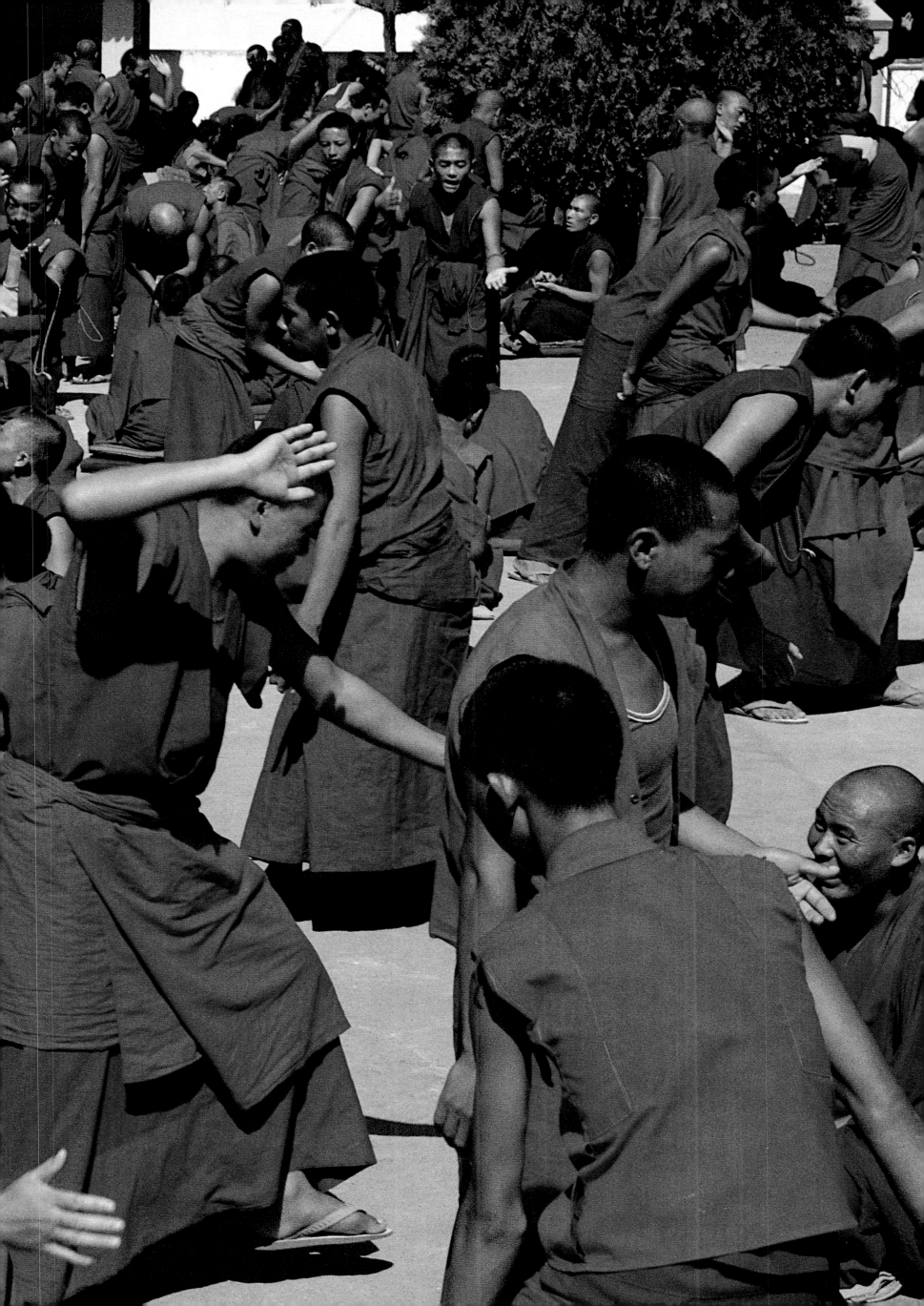

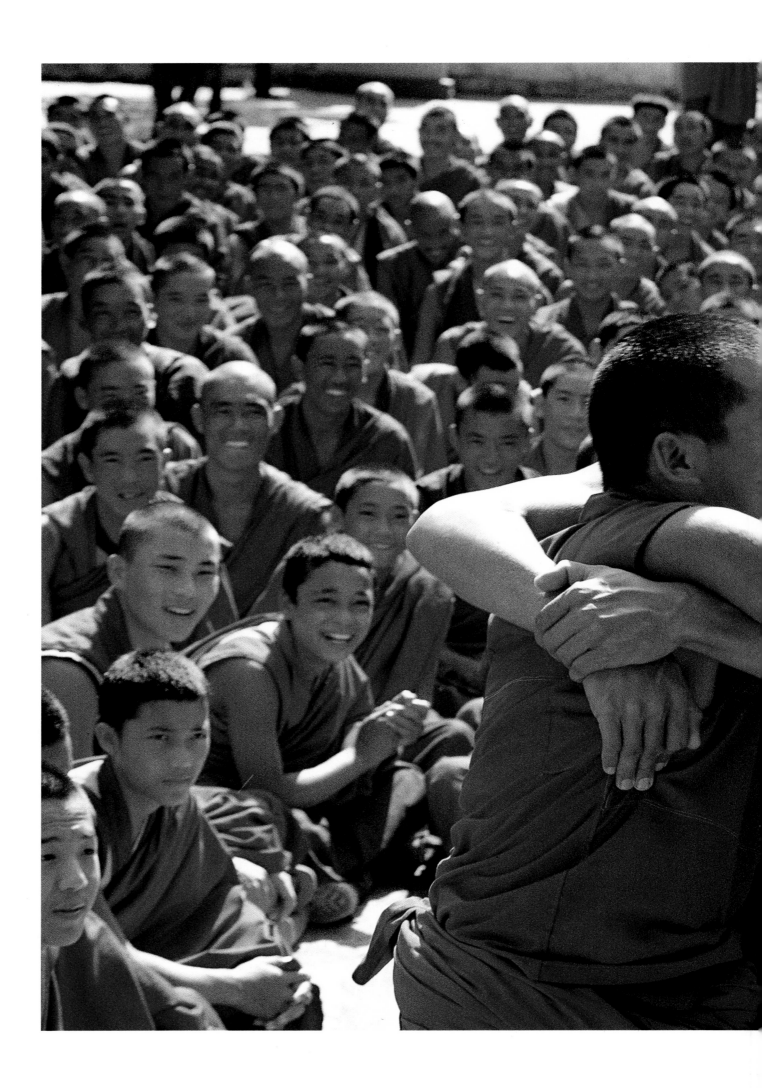

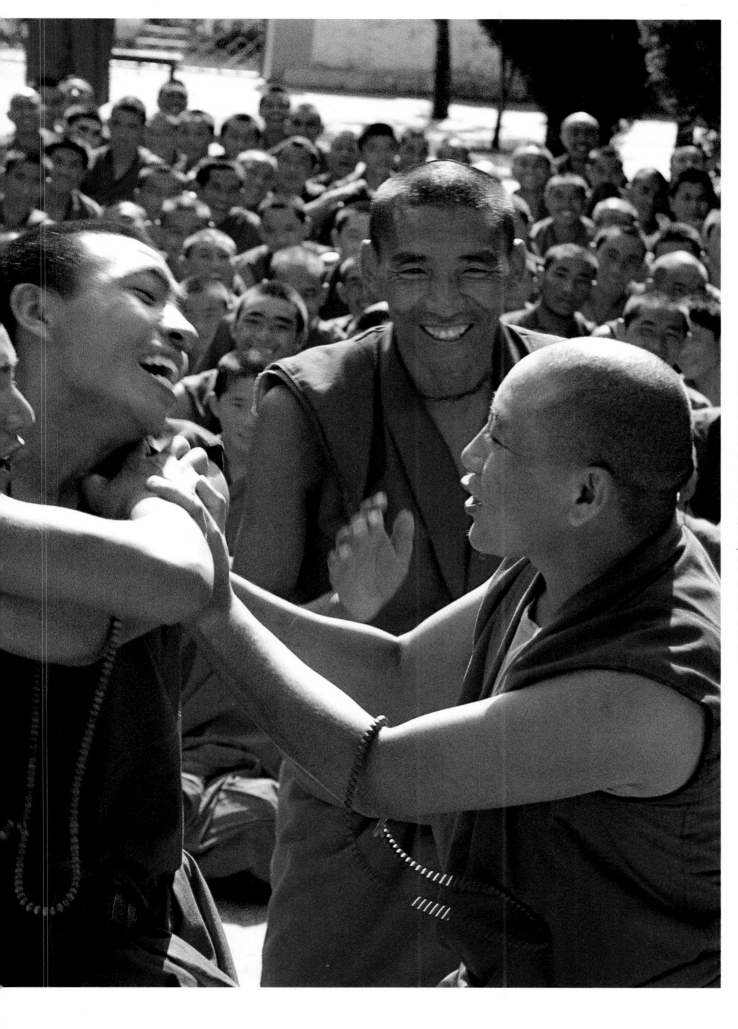

For lively and ambitious monks debate is the highlight of the day, a time to let off steam and pit wits against their classmates. After long sessions spirits still run high. Overleaf A geshe, or doctor of divinity, explains the lives of the Indian pandits to young monks. Since these Indian gurus from earliest Buddhist times developed the dharma's complex theories of mind and existence, they are held in great reverence by religious-minded Tibetans.

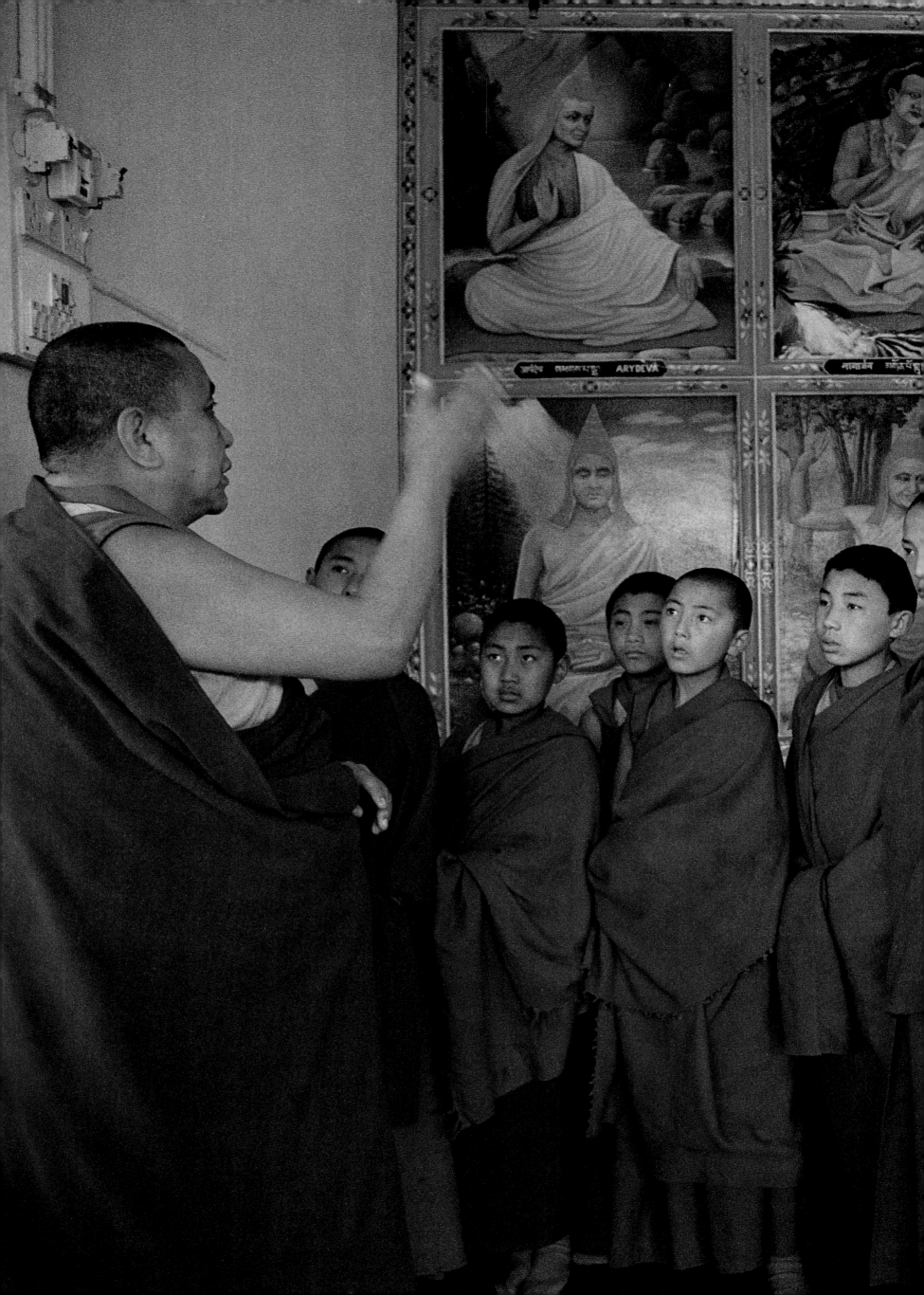

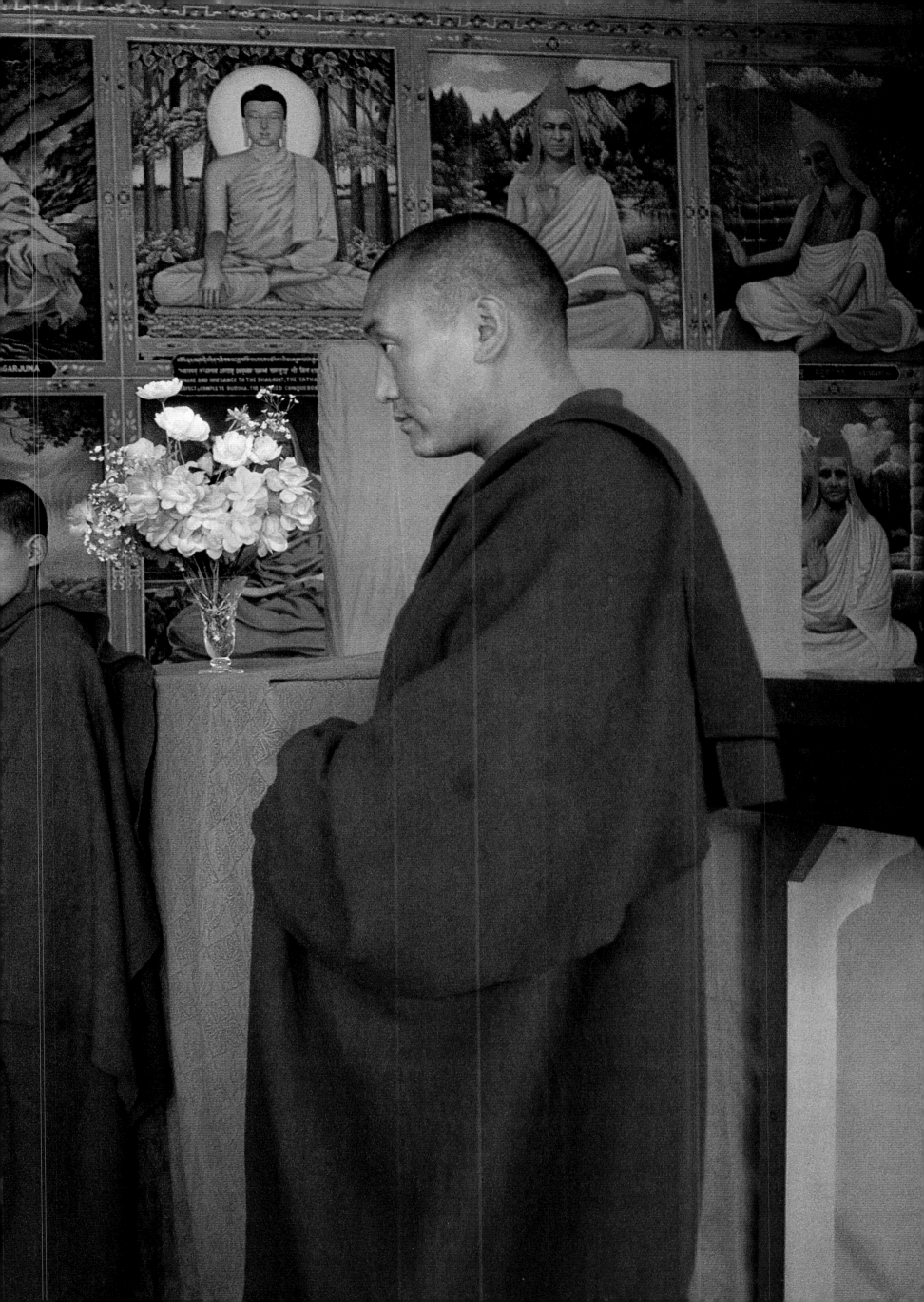

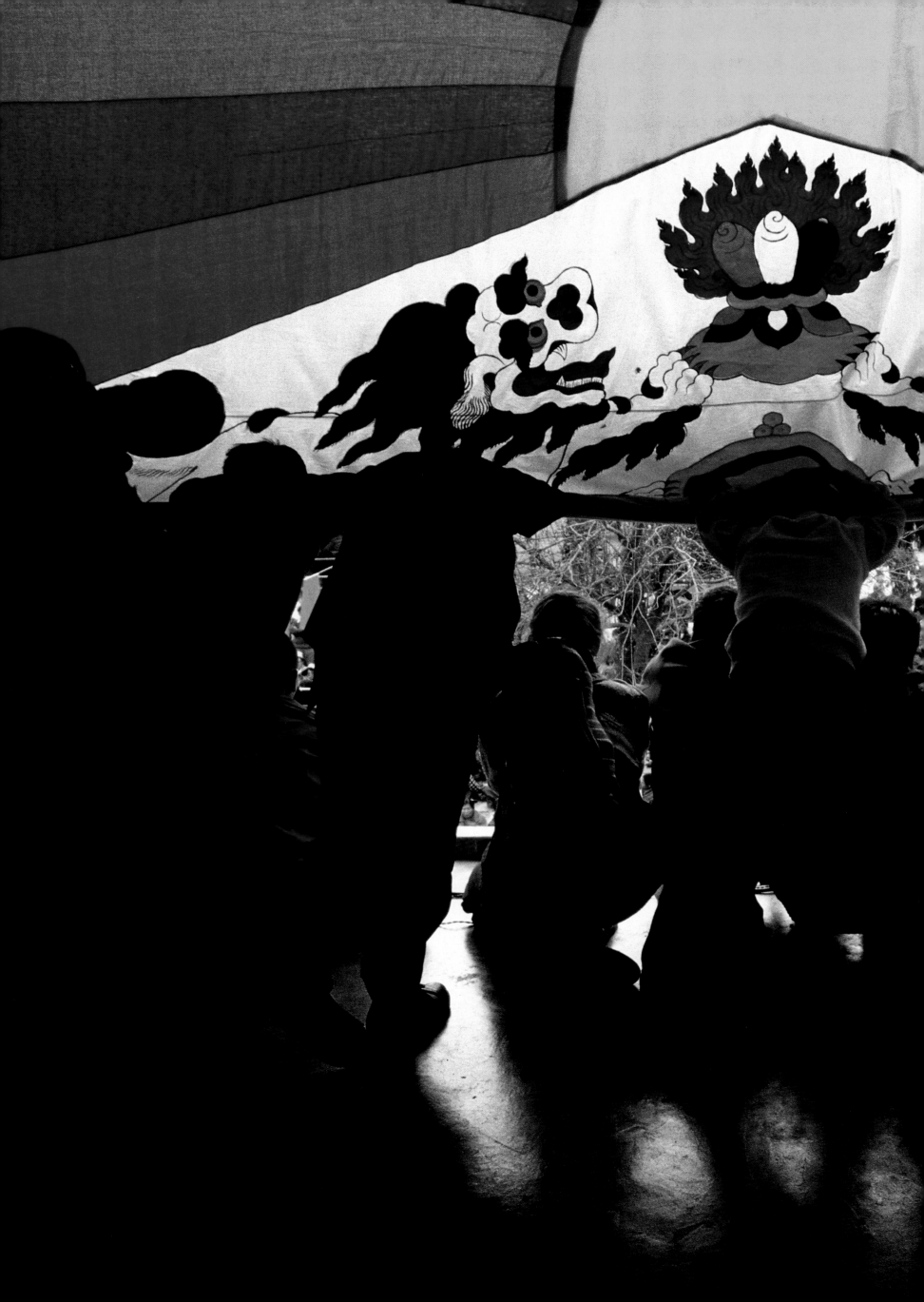

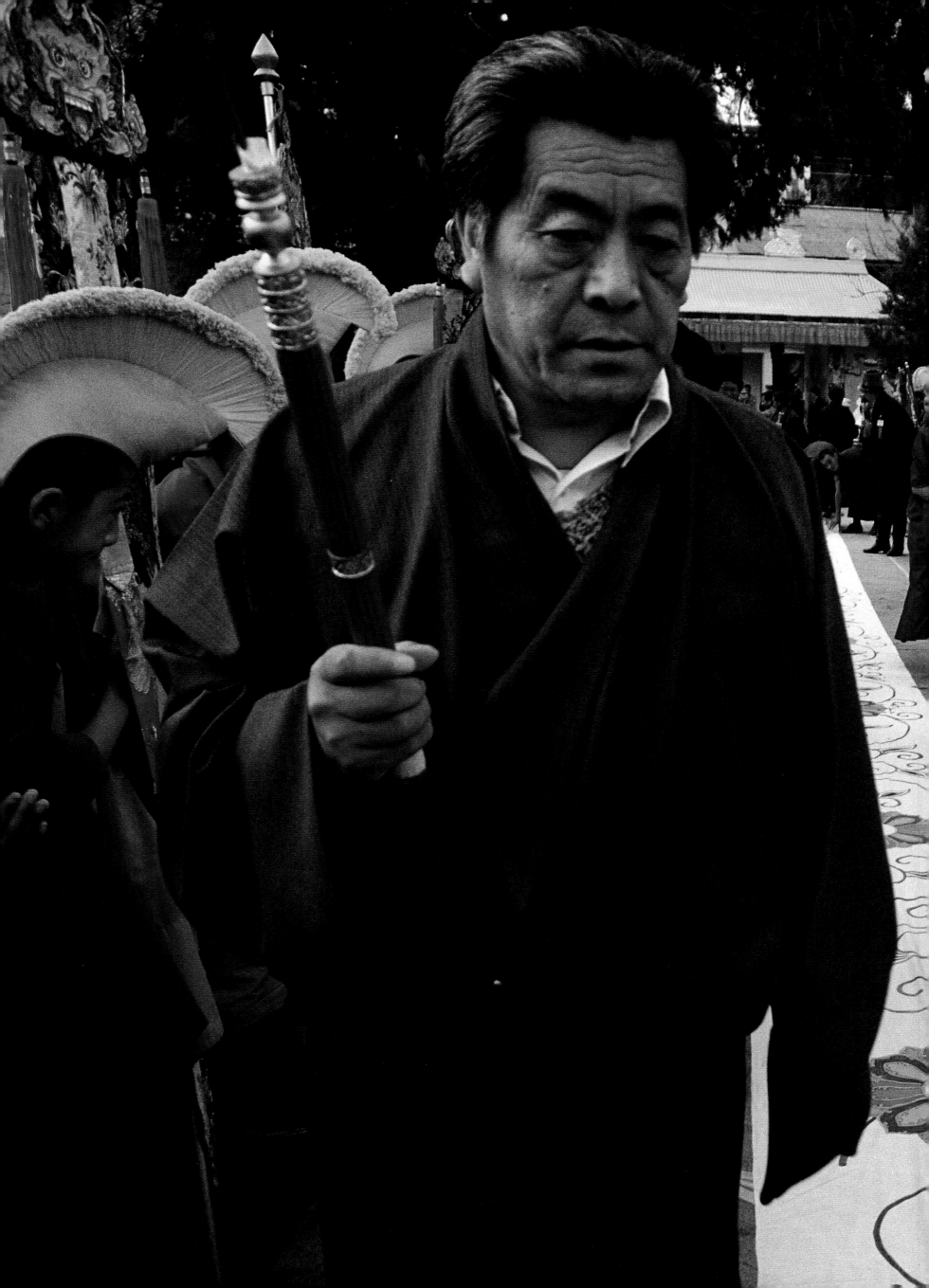

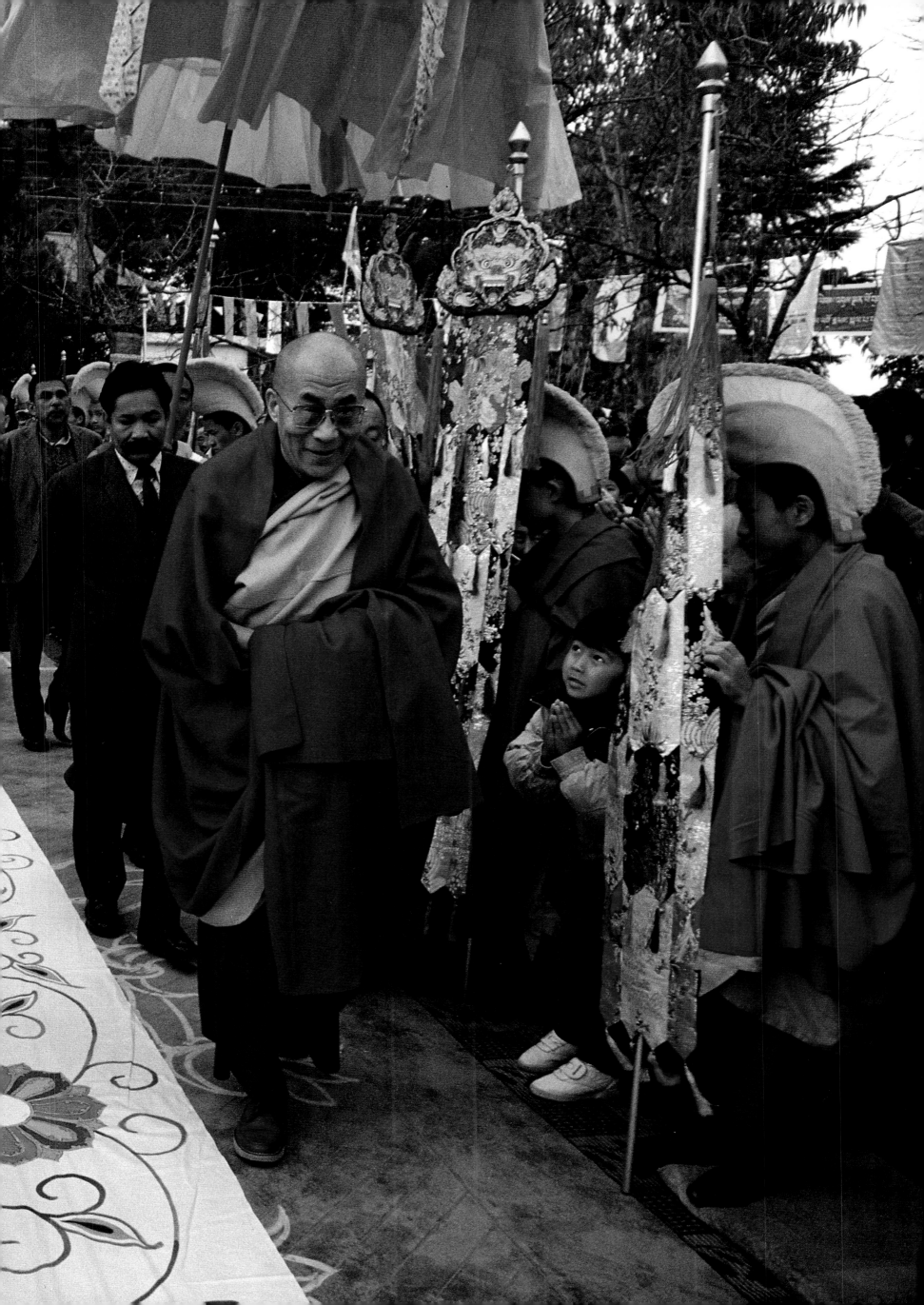

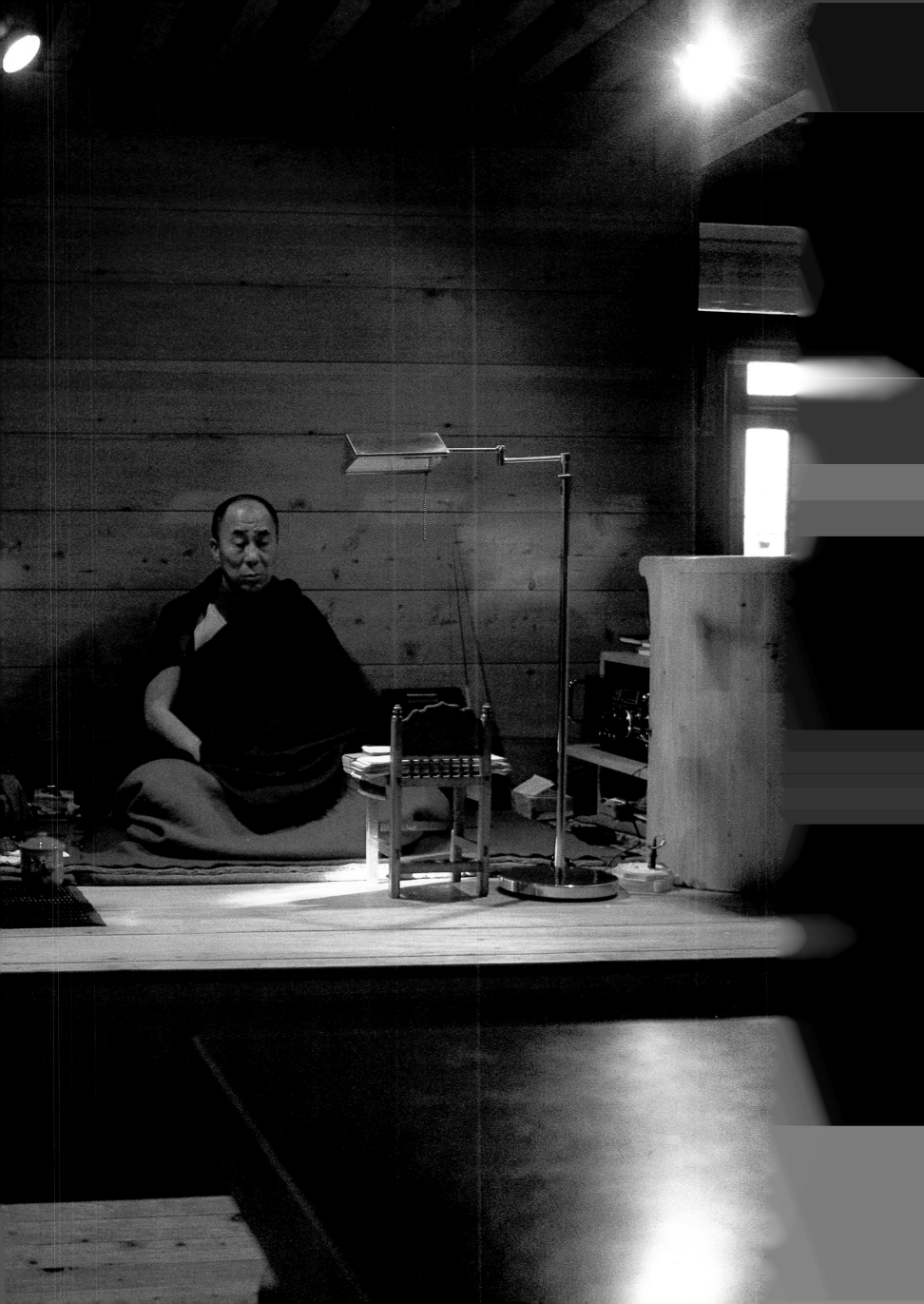

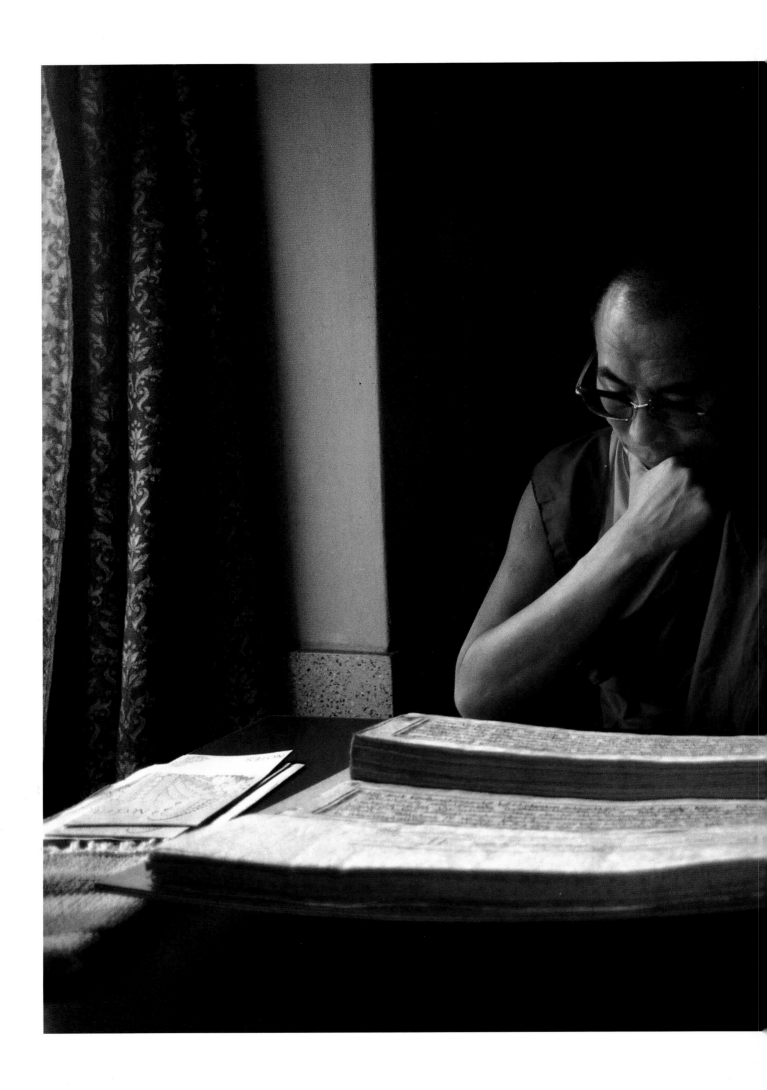

Left and
previous pages *The
Dalai Lama views the
loss of his palatial
homes in Lhasa
without regret. He
believes the simple
life is more
appropriate for a
monk. After three
hours of meditation
each morning, from
6a.m., he spends
a further three hours
reading* pejas, *or
loose-leaved religious
texts. Although his
personal lifestyle is
frugal, and his
possessions
utilitarian, when the
Dalai Lama performs
ceremonies - or
his people honour
him - all the
ritual splendour of
past Tibet is re-
enacted in exile.*

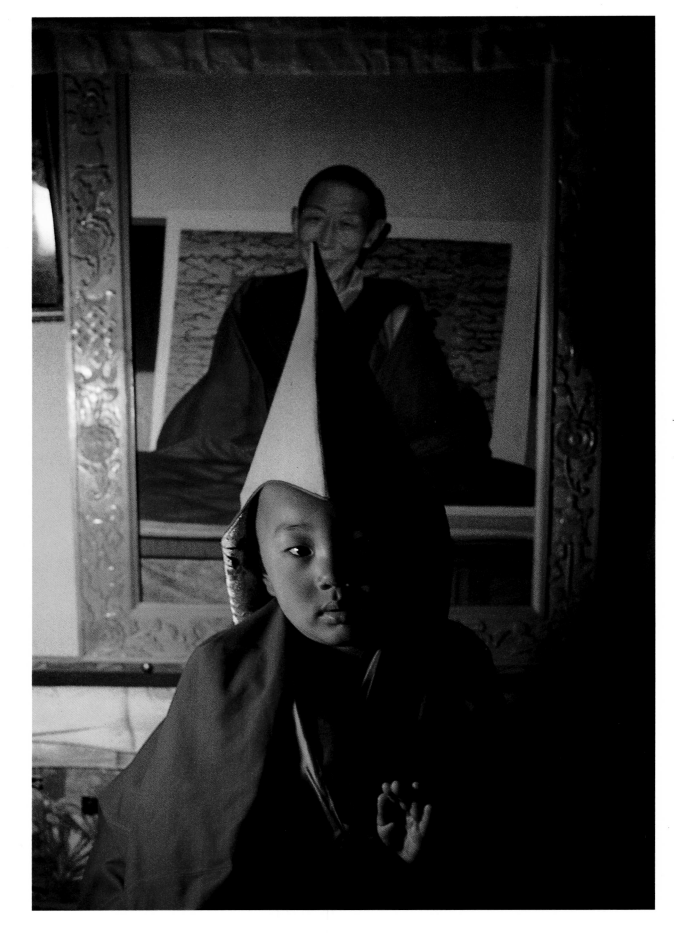

*When the
new incarnation of
Kyabje Trijang
Rinpoche, the Dalai
Lama's late Junior
Tutor, was found in
a refugee family in
1985, traditional
forms of divination
were used to confirm
his identity. Opposite
At a ceremony in
the central cathedral
all attention focuses
on the Dalai Lama.*

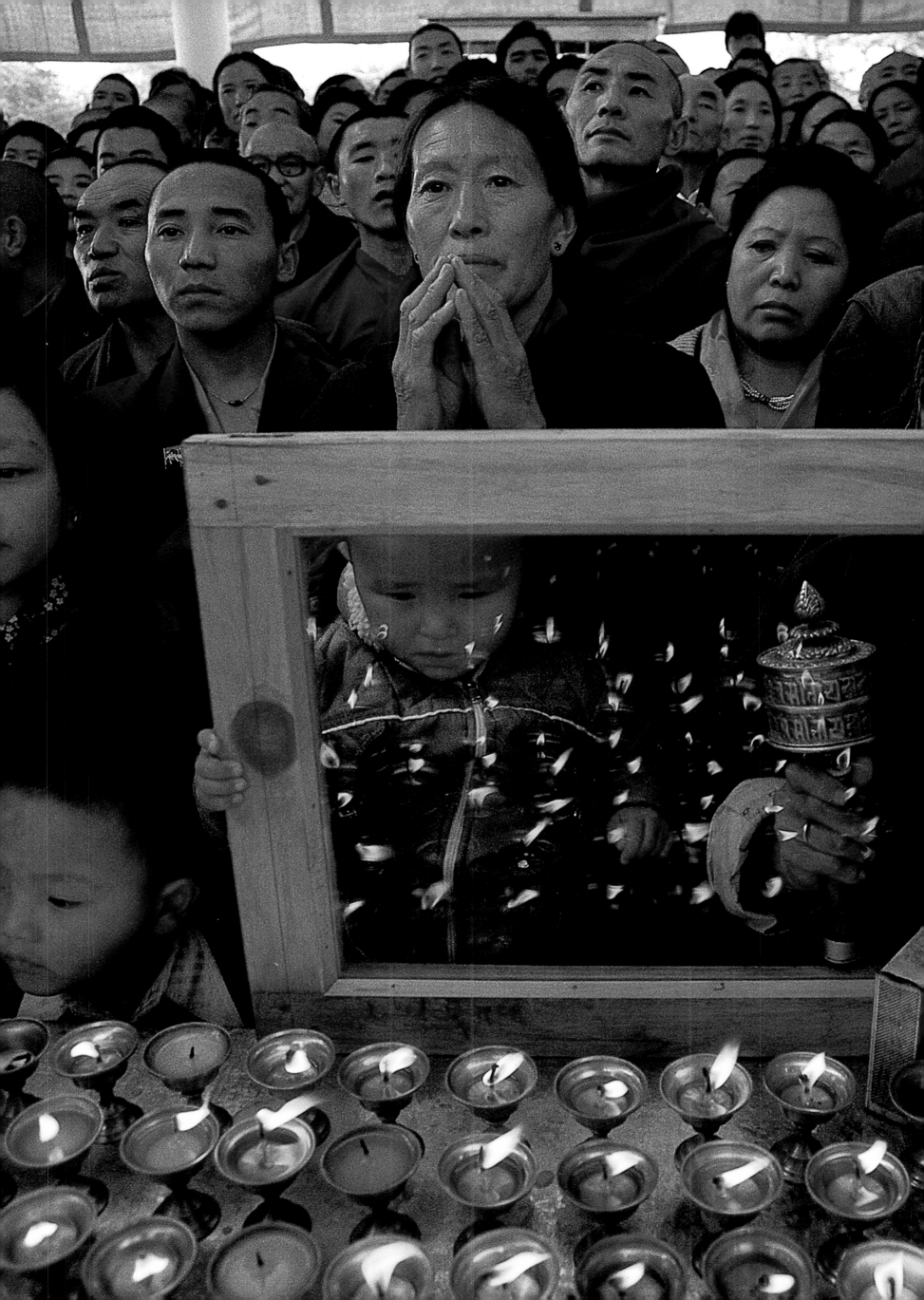

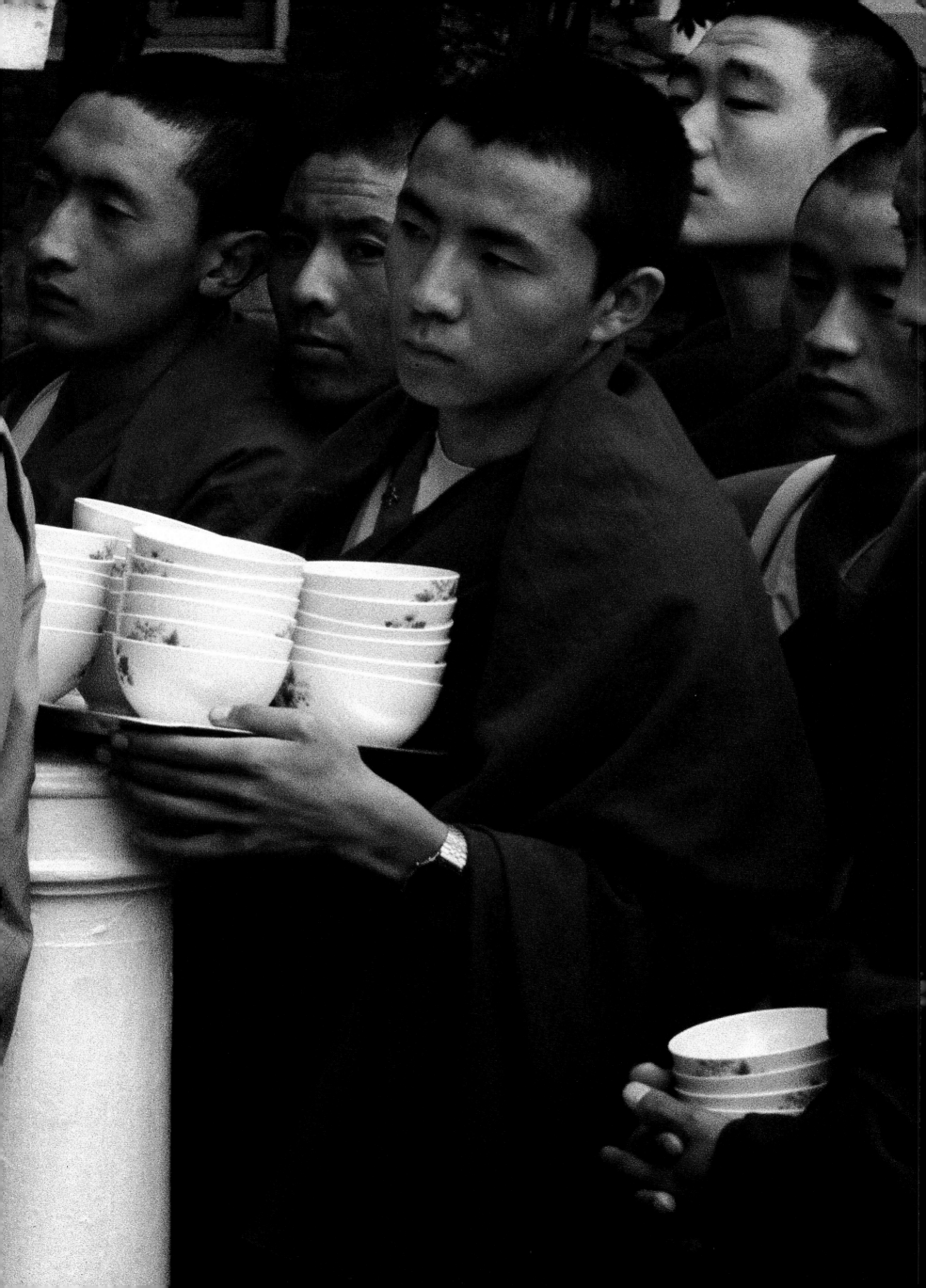

Members of the Dalai Lama's Tibetan bodyguard. Bottom *Doctor Tenzin Choedak, the Dalai Lama's Senior Physician, who spent seventeen years in Chinese prisons and labour camps.* Previous page *Monks from Namgyal, the Dalai Lama's personal monastery, wait to serve Tibetan salted tea during a* puja *inside the main cathedral.* Opposite *For thirty years Dharamsala has been home for the Fourteenth Dalai Lama and the headquarters of his government-in-exile. The community and institutions that have grown up around him have earned the township the sobriquet "Little Lhasa".*

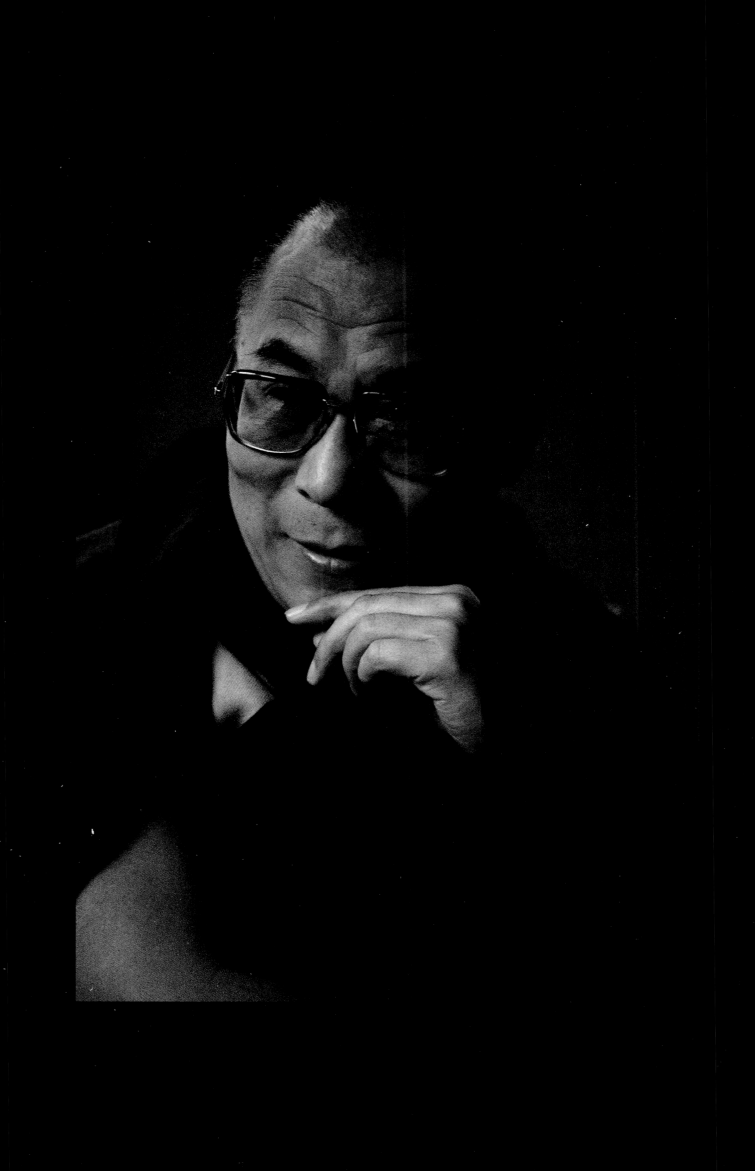

S ince religion pervades every aspect of Tibetan life, even lay celebrations are often held at religious locations. Here, middle-ranking men from the Dharamsala government-in-exile celebrate the Dalai Lama's Nobel Peace Prize in the central cathedral precincts. Following pages *The central cathedral, Namgyal Monastery and the Dalai Lama's neighbouring palace and gardens stand at the southern end of the steep ridge of McLeod Ganj, overlooking the Kangra Valley and the snowy Outer Himalayan range.*

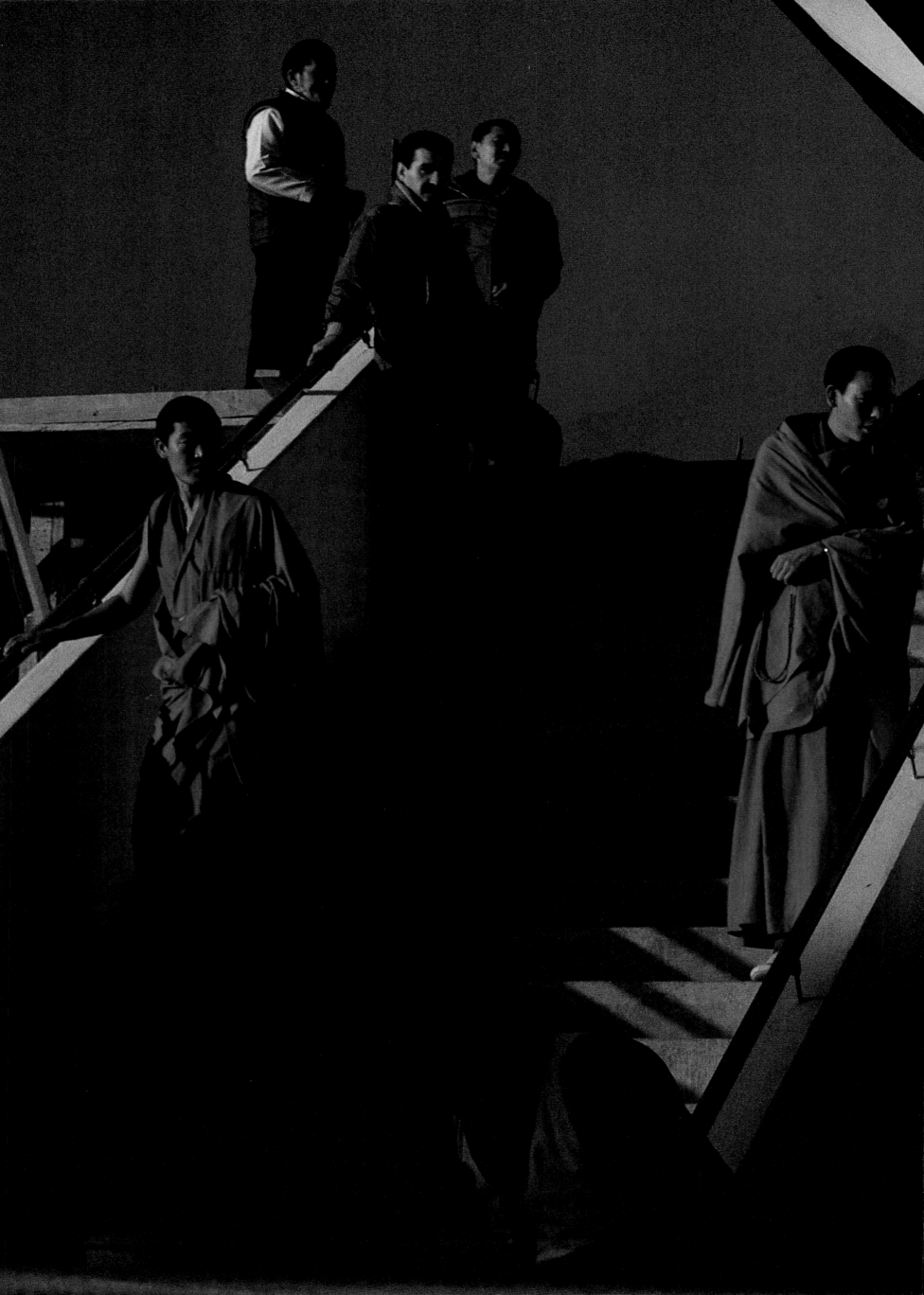

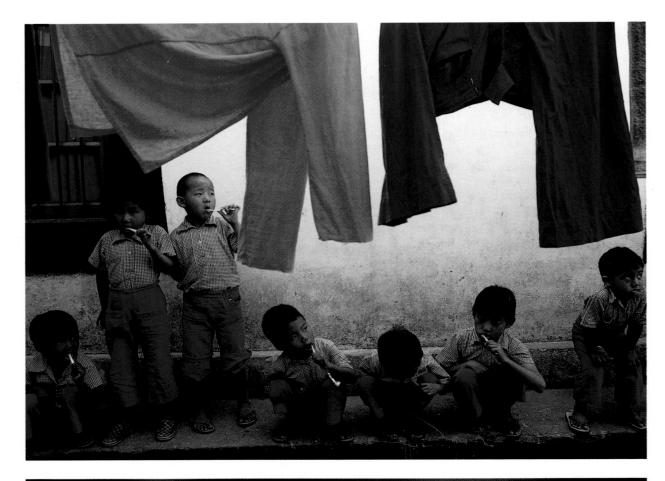

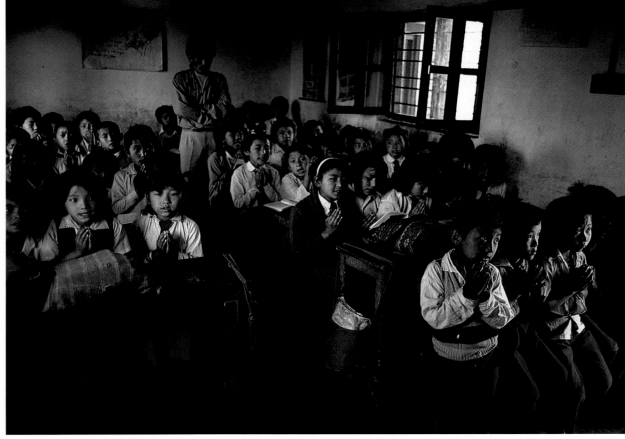

The chance to have a modern education has only come to Tibetan children through exile. Today residential and day schools offer them a solid academic foundation and a high proportion continue to study for degrees. Overleaf Dressed in his best brocade chuba, *this child watches women performing an impromptu dance after a prayer celebration to bring good luck in the New Year.*

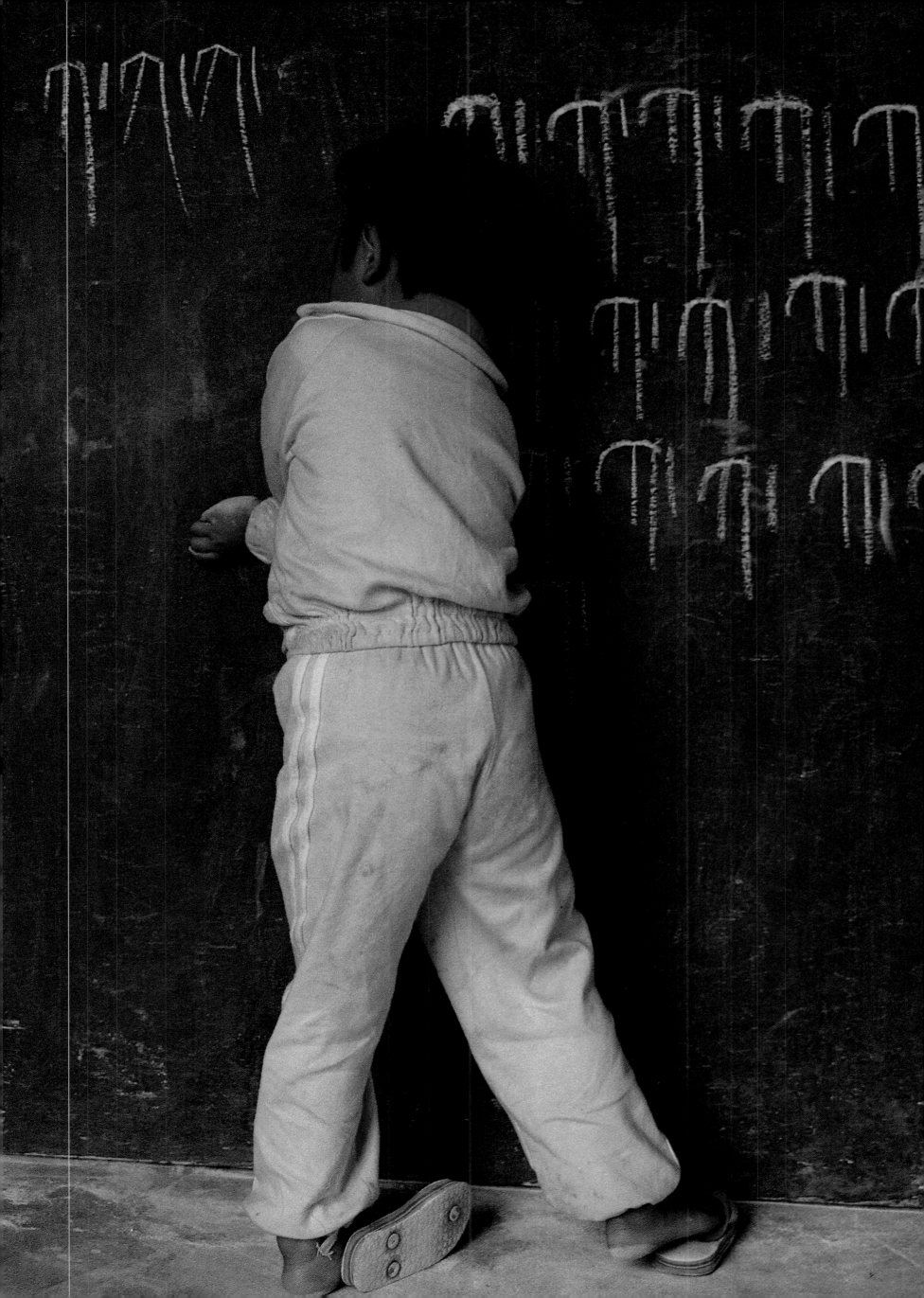

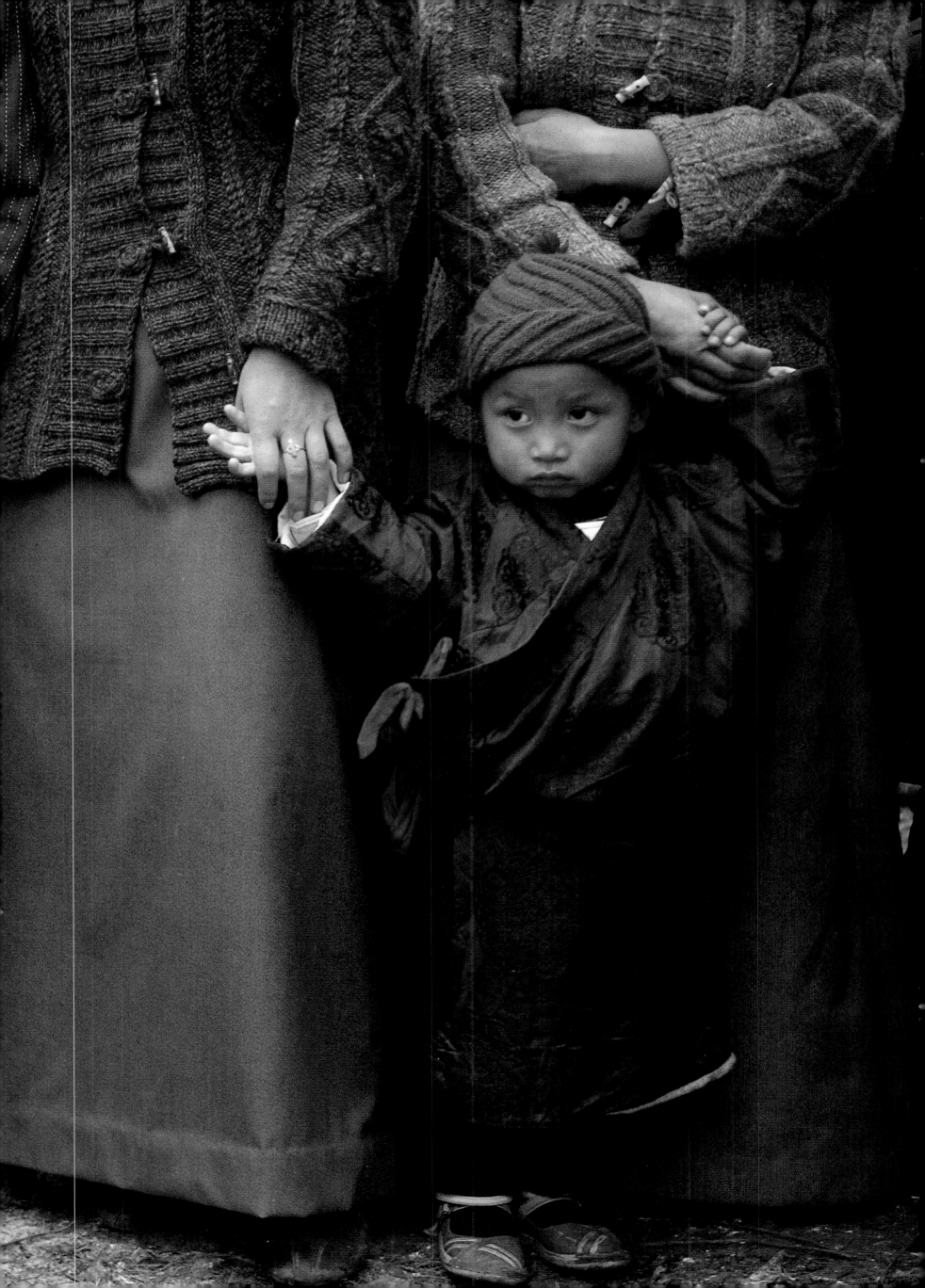

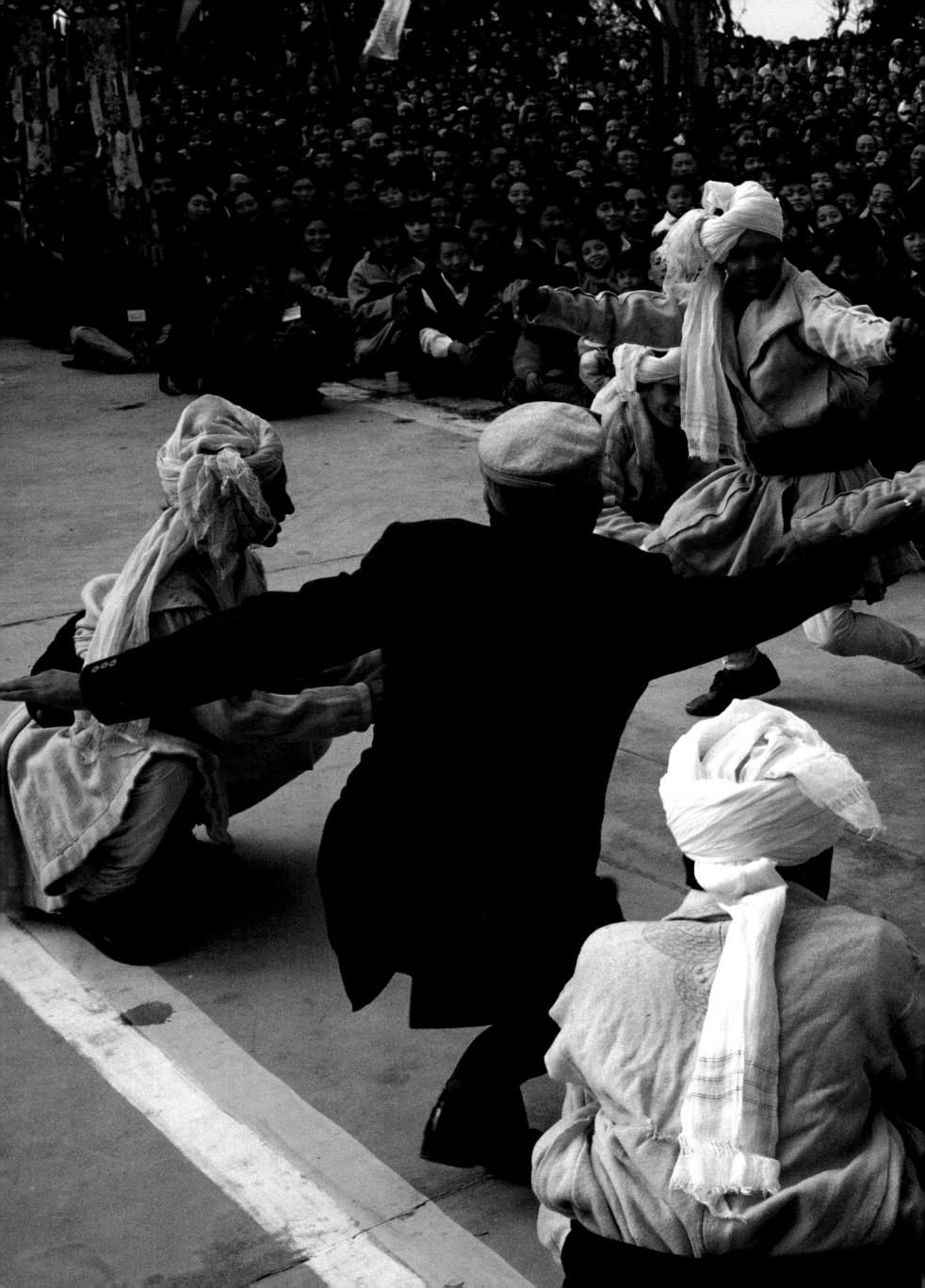

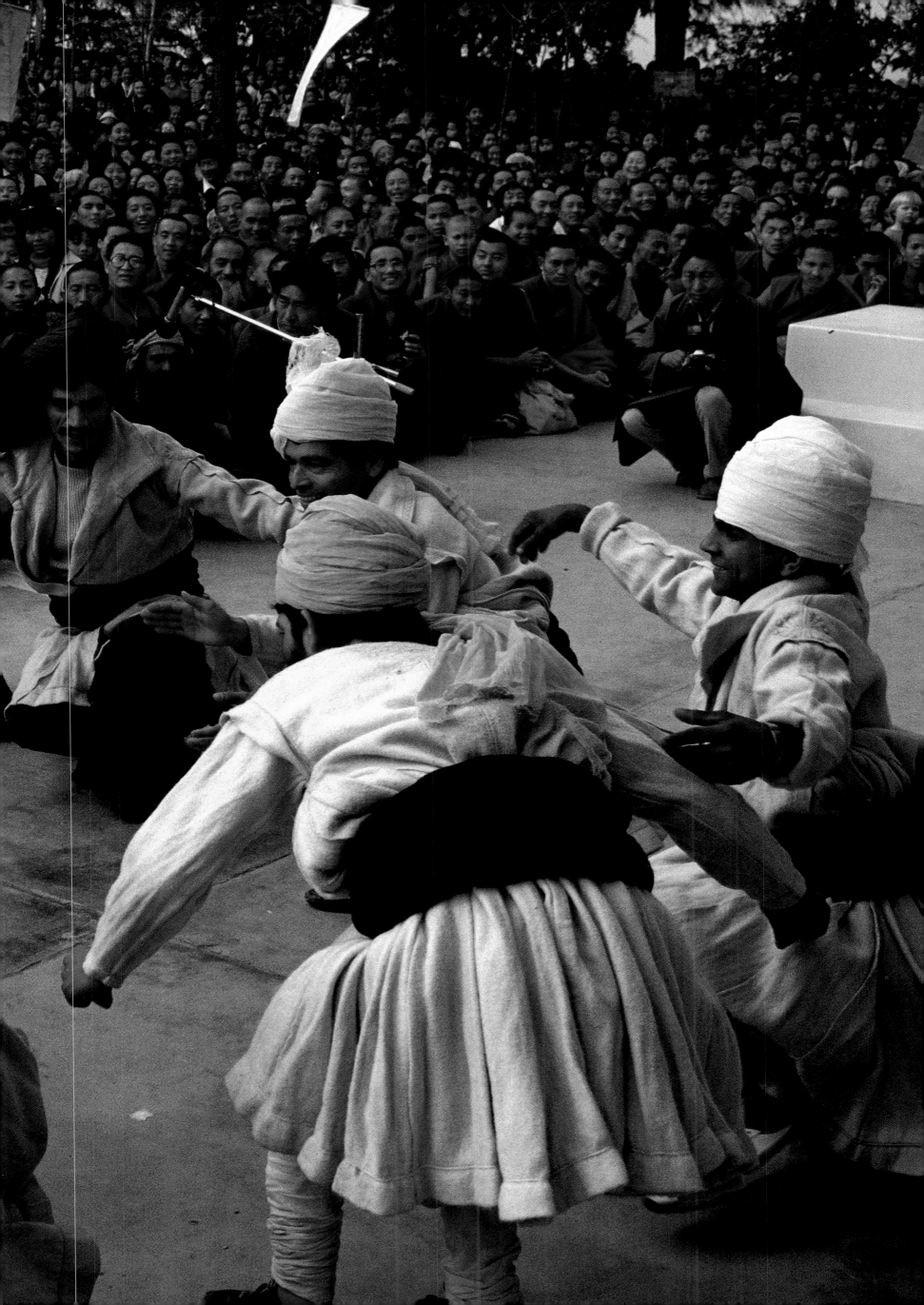

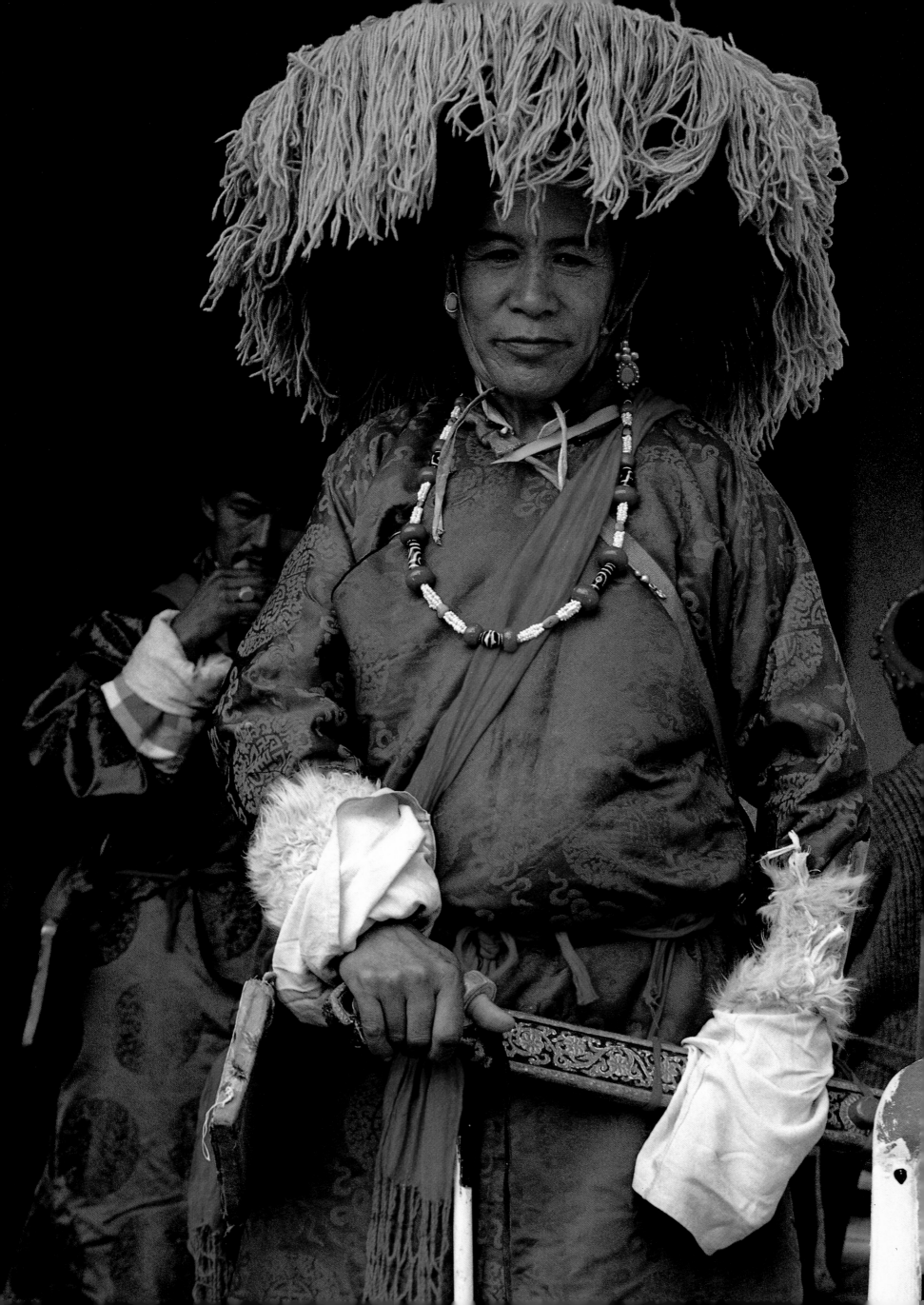

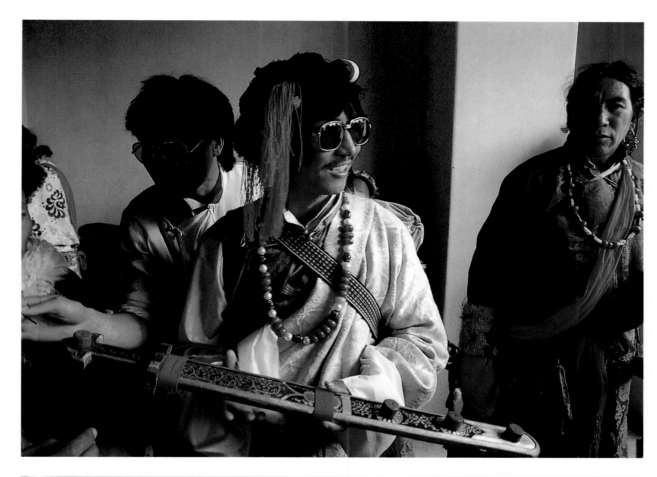

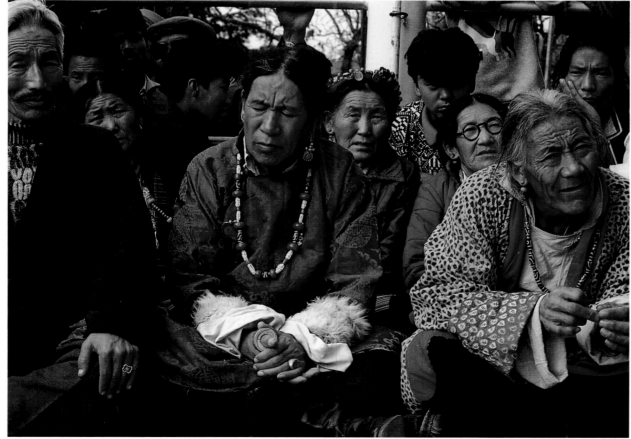

F inery that brings back a semblance of the colour and splendour of lost Tibet. With fake wooden swords representing the gold-chased silver broadswords studded with giant corals and turquoise that were used until the 1950s in Tibet, these men are dressed for a dance performance re-enacting ancient legends. *Previous page During celebrations for the Dalai Lama's return to Dharamsala after receiving the Nobel Peace Prize in December 1989, the local community of Gaddi shepherds dressed up in their best costumes and performed a vigorous dance for the holy man living as a guest in their hills.*

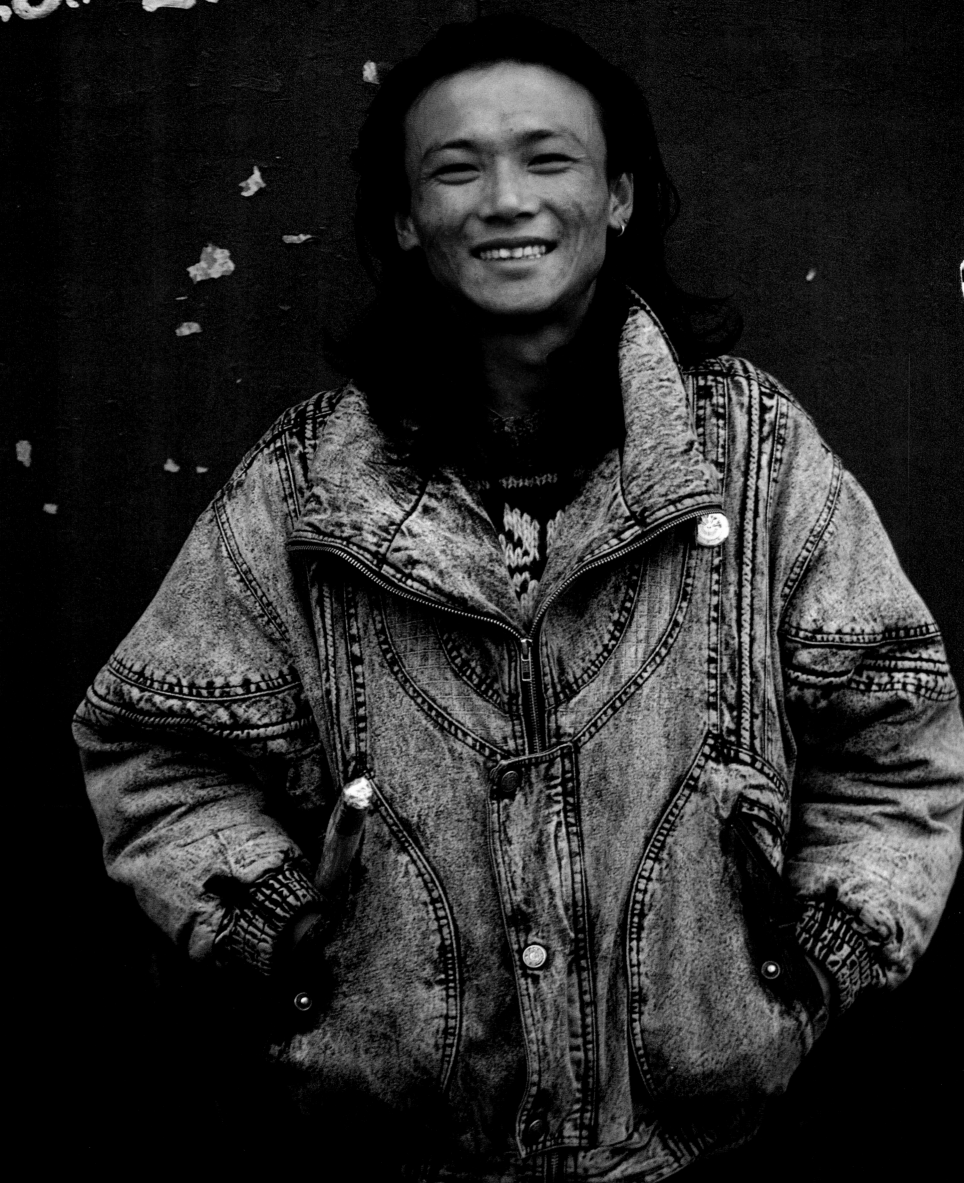

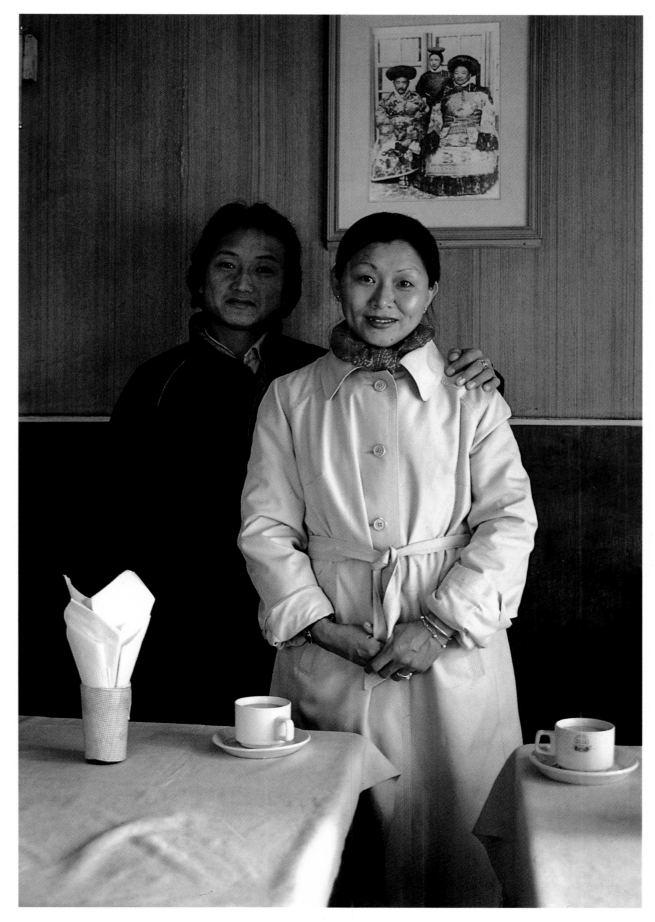

Unlike their bewildered parents, staring with fear at the unfamiliar world presented by India in 1959, young Tibetans raised on the subcontinent have assimilated easily with their modern surroundings. Following pages Tibetan hospitality is legendary and the host is vigilant in keeping his guests' glasses topped to the brim; a former State Thanka Painter, recently released from prison in Tibet, now teaches young students in Dharamsala.

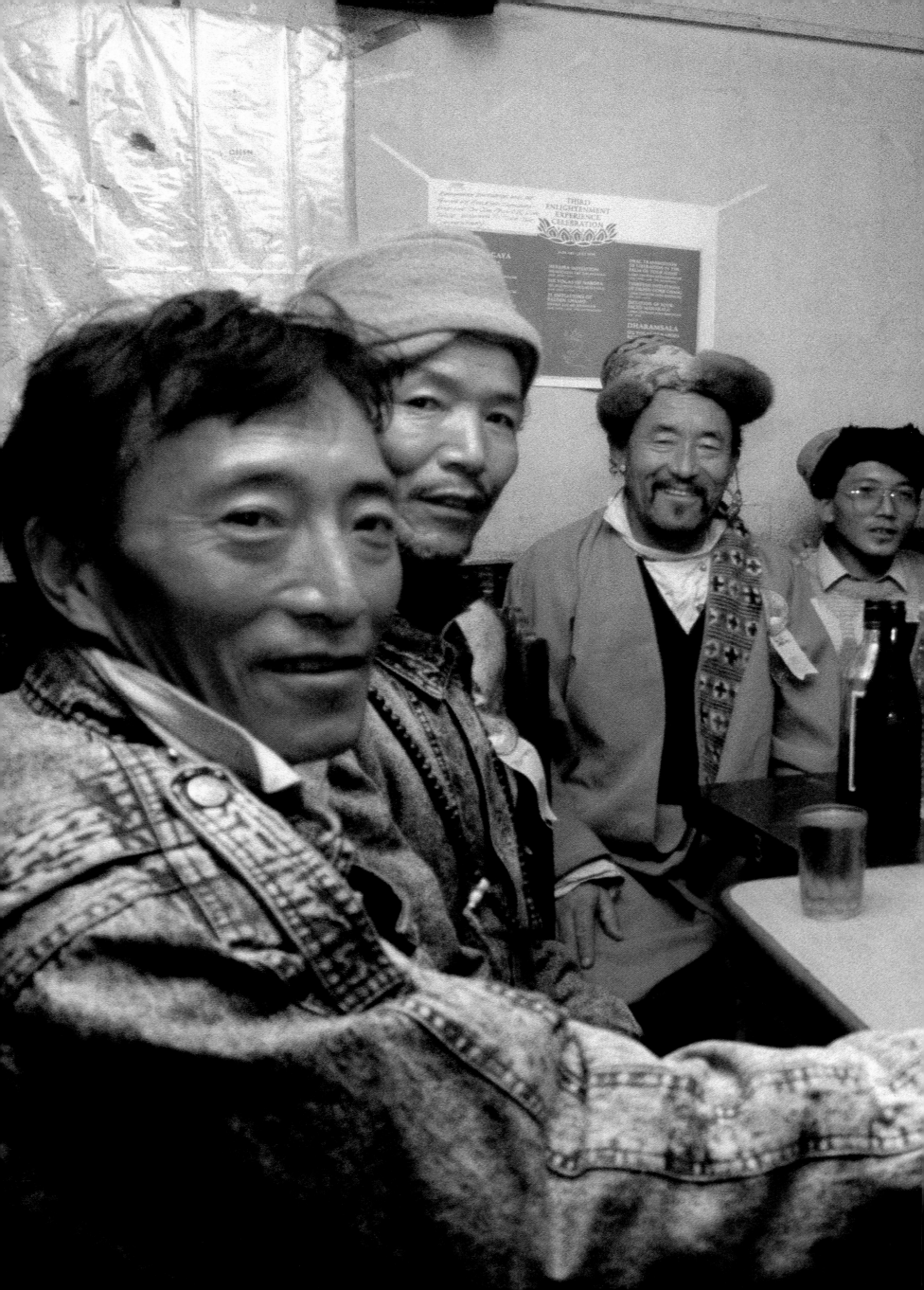

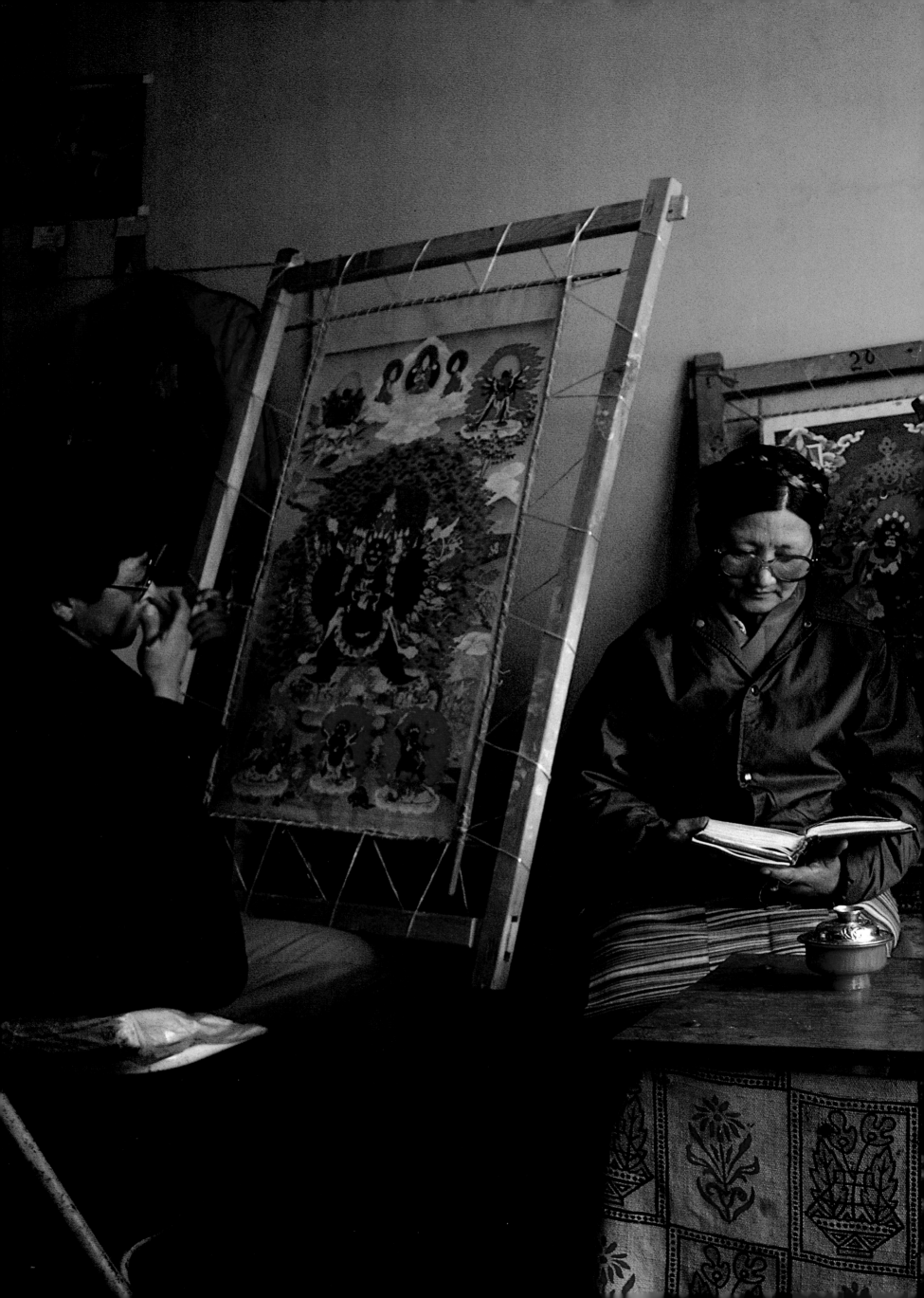

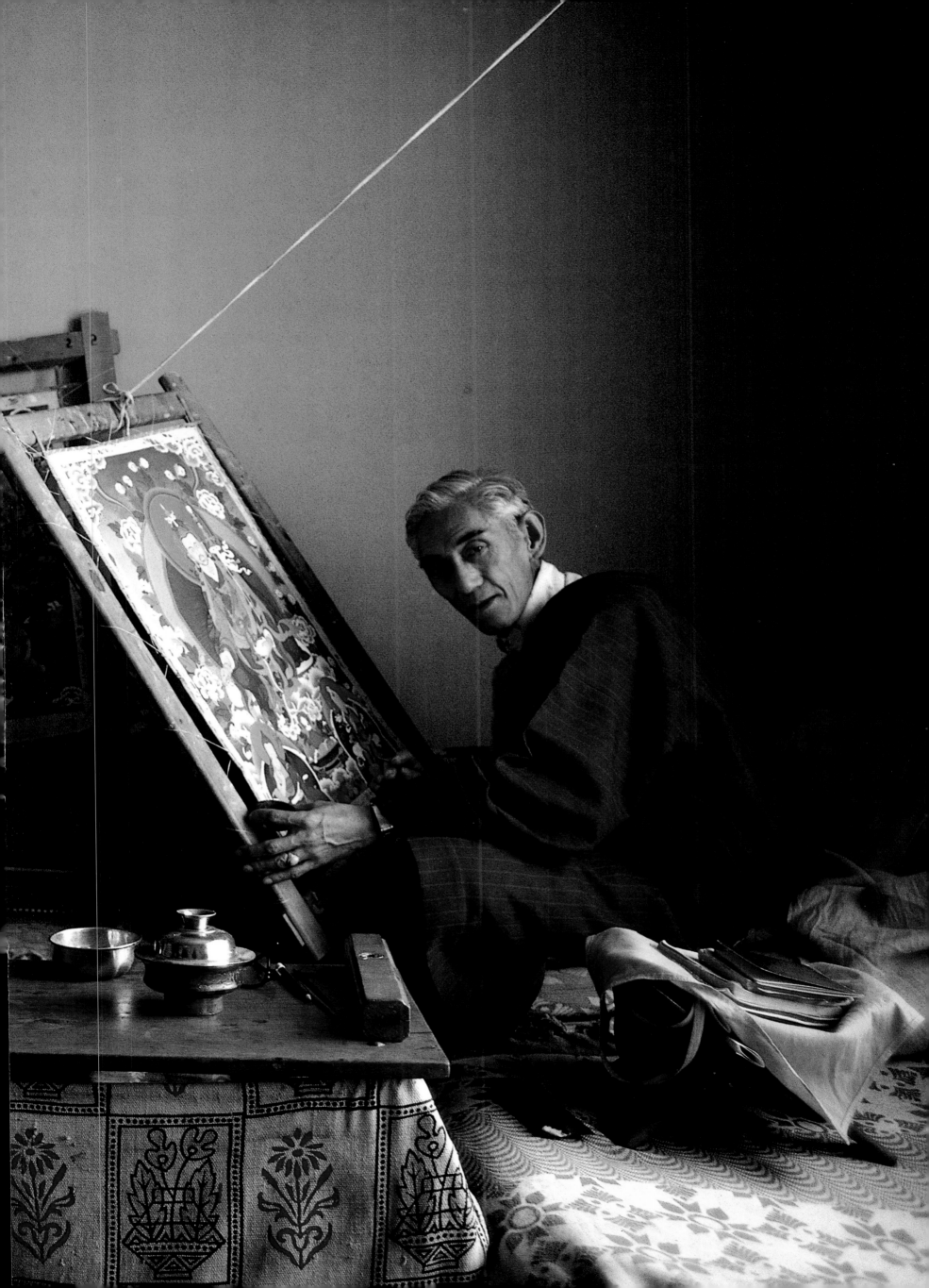

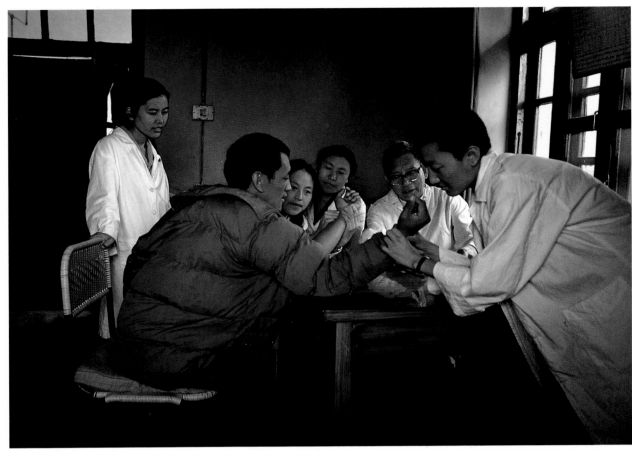

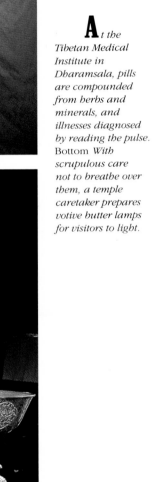

At the Tibetan Medical Institute in Dharamsala, pills are compounded from herbs and minerals, and illnesses diagnosed by reading the pulse. Bottom *With scrupulous care not to breathe over them, a temple caretaker prepares votive butter lamps for visitors to light.*

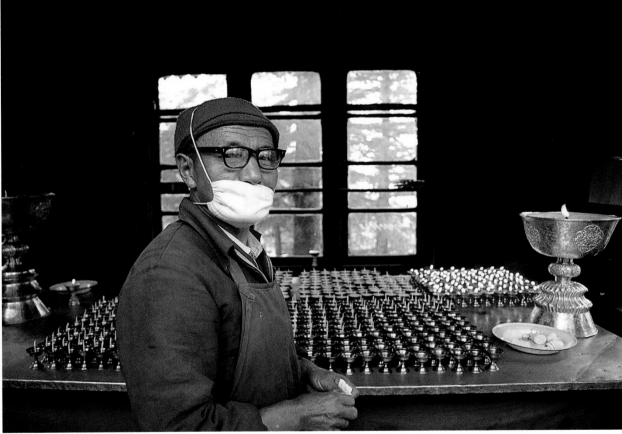

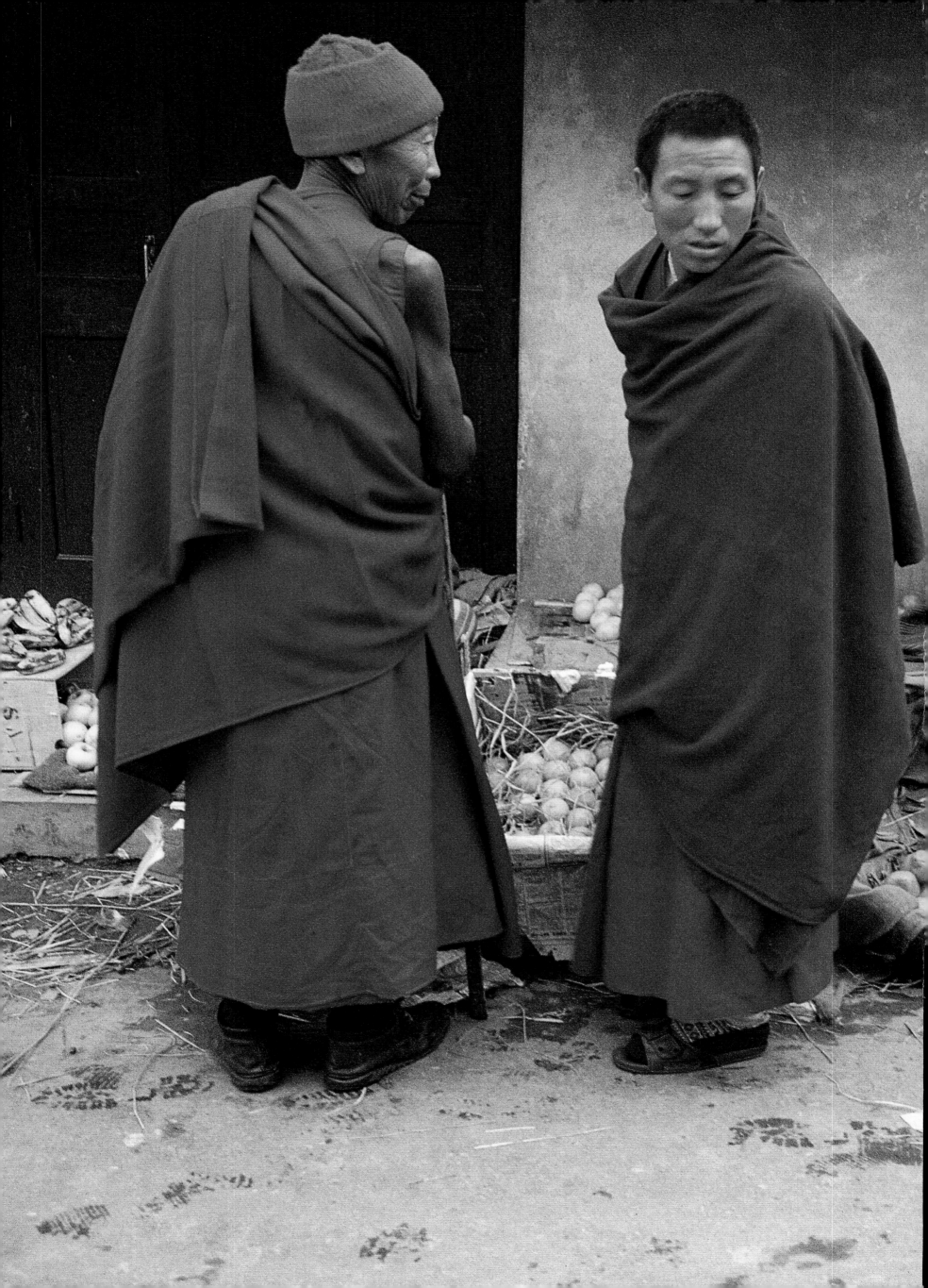

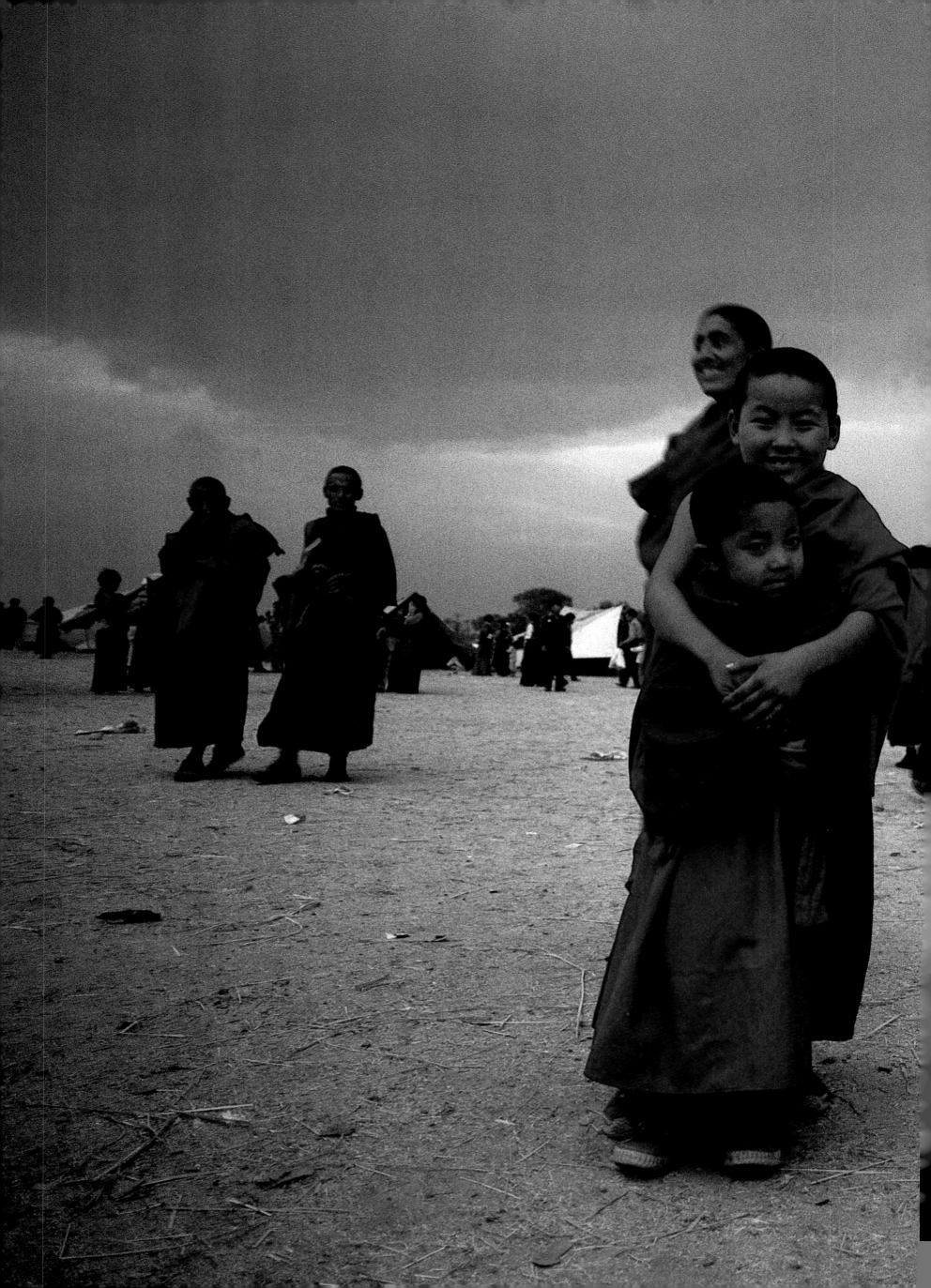

At dawn and dusk, in towns and cities throughout India, Tibetan sweater-sellers transport sacks of clothing to and from their pavement pitches. Bottom *In the south Indian state of Karnataka nearly thirty thousand Tibetans have pioneered as small-scale farmers.* Opposite *The craggy, barren landscape of Ladakh, with its high monasteries and whitewashed mud-brick houses, is often called "Little Tibet".* Previous pages *Three hundred and fifty thousand Himalayan Buddhists converged on Bodhgaya in December 1986 for a Kalachakra initiation; at wayside bazaars in India Tibetans are known to drive a hard bargain.*

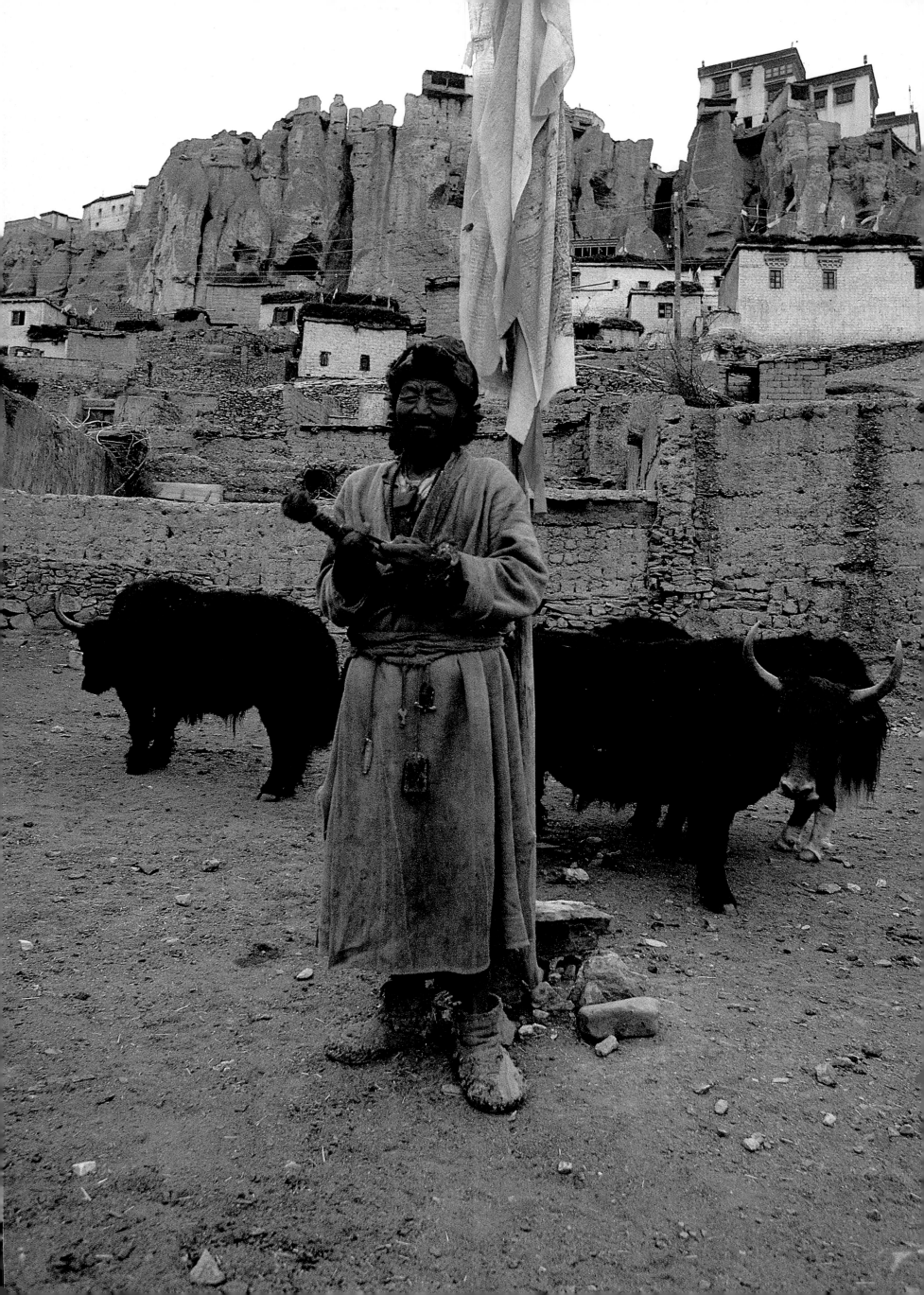

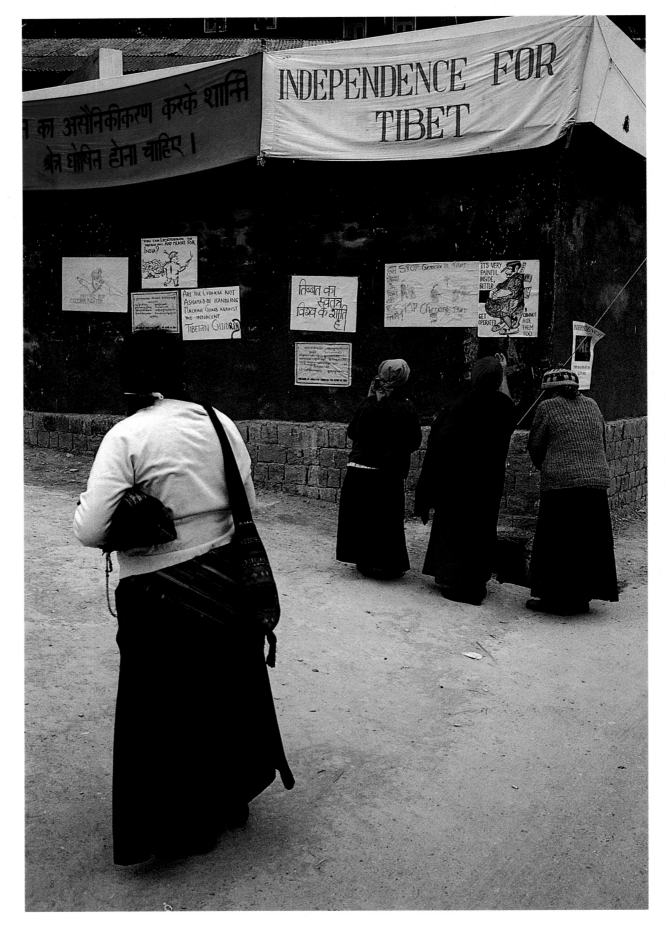

Regular demonstrations and marches with slogans, banners and posters in Tibetan, Hindi and English, keep Tibetans politically aware as well as reaching out to the world for help.

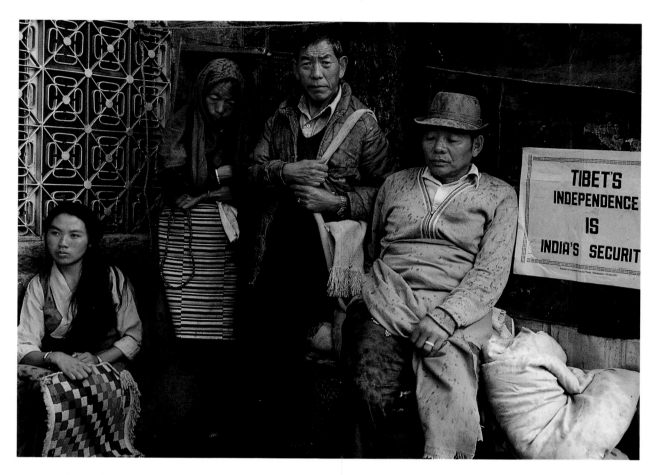

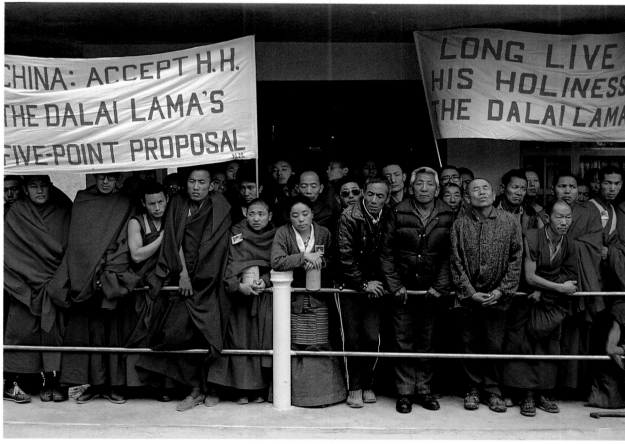

*Overleaf
Monks from the
Institute of Buddhist
Dialectics switch
their energies from
unravelling the
intellectual
intricacies of the
Buddha* dharma
*to condemning
recent political
repression in Tibet.*

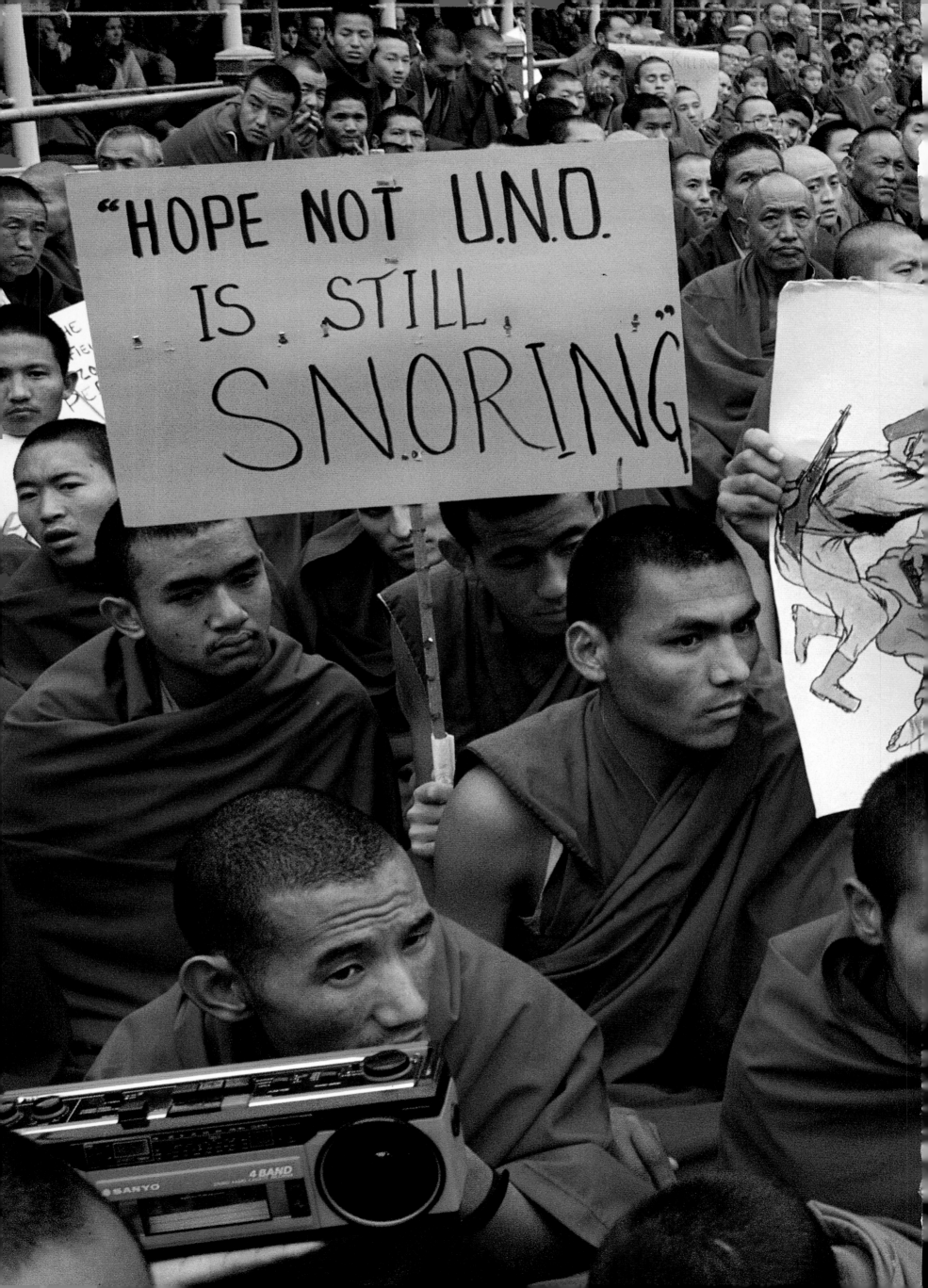

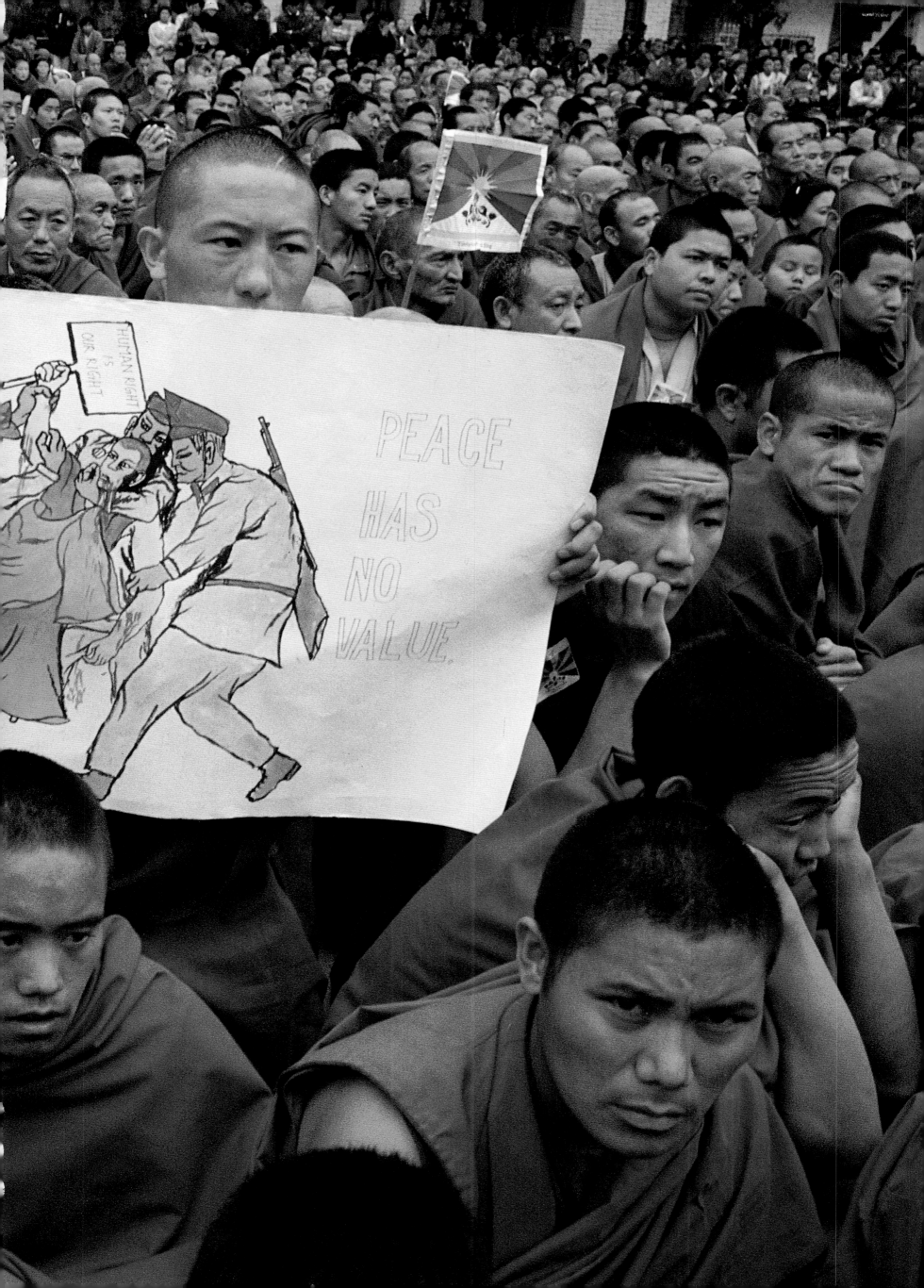

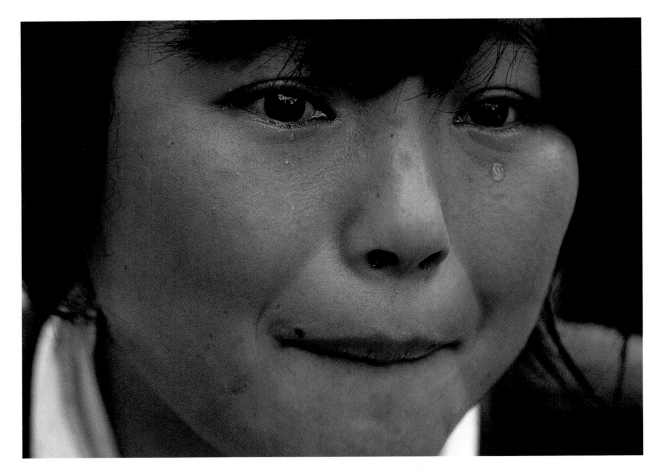

Emotions run high, even among younger, India-born Tibetans, when news of oppression and arrests reaches the exile community. Monks and nuns in India are strongly supportive of their counterparts in Tibet who have been jailed, tortured and shot for leading recent freedom demonstrations.

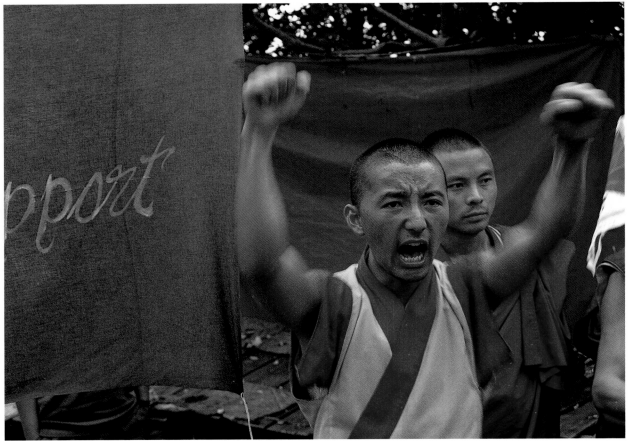

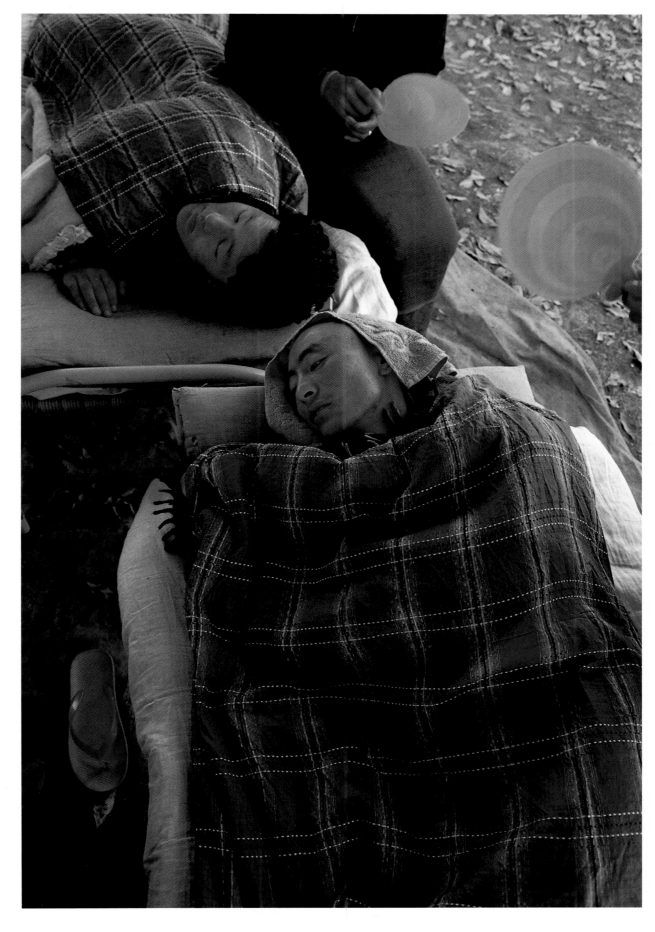

A *"fast-unto-death" in Delhi in May 1988 was halted on the eleventh day by a telegram from the Dalai Lama saying "Taking life is never permissable, including your own". Following pages Sleeping bodies block McLeod Ganj during a twenty-four-hour hunger strike in October 1987; a prisoner's jacket stitched from shreds of rags, and the blood-stained shirts of demonstrators shot in Lhasa, were smuggled to India and displayed at the March 10, 1989 rally in Dharamsala.*

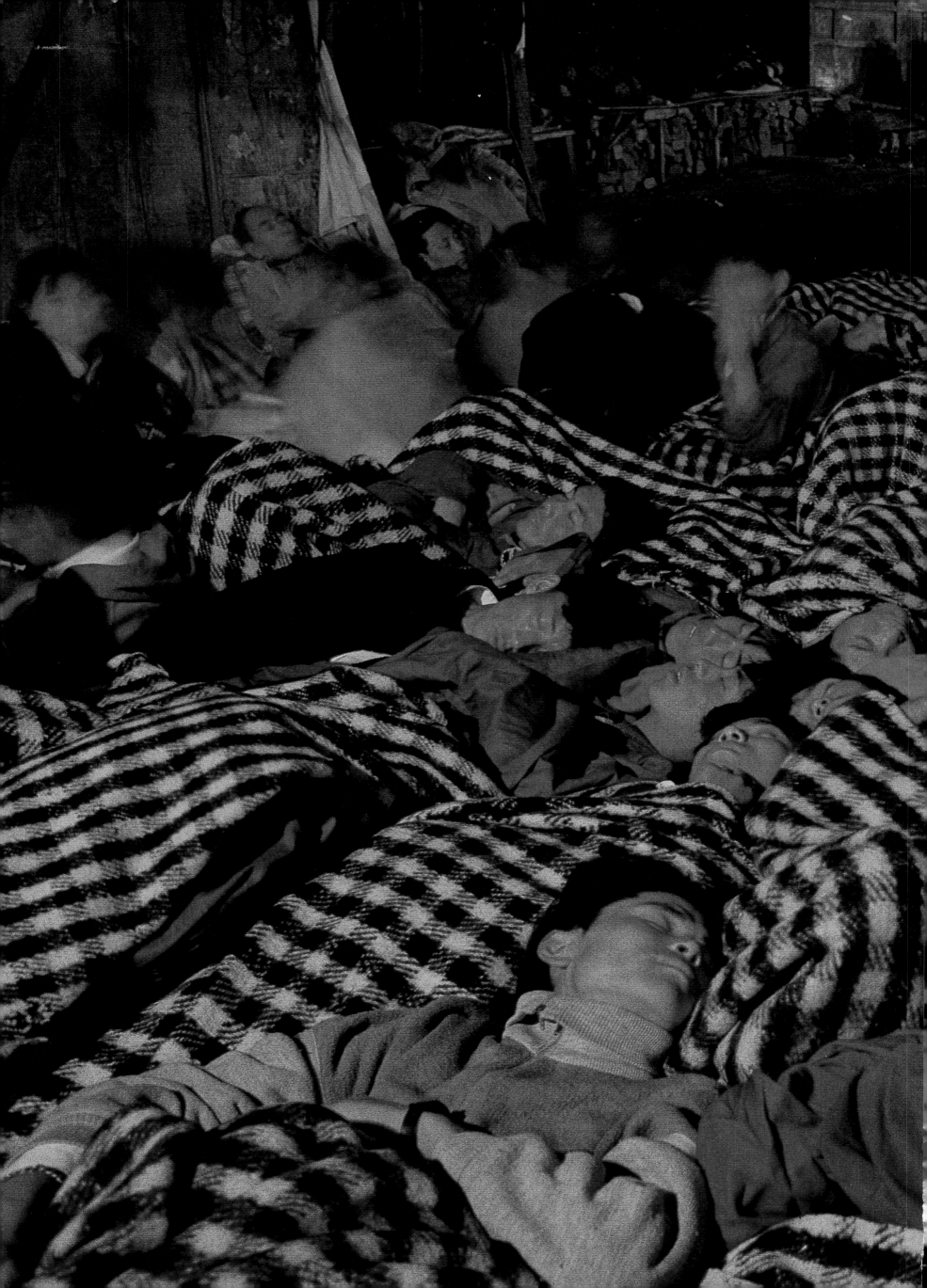

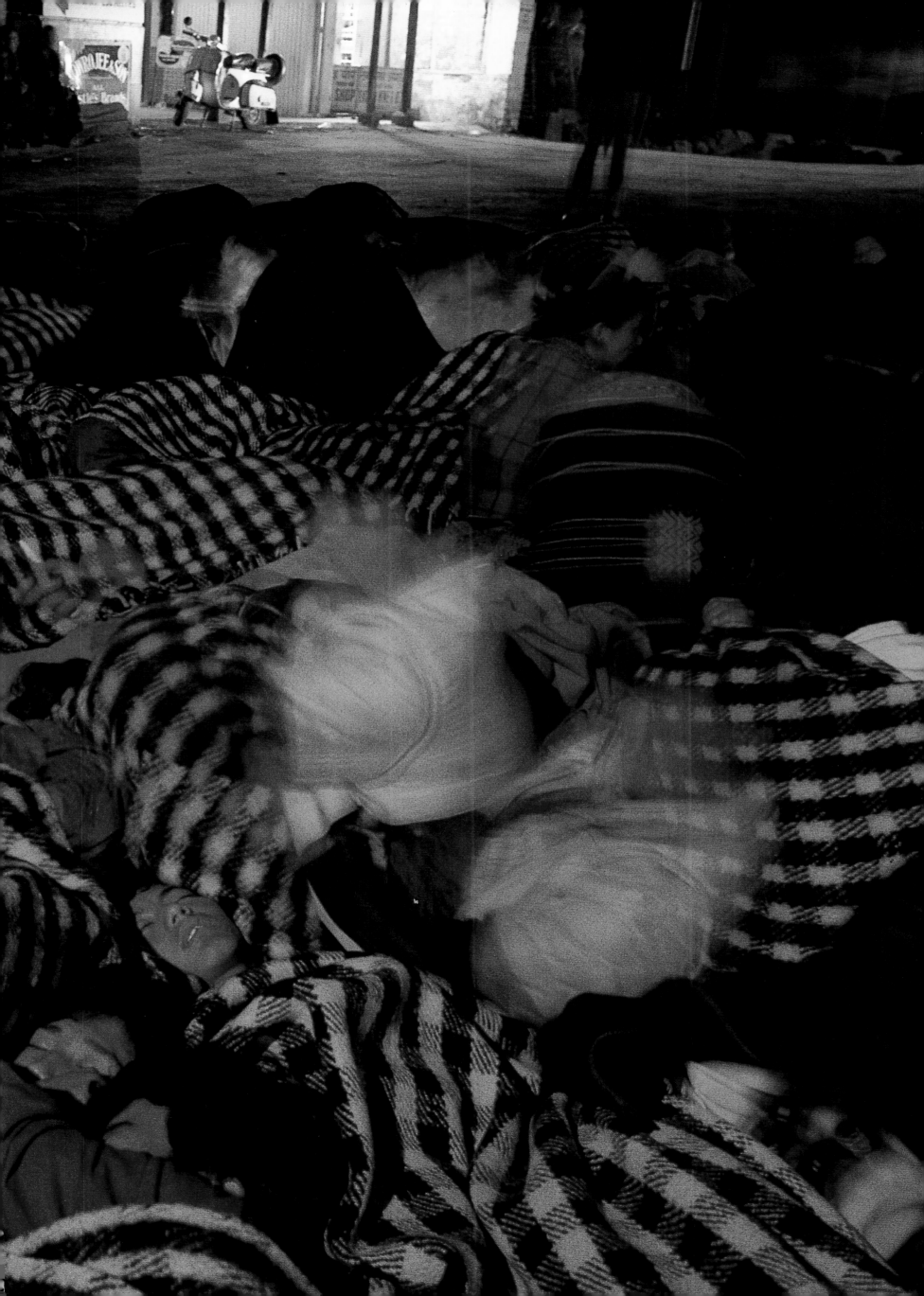

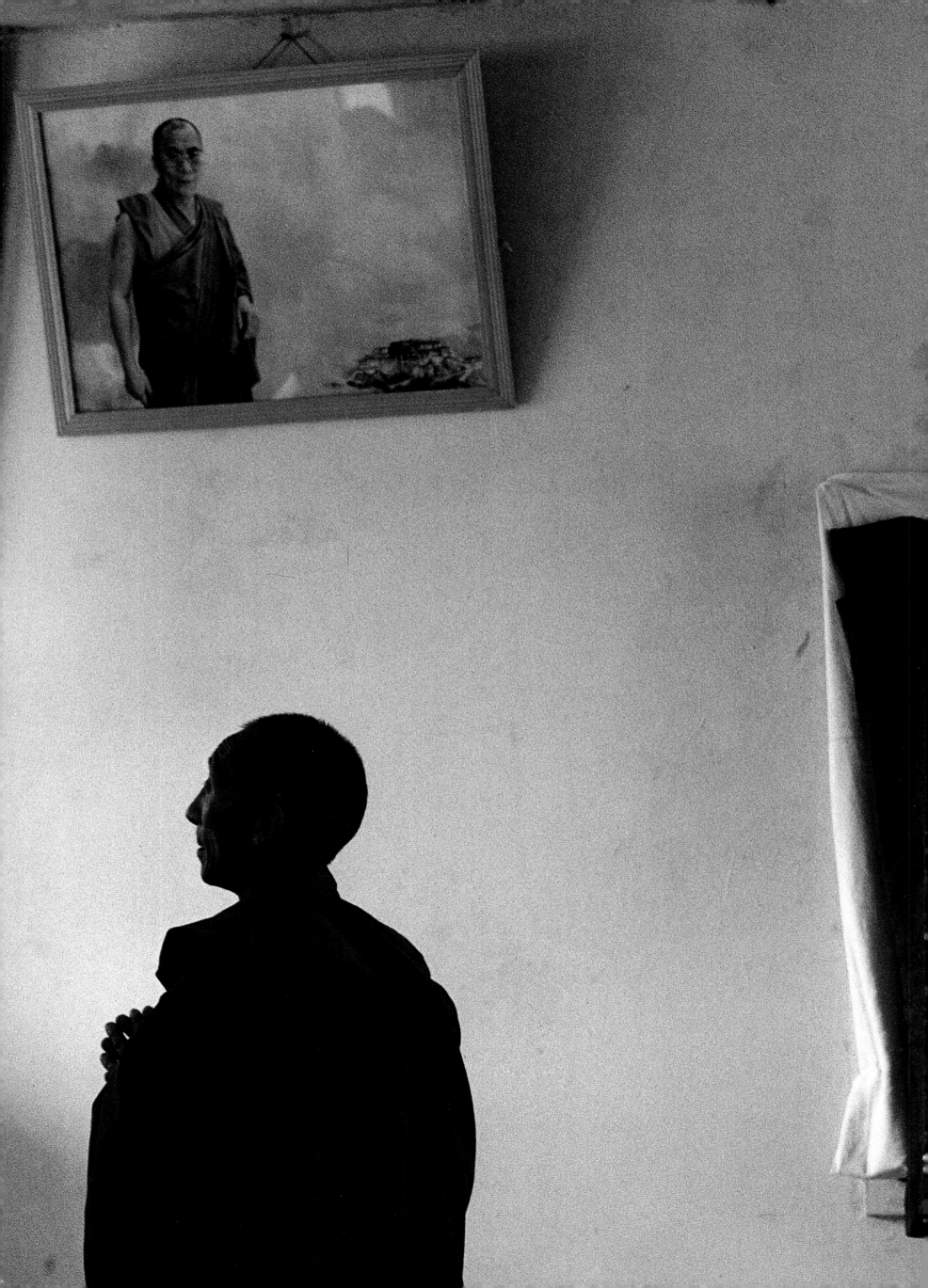

ༀༀ མཚམ་ཆེད་པོ་ལོ་བོ་ཆེ་གོ་གྲུབ་གྲགས་བ་ཚི་ཆེན་རོག་ཁམ་འདི་ལ།
ཁྲག་འཛི་ན་ཚུ་རུམ་ཆུ་ནོཥ་ཚུཧ་ཅུ་བ་ཆི་བ་བོ་ཆི་བ་གྲིག་བྱིག

BLOOD-STAINED CLOTHES OF THE TIBETAN DEMONSTRATORS
SHOT BY THE CHINESE POLICE ON 10th DECEMBER, 1988

Acknowledgements

We thank His Holiness the
Dalai Lama for always
anticipating and accomodating
our needs; Tenzin Geyche
Tethong and the staff of the
Information and International
Relations Office for their
courtesy and help, and all our
Tibetan friends for inspiring this
project. Special thanks also go
to Muriel Speeden for pruning
back the text.

Photographic Credits

Pages 8-9, 10, 15, 17, 23:
British Library
(India Office Library)
Pages 12, 13:
Family collection of Dolma
Yangzom
Pages 18, 19, 21 (bottom), 46-
47: Office of Information and
International Relations,
Dharamsala
Pages 21 (top), 22:
Marc Riboud/
Magnum Photo Agency
Pages 24, 26, 27, 29, 30, 32-33,
34, 36, 38-39:
Marilyn Silverstone/Magnum
Photo Agency